Georgia O'Keeffe Museum

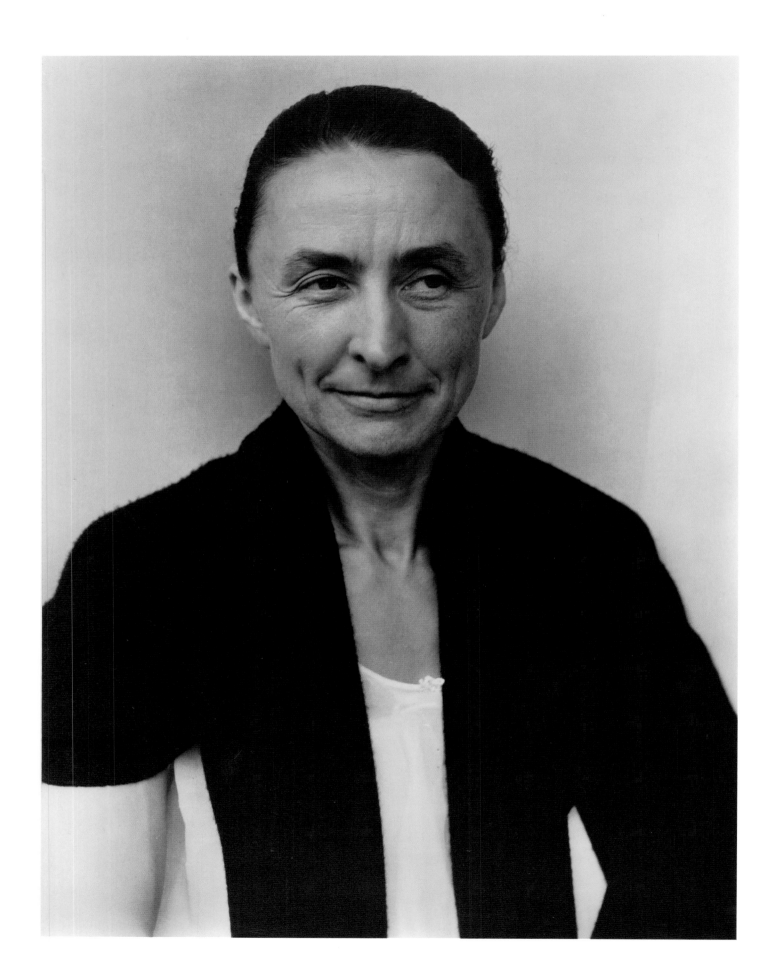

Georgia O'Keeffe Museum Collections

BARBARA BUHLER LYNES

ABRAMS, NEW YORK, IN ASSOCIATION WITH GEORGIA O'KEEFFE MUSEUM

FRONTISPIECE
Alfred Stieglitz
Georgia O'Keeffe
1932
Gelatin silver print, 9⅛ x 6⅞ (23.2 x 17.5)
Gift, The Georgia O'Keeffe Foundation
AS CR 1482

Project Manager: Margaret L. Kaplan
Editorial Assistant: Aiah R. Wieder
Designer: Katy Homans
Production Manager: Jane Searle

Library of Congress Cataloging-in-Publication Data

Lynes, Barbara Buhler
The Georgia O'Keeffe Museum / by Barbara Buhler Lynes.
p. cm.
Includes bibliographical references.
ISBN-13: 978-0-8109-0957-1 (hardcover)
ISBN-10: 0-8109-0957-x (hardcover)
1. O'Keeffe, Georgia, 1887-1986—Catalogs. 2. Art—New Mexico—Santa Fe—Catalogs. 3. Georgia O'Keeffe
Museum—Catalogs. I. O'Keeffe, Georgia, 1887–1986. II. Title.

N6537.039A4 2007
759.13—dc22

2006019894

Georgia O'Keeffe Museum

In the captions:
CR refers to the numbers listed in *Georgia O'Keeffe: Catalogue Raisonné*;
AS CR refers to the number listed in *Alfred Stieglitz: The Key Set*
Dimensions are given height by width by depth (if applicable) in inches, followed by centimeters in parentheses.

Published in 2007 by Abrams, an imprint of Harry N. Abrams, Inc.
All rights reserved. No portion of this book may be reproduced, stored in a retrieval system,
or transmitted in any form or by any means, mechanical, electronic, photocopying, recording, or otherwise,
without written permission from the publisher.

Printed and bound in Japan
10 9 8 7 6 5 4 3 2 1

HNA
harry n. abrams, inc.
a subsidiary of La Martinière Groupe
115 West 18th Street
New York, NY 10011
www.hnabooks.com

Contents

ACKNOWLEDGMENTS

This project could not have been completed without the help and support of many people, and I wish to express my gratitude to everyone who assisted with it. At the Georgia O'Keeffe Museum, I am especially grateful to George G. King, Director, for both his support and encouragement, as well as to Heather Hole, Assistant Curator, and Judy Smith, Registrar, who attended to many of its numerous details. I am also grateful for the generous support of the Board and National Council of the Georgia O'Keeffe Museum and The Burnett Foundation.

At Harry N. Abrams, Inc., I wish to thank Margaret L. Kaplan, Editor at Large, Aiah R. Wieder, Editorial Assistant, Katy Homans, Designer, and Jane Searle, Senior Production Manager.

BARBARA BUHLER LYNES
Curator, Georgia O'Keeffe Museum
The Emily Fisher Landau Director, Georgia O'Keeffe Museum Reasearch Center

Foreword

It is with great pride and enthusiasm that we publish this volume on the occasion of the Museum's tenth anniversary that we are celebrating in 2007. It is the second of two volumes dedicated to the Museum's permanent collection, the first of which was published when the Museum opened in 1997. As the introduction to this volume indicates, our collections have grown exponentially in ten years—from under 100 O'Keeffe works in 1997 to 1,149 now, which is representative of more than half of her artistic output. This figure does not include works by other artists or the archival materials in our collection that have also increased dramatically. The recent, extraordinary gift from The Georgia O'Keeffe Foundation at the time of its dissolution in March 2006 is the largest reason for this dramatic growth, but the vision and generosity of our founders, Anne and John Marion, are the principal reasons for the institution's overall well-being. Their dedication and passion for the success of the Museum has been clear from the outset, and generations of future Museum visitors will have them to thank for creating such an important institution.

I wish to thank Museum president Saul Cohen and his predecessor, Lee Dirks, for the endless hours they devoted in assisting and lending their expertise to the completion of the complex transaction that resulted in The Georgia O'Keeffe Foundation gift. Every museum should be lucky enough to have board members who give so much of their time and knowledge to the institution they serve. Raymond R. Krueger, Chairman of the Board of The Georgia O'Keeffe Foundation until it closed, and grandnephew of Georgia O'Keeffe, was also extremely generous of his time in attending to the extensive details of the gift, and we thank him for his commitment in this regard. Other former Foundation board members who endorsed the gift and whose support we greatly appreciate include Juan Hamilton, O'Keeffe's close friend and associate; Anne d'Harnoncourt, the George D. Widener Director and Chief Executive Officer, Philadelphia Museum of Art; Earl A. Powell III, Director, National Gallery of Art; June O'Keeffe Sebring, O'Keeffe's niece; Robert P. Worcester, President, The Georgia O'Keeffe Foundation; and administrative director Agapita Judy Lopez. All are important to us.

For all she has done for the Museum as its Curator and as the Emily Fisher Landau Director of the Museum's Research Center, I wish to thank Barbara Buhler Lynes for her outstanding work and, in particular, for her careful oversight in the organization and production of this volume. She is responsible for our exhibitions, oversees the collection, and runs the Research Center. The Museum is extremely fortunate to have a scholar of her stature on its staff.

For a young museum that has accomplished as much as we have in ten years, I would like to thank the members of the board of directors, the National Council, and our dedicated staff for all of their contributions to our success. We look forward to celebrating our tenth anniversary with all of you.

GEORGE G. KING

Director, Georgia O'Keeffe Museum

Introduction

THE MUSEUM

The Georgia O'Keeffe Museum in Santa Fe, New Mexico, opened to the public in July 1997, with the goals of honoring and perpetuating Georgia O'Keeffe's (1887–1986) artistic legacy and exploring her role in the development of the art of her time. In its first ten years, the Museum has welcomed nearly three million visitors from all over the world, and is an important destination for those interested in O'Keeffe's art and, more broadly, in American Modernism—the most advanced art produced in the United States since the late 19th century.

It is rare for any artist to have an institution created primarily to exhibit his or her work, but the founders of the Museum, Anne and John Marion, recognized that the breadth of O'Keeffe's art held appeal for a wide national and increasingly international audience, and they decided to honor the artist's achievement in this singular way.

Over the course of her career, O'Keeffe worked in various parts of the country. Early on, she was associated with New York, where her career began in 1916 and where she was recognized as one of America's most important artists and enjoyed ongoing critical success. The Marions, however, decided to establish the Museum in northern New Mexico, where the artist lived and worked for the last four decades of her life.

In the mid-1990s, through The Burnett Foundation, they began amassing the core of what has become the world's largest public collection of O'Keeffe's work. To house this collection, they purchased one of Santa Fe's older buildings and engaged the well-known New York architectural firm of Gluckman Mayner to transform and expand it into an elegant exhibition space of more than 5,000 square feet.

Since its opening, the Museum has steadily added to its collections and facilities through the continuing generosity of The Burnett Foundation and other donors. In 1999, the Museum became the steward of the house that O'Keeffe purchased in 1940 at Ghost Ranch, approximately 65 miles northwest of Santa Fe, and in 2001, it opened the Georgia O'Keeffe Museum Research Center. Planned from the beginning to be an integral part of the Museum, the Research Center is the only museum-related facility in the world dedicated to the study of American Modernism. Together, the Museum and the Research Center organize exhibitions and educational programs that command national attention.

The Georgia O'Keeffe Foundation, an entity established in 1989 to preserve the artist's legacy and to oversee the distribution of Georgia O'Keeffe's estate, in 2006 determined to transfer its remaining assets to the Museum.[1] In addition to works of art and archival materials,

1. Since 1989, the Foundation has distributed work from its collection to distinguished national and international art institutions, including the Georgia O'Keeffe Museum, and has been generous in lending work to the Museum as well as other institutions for exhibitions. In 1992, it sponsored research for a catalogue raisonné of the artist's work, which was published in 1999 with the support of the National Gallery of Art, The Burnett Foundation, and the Luce Foundation, and it participated in an international exhibition of O'Keeffe's art that opened in 1993. From its inception, it has cared for the artist's house and studio in Abiquiu, New Mexico, now a National Historic Landmark. And since 1997, the Foundation and the Georgia O'Keeffe Museum have worked closely on a number of objectives, including an extensive oral history project.

these assets included the house that O'Keeffe purchased in Abiquiu, New Mexico, in 1945, and an endowment fund earmarked primarily to assure its continuing operation, maintenance, and preservation.

Although many O'Keeffe works remain in private collections or are housed in public institutions in the United States and around the world, the Georgia O'Keeffe Museum is where the visitor can experience the largest single grouping of her art, including examples dating from 1901 through 1982—two years before failing health forced the artist into retirement. The Museum is fortunate to own a full range of O'Keeffe's work, including many of her iconic pieces.

It is our hope that this selection of works from the Museum's collection will familiarize the reader with the range of our holdings and, for those unfamiliar with her work, will suggest the nature of O'Keeffe's singular approach to conveying her experience of the world. Of course, to appreciate this work to its fullest extent, one must see it. We therefore hope that this handsome publication will encourage readers to visit the Georgia O'Keeffe Museum and experience the work of one of America's most important artists at first hand.

THE COLLECTION

When the Museum opened, its collection of 116 works included 94 by O'Keeffe, the largest group of works by the artist in any museum in the world. In the last 10 years, the collection has grown steadily with the extraordinary help and continuing generosity of The Burnett Foundation as well as the support of many individual donors, whose gifts include works by O'Keeffe as well as works by a number of her contemporaries.[2]

In 2006, the collection expanded dramatically when The Georgia O'Keeffe Foundation transferred its remaining artworks to the Museum. This included 981 works by O'Keeffe: 163 finished paintings, drawings, and sculptures; 669 sketches; and 149 photographs by O'Keeffe. It also included 1,770 photographs by various professional photographers—of O'Keeffe, important events in her life, her animals and friends, New Mexico houses, and the subjects she painted. The Museum's collection now includes 2,989 works: 1,149 by O'Keeffe, and 1,840 by other artists.

This catalogue reproduces 335 works. Those by O'Keeffe are organized by subject and, for the most part, are chronological within those subjects. Exceptions occur when O'Keeffe depicted a particular motif more than once over a number of years, in which case these images have been brought together.

For works that can be associated with more than one category, the predominating form within the image establishes its subject category. And when O'Keeffe addressed the same subject in more than one medium, these works have been brought together.

2. The Museum's archival collections have grown substantially since 1997 and are housed at its Research Center. In 1999, the Museum received a gift from Juan and Anna Marie Hamilton of the tangible, personal property that was owned by O'Keeffe at the time of her death. These materials include, among other things, the library from O'Keeffe's Ghost Ranch house, her art materials, her clothes, and the collections of found objects that she often made the subject of her work. In addition, the Museum has received the archive of the distinguished scholar William Innes Homer; the papers of O'Keeffe's friend Maria Chabot; more than 600 original O'Keeffe letters; and the extensive archive of materials included in the transfer of assets from The Georgia O'Keeffe Foundation.

All of the paintings and sculptures in the collection by other artists are reproduced here, as well as a selection of photographs, including three by O'Keeffe.

Over the years, O'Keeffe wrote thousands of letters to relatives and friends that provide a great deal of information about her life and her work, and she often spoke with writers, who quoted her in various publications. She was the author of a book, *Georgia O'Keeffe* (Viking Press, 1976), in which she explained the inception of the works she chose as illustrations, and she was the subject of the film *Georgia O'Keeffe,* produced and directed by Perry Miller Adato and aired on PBS in 1977. O'Keeffe's words from many of these sources are included in this volume.

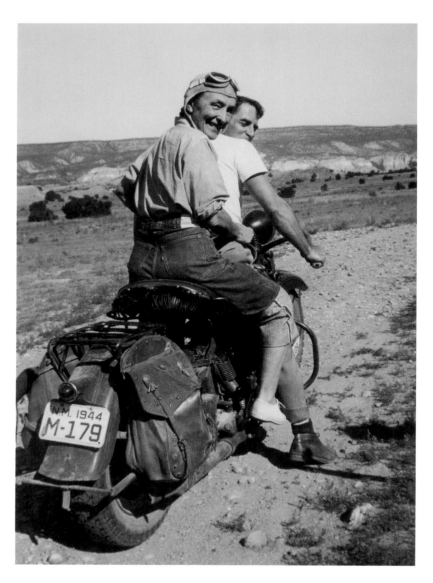

Maria Chabot, *O'Keeffe Hitching a Ride to Abiquiu, Ghost Ranch,* 1944
See page 339

Where I was born and where and how I have lived is unimportant. It is what I have done with where I have been that should be of interest. (*Georgia O'Keeffe*, 1976, unpaginated text.)

I have but one desire as a painter—that is to paint what I see, as I see it, in my own way, without regard for the desires or taste of the professional dealer or the professional collector. I attribute what little success I have had to this fact. I wouldn't turn out stuff for order, and I couldn't. It would stifle any creative ability I possess. . . . "Women don't make good painters," they said. I had never thought of it that way. I just painted, that was all. (Georgia O'Keeffe in B. Vladimir Berman, "She Painted the Lily and Got $25,000 and Fame for Doing It! Not in a Rickety Atelier but in a Hotel Suite on the 30th Floor, Georgia O'Keefe [*sic*], New Find of Art World, Sets Her Easel," *New York Evening Graphic* [12 May 1928], 3M.)

Abstraction

Nothing is less real than realism. Details are confusing. It is only by selection, by elimination, by emphasis, that we get at the real meaning of things. (Georgia O'Keeffe in "I Can't Sing, So I Paint! Says Ultra Realistic Artist; Art Is Not Photography—It Is Expression of Inner Life!: Miss Georgia O'Keeffe Explains Subjective Aspect of Her Work," *New York Sun* [5 December 1922], 22.)

PLATE I

Georgia O'Keeffe began working with abstraction in 1915, and was then one of a handful of American artists exploring this means of expression, such as Arthur Dove, Manierre Dawson, and Alfred Maurer. Although some of her subsequent work depicted subjects representationally, abstraction remained her primary expressive language until 1923, when she confronted the critical response to her first retrospective exhibition that interpreted her work as a manifestation of her sexuality. In an attempt to direct the critics away from what she considered to be misreadings of her art, she increasingly shifted her attention to the depiction of recognizable forms. By the mid-1920s she had redefined herself as a representational painter, and she remains best known today for her works with recognizable subject matter.

Abstraction was always her preferred language, however, and it remained the underpinning of her art. But for over a quarter century, with few exceptions, she made clear the sources of her abstractions by demonstrating that they evolved toward the end of a series of paintings that had begun with highly representational forms, as in the six Jack-in-the-pulpit paintings she completed in 1930. She discontinued this practice in the late 1950s, when she was in her 60s, preferring again to work directly with abstraction almost exclusively until failing eyesight ended her career in 1984.

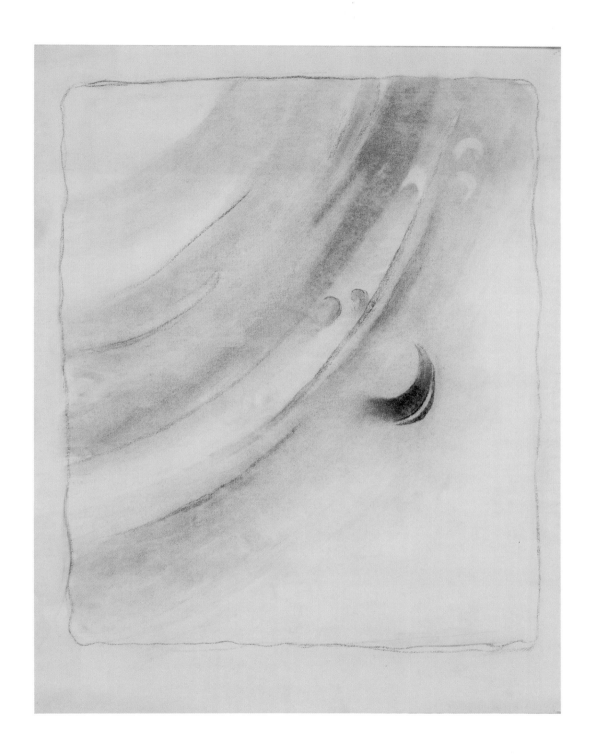

PLATE 2

Whatever the degree of abstraction in O'Keeffe's work, her point of departure was always the visible world, and although the sources for most of her early abstractions remain elusive, some are documented or can be suggested from other evidence. For example, a letter O'Keeffe wrote in 1916 indicates that the simple, elegantly balanced vertical and horizontal lines and the delicate rhythmic intervals between them in the watercolor *Black Lines* were inspired by her observation of skyscrapers seen from the window of her New York apartment. (In O'Keeffe to Stieglitz, 22 November 1916, Georgia O'Keeffe/Alfred Stieglitz Archive, Collection of American Literature, Beinecke Rare Book and Manuscript Library, Yale University, New Haven. Photographer Alfred Stieglitz [1864–1946] was O'Keeffe's first champion and, from 1924 until his death, her husband.)

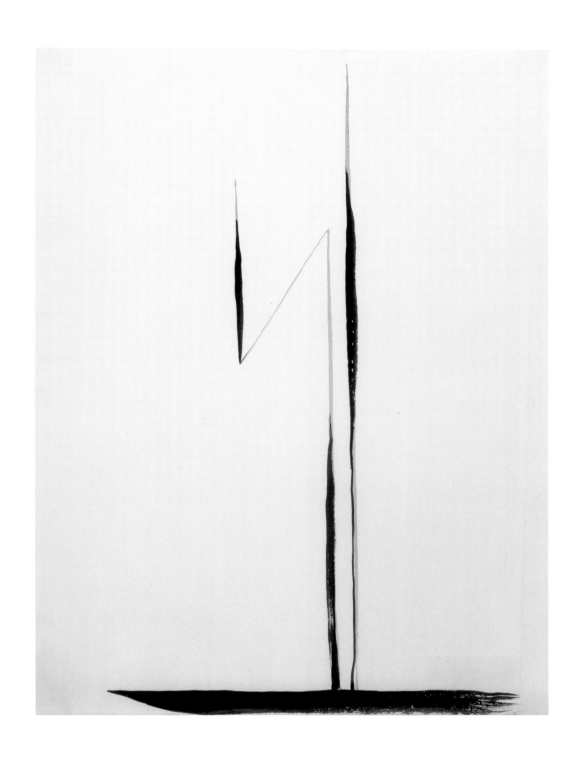

PLATE 2
Black Lines
1916
Watercolor on paper, 24½ x 18½ (62.2 x 47)
Promised gift, The Burnett Foundation

CR 63

PLATE 3

The centralized, womb-like spiral of *Blue II* seems to substantiate connections critics in the 1920s made between O'Keeffe's work and female sexuality. Yet when she made this watercolor, O'Keeffe was intensely involved in playing the violin, and both the form and expressive resonance of the spiral in her watercolor most likely derive from the scroll-shaped termination of the neck of the instrument that was in her field of vision as she played it.

In the 1970s, feminist artists and art historians were particularly drawn to centralized (circular) forms in O'Keeffe's work that, to them, closely resembled parts of a woman's sexual anatomy. They perceived centralized forms as the first manifestations of an iconography they believed was specifically representative of the feminine (see also, for example, plates 17, 19, 21, 22, 114, 115). Although O'Keeffe was then a feminist and had been a member of the National Woman's Party since the 1910s, she rejected these 1970s ideas about her art, just as she had rejected sex-based readings of her art in the 1920s, as an interpretation of her work that limited it to her gender and defined her primarily as a woman artist rather than as she defined herself: an artist.

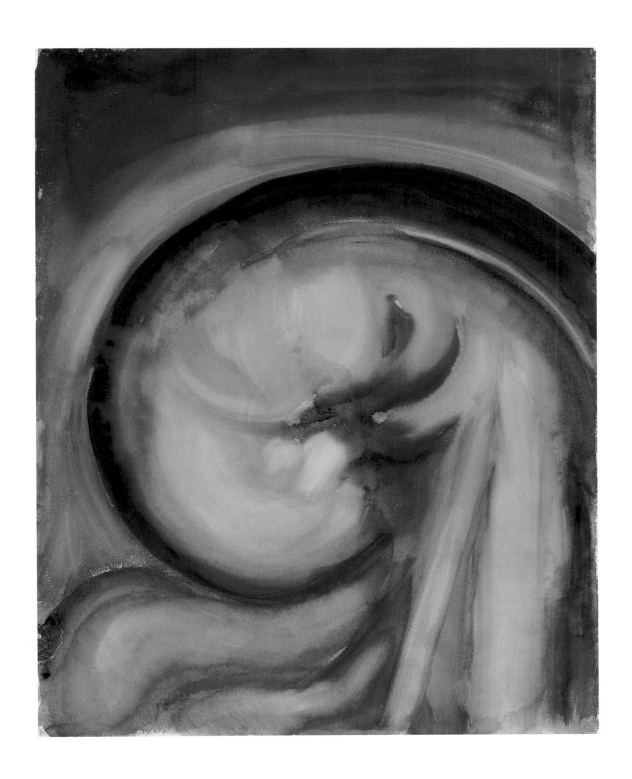

PLATE 3

Blue II

1916

Watercolor on paper, 27⅞ x 22¼ (70.8 x 56.5)

Gift, The Burnett Foundation

CR 120

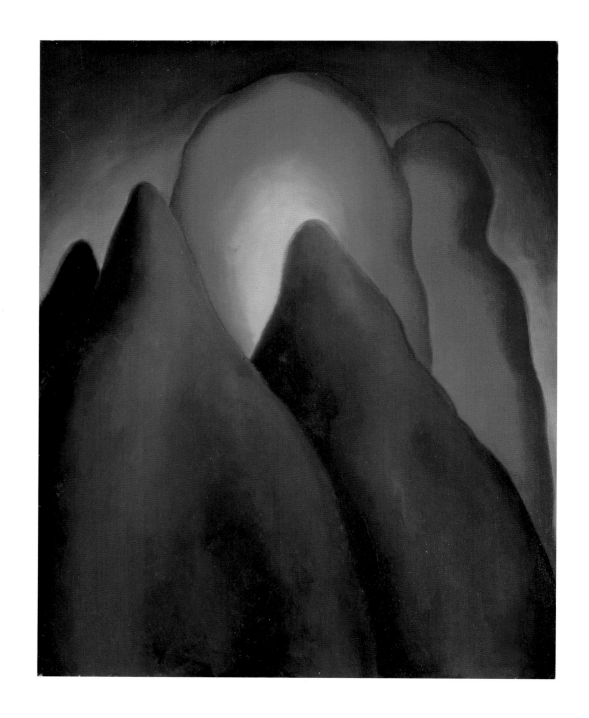

PLATE 4

Anything

1916

Oil on board, 20 x 15¼ (50.8 x 40)

Gift, The Georgia O'Keeffe Foundation

CR 90

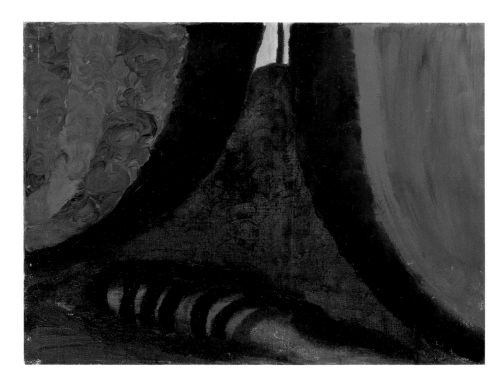

PLATE 5
Untitled (Tent Door at Night)
1916
Graphite on paper, 4 x 5¼ (10.2 x 13.3)
Gift, The Georgia O'Keeffe Foundation

CR 111

PLATE 6
Untitled (Tent Door at Night)
1916
Watercolor on paper, 19 x 25 (48.3 x 63.5)
Gift, The Georgia O'Keeffe Foundation

CR 112

PLATE 7
Inside the Tent While at U. of Virginia
1916
Oil on canvas, 18¼ x 23⅜ (46.3 x 60)
Gift, The Georgia O'Keeffe Foundation

CR 115

Another dimension of O'Keeffe's keenly modernist sensibilities is apparent in these two works. They are conceptual rather than imitative portraits, and thus, unlike traditional approaches to portraiture, they are realized through abstraction rather than realism. Each painting belongs to a series of abstract portraits of two friends—photographer Paul Strand, whom O'Keeffe first met when she visited New York in June 1917, and Kindred M. Watkins, a mechanic who was one of her friends in Canyon, Texas.

PLATE 8
Untitled (Abstraction/Portrait of Paul Strand)
1917
Watercolor on paper, 12 x 8⅞ (30.5 x 22.5)
Promised gift, The Burnett Foundation

CR 191

PLATE 9
Portrait—W—No. III
1917
Watercolor on paper, 12 x 8⅞ (30.5 x 22.5)
Gift, The Burnett Foundation and The Georgia O'Keeffe Foundation

CR 194

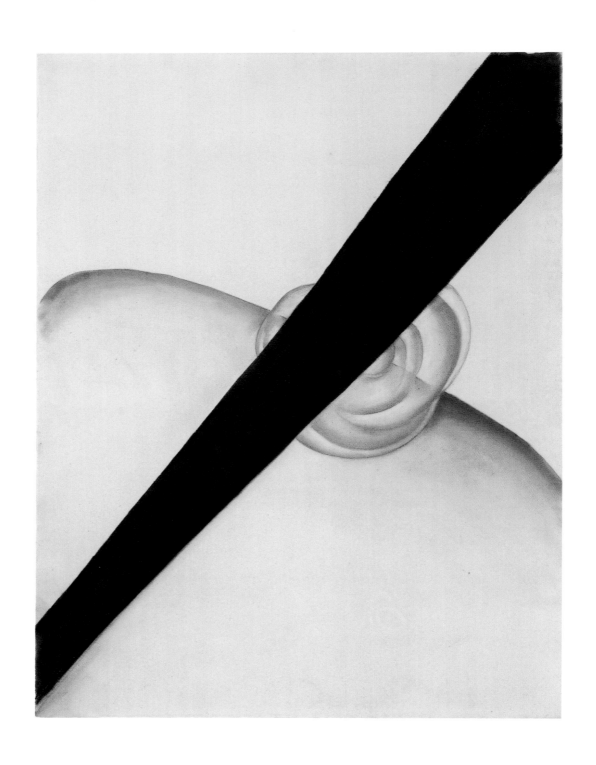

PLATE 10

Black Diagonal

1919

Charcoal on paper, 24⅝ x 18¾ (62.5 x 47.6)

Promised gift, The Burnett Foundation

CR 276

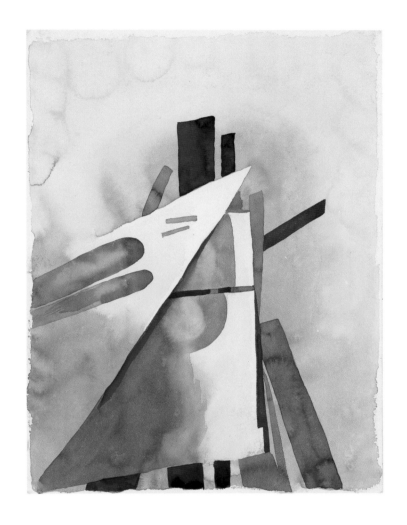

O'Keeffe worked in series throughout her career and often made drawings in either pencil or charcoal—sometimes in both—as preludes to her pastels and oil paintings. In such preliminary studies, she worked out issues of tonality before moving to color, as in these two works from 1919. See also, for example, works from the 1940s (plates 206–10), from 1959 and 1960 (plates 28–30), and the *From a Day with Juan* series (plates 41–46).

After 1918, O'Keeffe gained an intimate knowledge of photography through her association with Stieglitz. As she wrote in 1922: "I have looked with great interest through rafts of photographs done before the war by [Eduard] Steichen, [Adolph] De Meyer, [Alvin Langdon] Coburn, [Fred] Holland Day, [Clarence] White, [Gernot] Kuehn, Frank Eugene [Smith], [James] Craig Annan, [Robert] Demachy and many others. . . . To me Stieglitz [photographs] are aesthetically, spiritually significant in that I can return to them, day after day, have done so almost daily for a period of four years with always a feeling of wonder and excitement. . . ." (In Georgia O'Keeffe, "To MSS. and its 33 subscribers and others who read and don't subscribe!" letter to the editor, *MSS.*, no. 4 [December 1922]: 17.)

The subtle tonalities possible in the medium of photography helped shape her vision as well as the organization and structure of her work. As a result, most of her pastels and oil paintings from the late teens and beyond employ the tonal modulations of a single or a limited number of hues to achieve the illusion of volume, defining her as one of the first American artists to understand the potential of photography as both a technical and conceptual resource for painting.

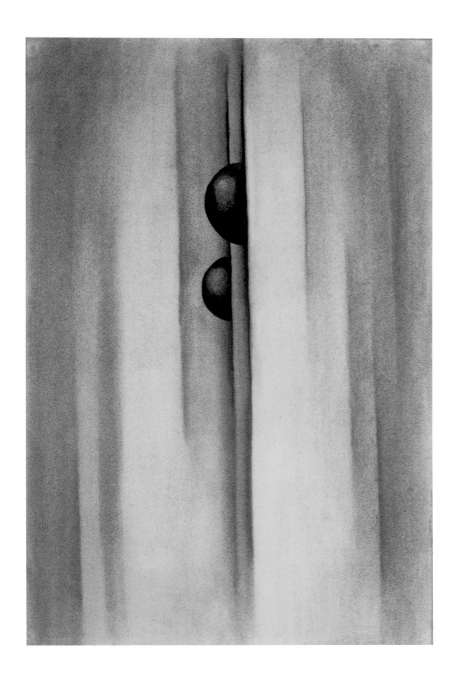

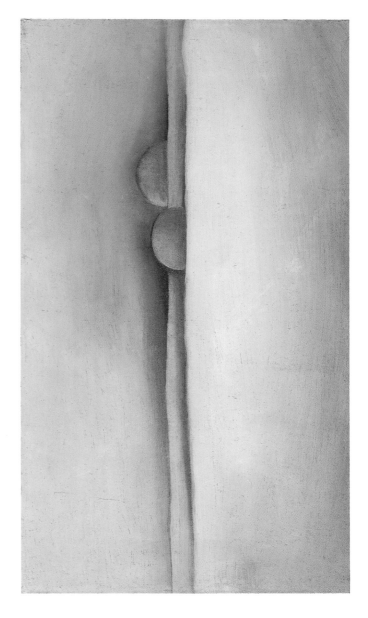

PLATE 12

No. 17 — Special

1919

Charcoal on paper, 19¾ x 12¾ (50.2 x 32.4)

Gift, The Burnett Foundation and The Georgia O'Keeffe Foundation

CR 280

PLATE 13

Green Lines and Pink

1919

Oil on canvas, 18 x 10 (45.7 x 25.4)

Gift, The Burnett Foundation and The Georgia O'Keeffe Foundation

CR 282

PLATE 14

The pulsating rhythms and repeating shapes of *Series I—From the Plains,* derive from particular sounds that, for O'Keeffe, evoked associations with a specific place. As she later recalled: "*Series I—From the Plains* . . . [was] painted in New York months after I left that wide world [Texas]. The cattle in the pens lowing for the calves day and night was a sound that has always haunted me. It had a regular rhythmic beat like the old Penitente songs [which she had heard in New Mexico], repeating the same rhythms over and over all through the day and night. It was loud and raw under the stars in that wide empty country." (In *Georgia O'Keeffe,* 1976, unpaginated text accompanying entry 3.)

O'Keeffe's treatment of lights and darks in this painting relates to her keen observation of the subtle tonal variations as well as the ambiguities often observable in black-and-white photographs. In *Series I—From the Plains,* the use of light areas on the horizon suggests an actual light source in nature, but in the lower part of the painting the lights seem contradictory to that. There, the very subtle transitions from dark to light establish volumes that appear to be unmodulated by the light emanating from the horizon—a phenomenon frequently seen in images in which there are multiple sources of light, and especially obvious in many photographs.

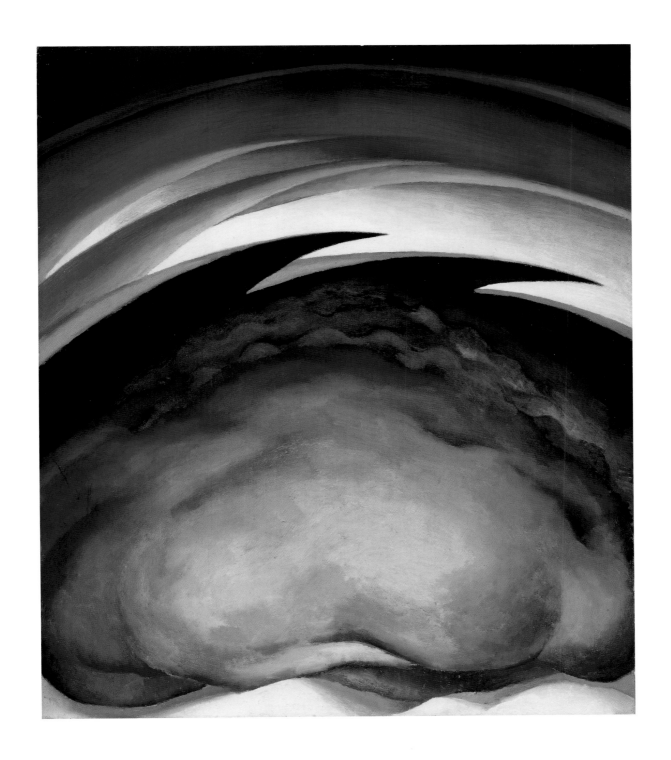

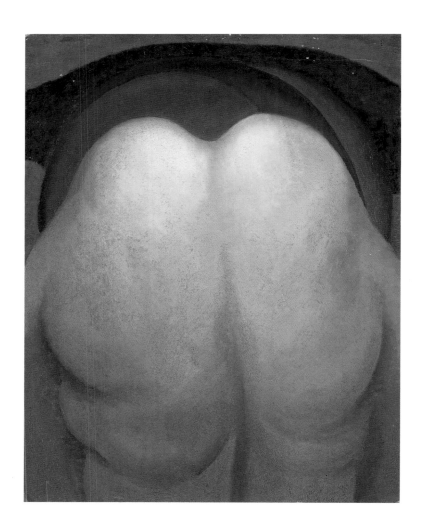

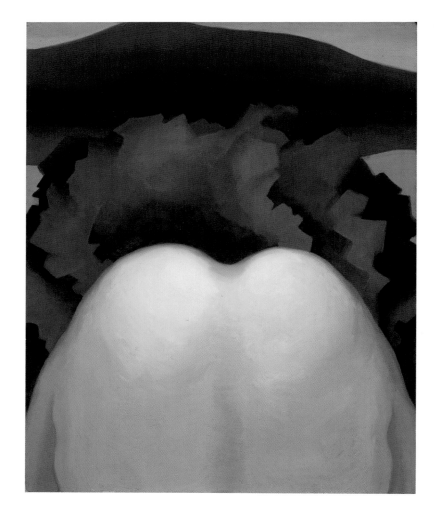

PLATE 15

Series I—No. 10A

1919

Oil on board, 20⅛ x 15⅞ (51.1 x 40.3)

Gift, The Georgia O'Keeffe Foundation

CR 290

PLATE 16

Series I, No. 10

1919

Oil on canvas, 20⅛ x 16⅛ (51.1 x 41)

Gift, The Georgia O'Keeffe Foundation

CR 291

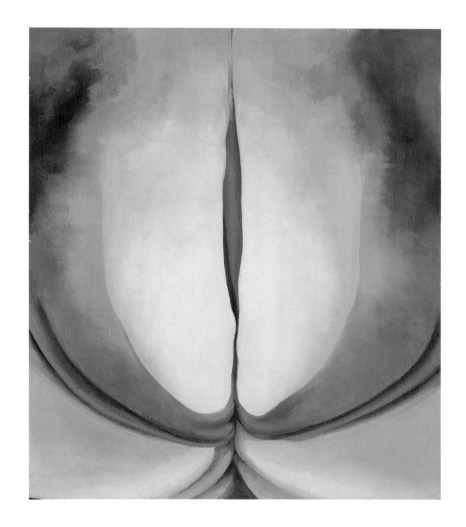

PLATE 17

Blue Line

1919

Oil on canvas, 20⅛ x 17⅛ (51.1 x 43.5)

Gift, The Burnett Foundation and The Georgia O'Keeffe Foundation

CR 294

PLATE 18

O'Keeffe often used photographs directly as inspirations for her own images. For example, *Series I, No. 12* can be read as a pure abstraction; but it also can be seen as derived from certain prints in Stieglitz's ongoing photographic "portrait" of O'Keeffe that extended from the 1910s to the late 1930s. It is more than likely that the geometric forms in this painting are based on the shapes of her neck and upper torso seen in numerous photographs Stieglitz made in the late 1910s. In referring to Stieglitz's photographs of her, O'Keeffe explained: "I can see myself and it has helped me to say what I want to say—in paint." (In Allan Keller, "Animal Skulls Fascinate Georgia O'Keefe [*sic*] but She Can't Explain It—Not in Words: If She Could She'd Have to Do It by Painting Another Animal Skull—New York Artist Paints Because She Has To, but Must Be Alone," *New York World-Telegram* [13 February 1937], A2.)

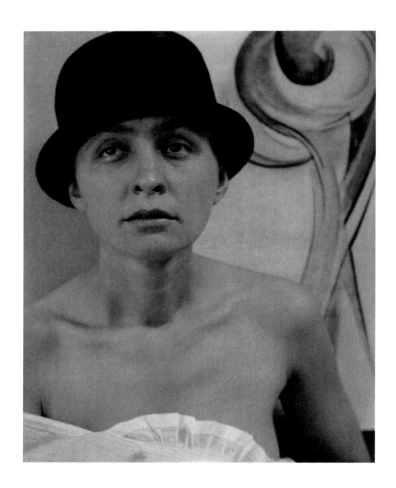

Figure 1
Georgia O'Keeffe
1918
Alfred Stieglitz
Palladium print, 9¼ x 7¹¹⁄₁₆ (23.8 x 19.5)
The Art Institute of Chicago

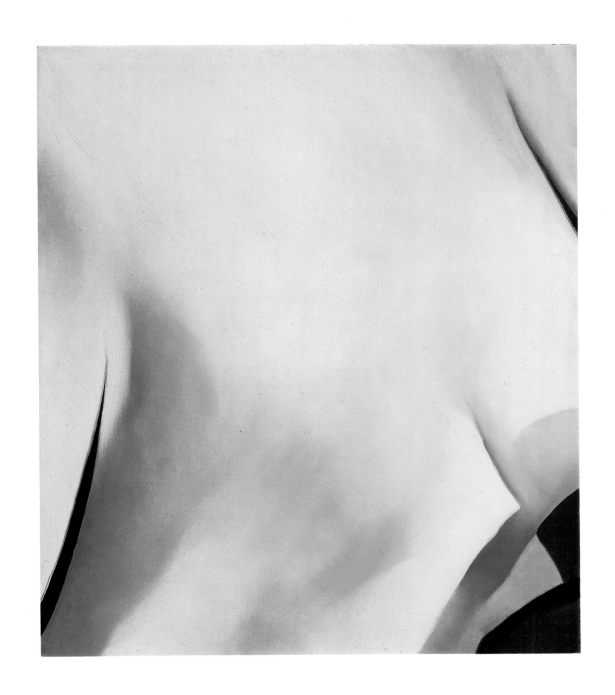

PLATE 18
Series I, No. 12
1920
Oil on canvas, 20 x 16¼ (50.8 x 41.3)
Gift, The Burnett Foundation and The Georgia O'Keeffe Foundation
CR 311

33

PLATES 19—20

Many works inspired by studies of water in the early 1920s are quite provocative, such as *Abstraction Seaweed and Water—Maine,* which can be read as a study based on human or plant reproductive anatomy. No less ambiguous in subject reference is *Abstraction of Stream* or *Pond in the Woods* (plate 21.) These works fueled ideas connecting O'Keeffe's work with her sexuality, yet there can be little question that O'Keeffe intended their forms, whether startlingly two-dimensional or fluidly modulated, to be abstract realizations of particular shapes, colors, and movements she observed in the natural world and consistently celebrated in her work. As she later pointed out: "Eroticism! . . . That's something people themselves put into the paintings. They've found things that never entered my mind." (In Dorothy Seiberling, "The Female View of Erotica," *New York Magazine* 7, no. 6 [11 February 1974]: 54.)

Water continued to be an ongoing motif in O'Keeffe's work, and she celebrated both its abundant presence in some parts of the world and its relative absence in others. The polarities of her experience are obvious when one considers *Storm Cloud, Lake George,* 1923 (plate 196) or *Green and White,* 1957/1958 (plate 236), a painting inspired by waterfalls she saw during a trip to Peru in 1956, alongside certain works of northern New Mexico subject matter, such as *Untitled (Dry Waterfall, Ghost Ranch),* c. 1943 (plate 208).

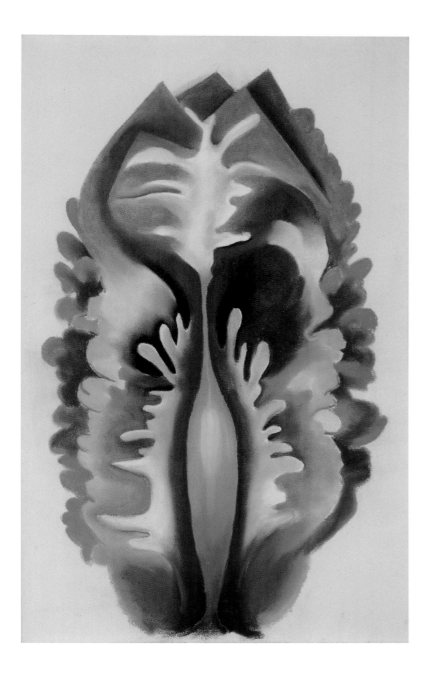

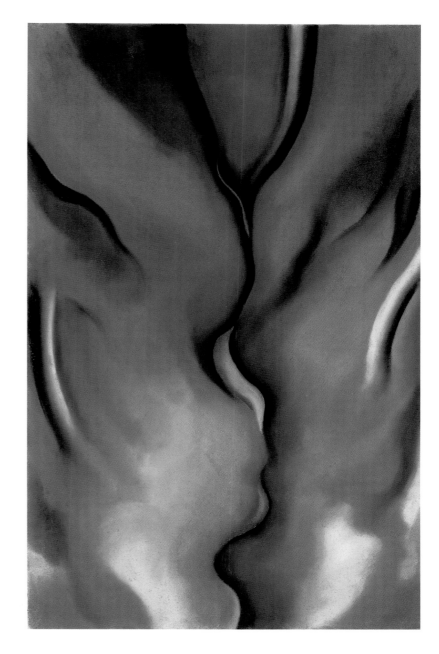

PLATE 19

Abstraction Seaweed and Water—Maine

1920

Pastel on paper, 28⅜ x 17¼ (72.1 x 45.1)

Gift, The Georgia O'Keeffe Foundation

CR 326

PLATE 20

Abstraction of Stream

1921

Pastel on paper, 27¼ x 17½ (70.5 x 44.5)

Promised gift, The Burnett Foundation

© 1987 Private collection

CR 342

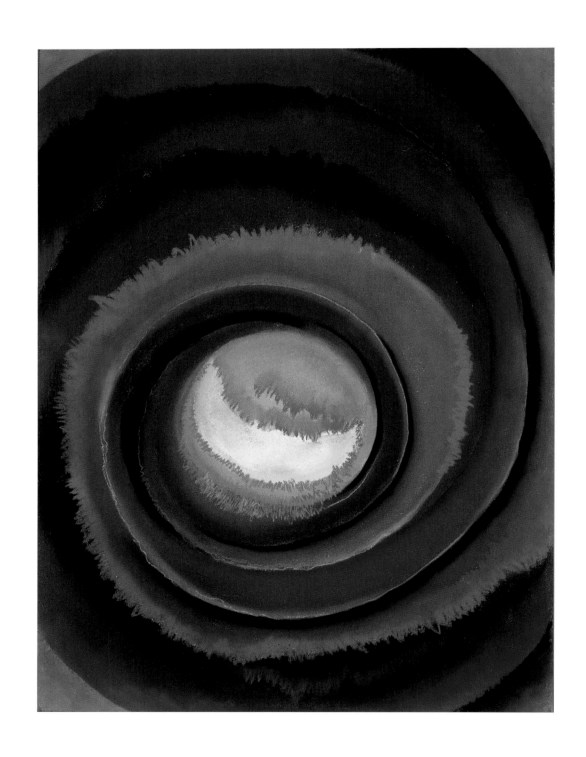

PLATE 21

Pond in the Woods

1922

Pastel on paper, 24 x 18 (61 x 45.7)

Promised gift, The Burnett Foundation

CR 397

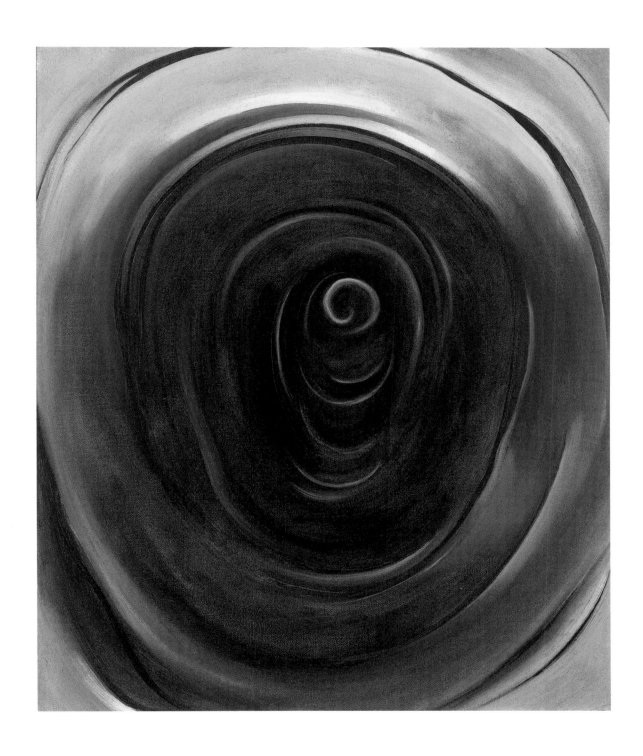

PLATE 22
A Piece of Wood I
1942
Oil on canvas, 24 x 20 (61 x 50.8)
Promised gift, The Burnett Foundation
CR 1030

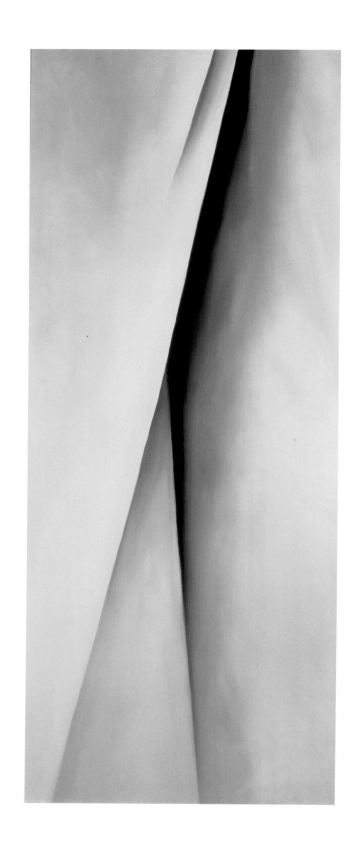

PLATE 23

Abstraction White

1927

Oil on canvas, 34 x 14 (86.4 x 35.6)

Promised gift, The Burnett Foundation

CR 571

38

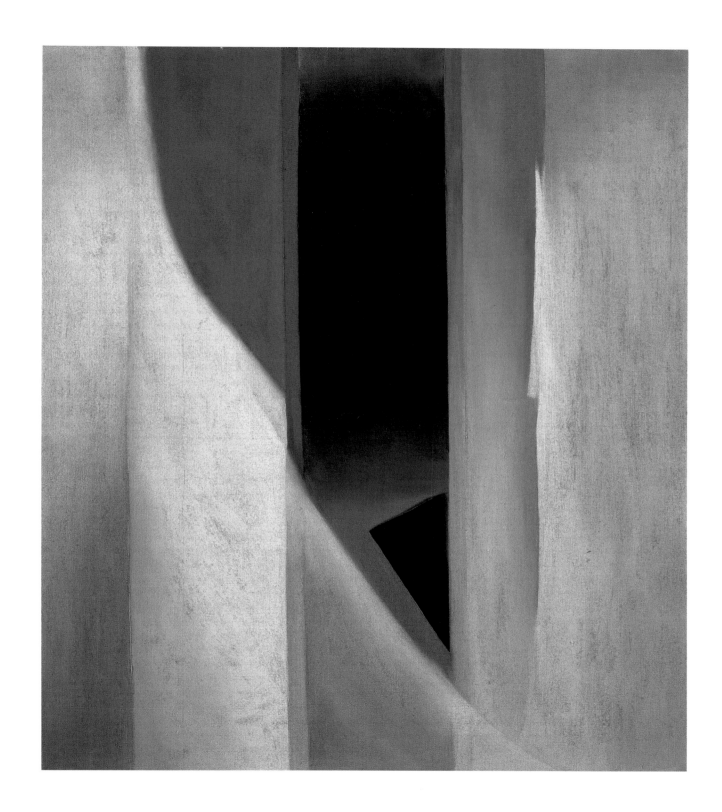

PLATE 24
Blue II
1958
Oil on canvas, 30 x 26 (76.2 x 66)
Gift, The Burnett Foundation and The Georgia O'Keeffe Foundation
CR 1331

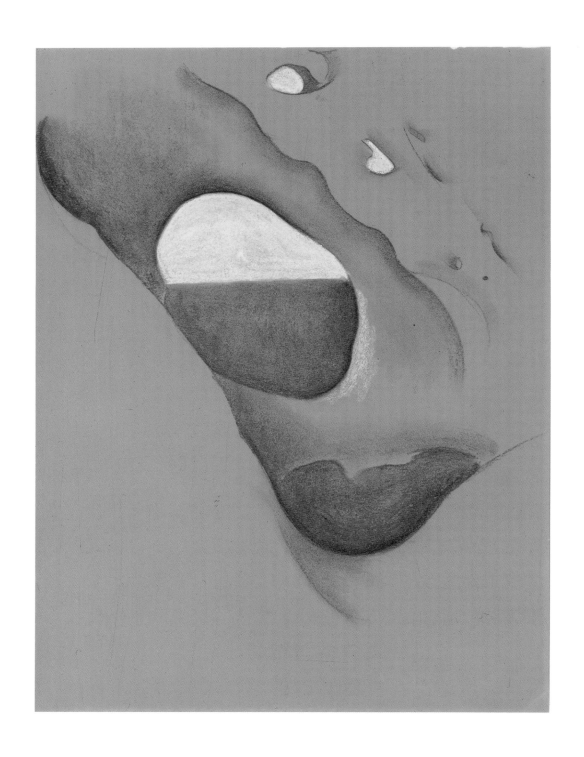

PLATE 25
Untitled (Abstraction)
1943
Charcoal and white chalk on paper, 24 x 17⅞ (61 x 45.4)
Gift, The Georgia O'Keeffe Foundation
CR 1051

40

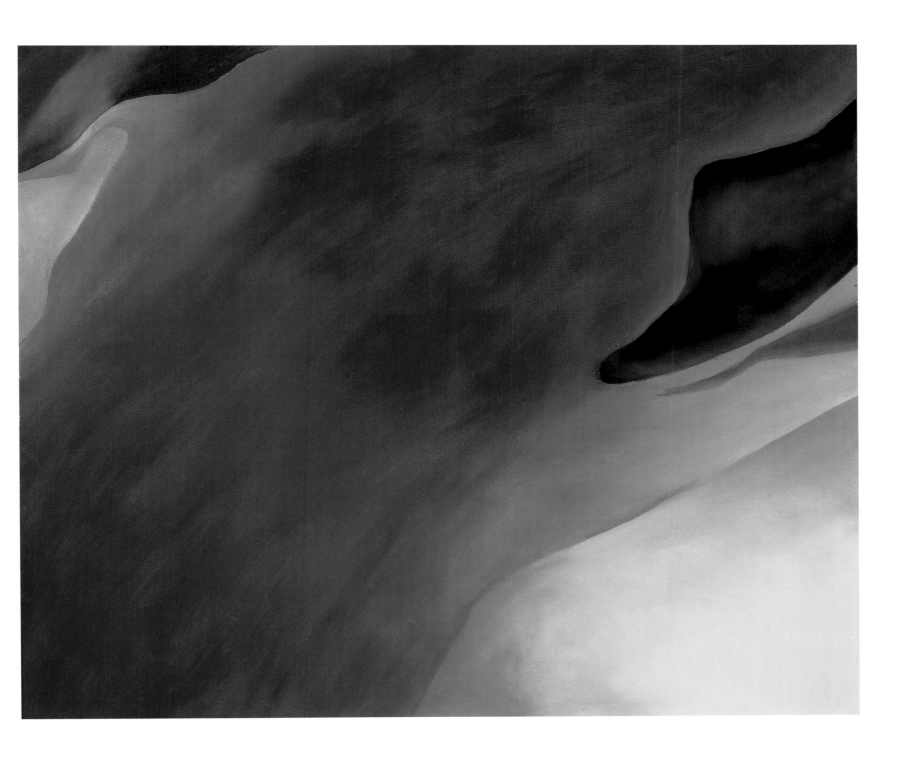

PLATE 26
Blue—A
1959
Oil on canvas, 30 x 36 (76.2 x 91.4)
Gift, The Georgia O'Keeffe Foundation
CR 1356

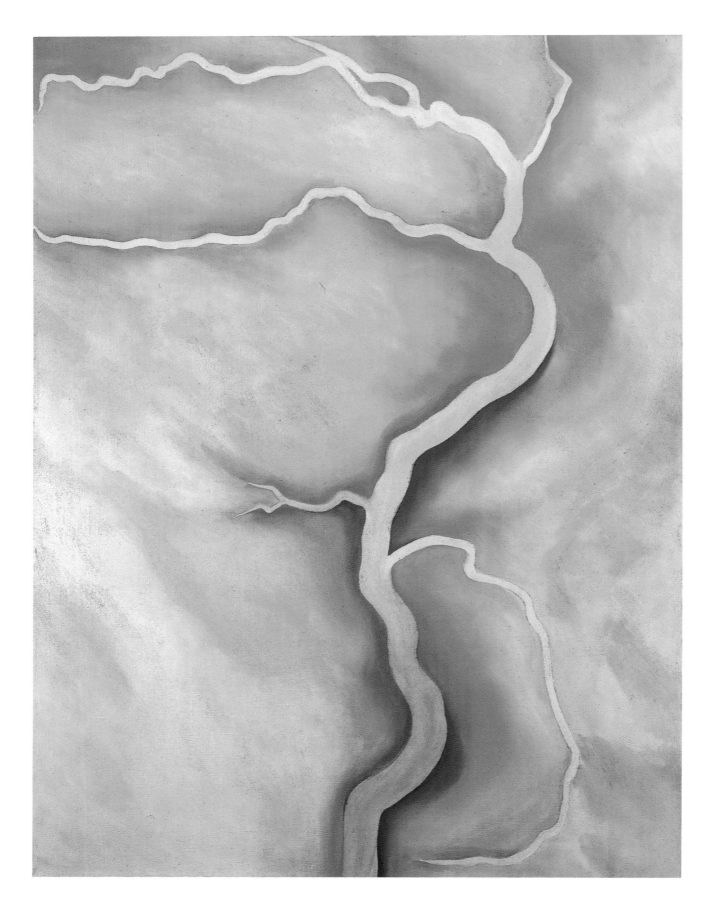

PLATE 27

From the River—Pale

1959

Oil on canvas, 41½ x 31⅛ (105.4 x 79.7)

Gift, The Georgia O'Keeffe Foundation

CR 1360

PLATES 28–40

In the late 1950s, O'Keeffe began a number of trips by airplane that carried her around the world several times. These experiences inspired paintings in series of either cloud, land, or water formations seen from the sky, a perspective then unique to twentieth-century art.

As she explained: "I once spent three and a half months flying around the world. I was surprised that there were so many desert areas with large river beds running through them. I made many drawings about one and a half inches square of the rivers seen from the air. At home I made larger charcoal drawings from the little pencil drawings. Later I made paintings from the charcoal drawings. The color used for the paintings had little to do with what I had seen—the color grew as I painted." (In *Georgia O'Keeffe*, 1976, unpaginated text accompanying entry 103.) "One day when I was flying back to New Mexico, the sky below was a most beautiful solid white. It looked so secure that I thought I could walk right out on it to the horizon if the door opened. The sky beyond was a light clear blue. It was so wonderful that I couldn't wait to be home to paint it." (In *Georgia O'Keeffe*, 1976, unpaginated text accompanying entry 106.)

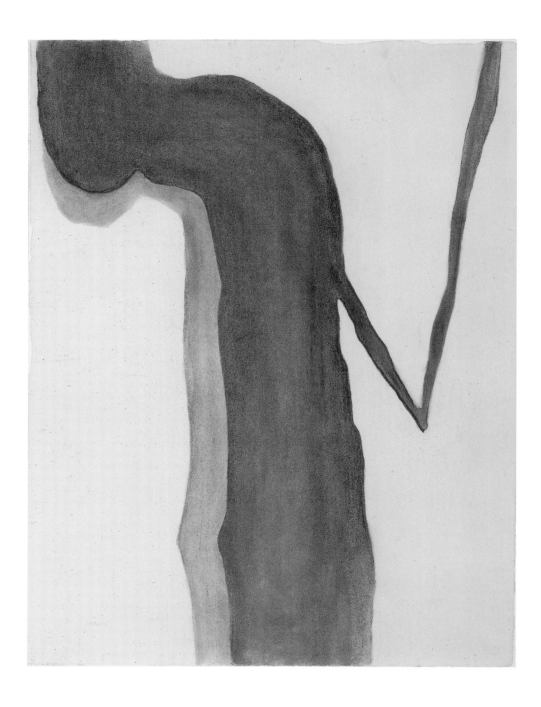

PLATE 28
Untitled (Abstraction/River)
1959
Black ball-point pen on paper, 9 x 6⅞ (22.9 x 17.5)
Gift, The Georgia O'Keeffe Foundation

CR 1338

PLATE 29
Drawing V
1959
Charcoal on paper, 24½ x 18¾ (62.2 x 47.6)
Gift, The Burnett Foundation and The Georgia O'Keeffe Foundation

CR 1339

44

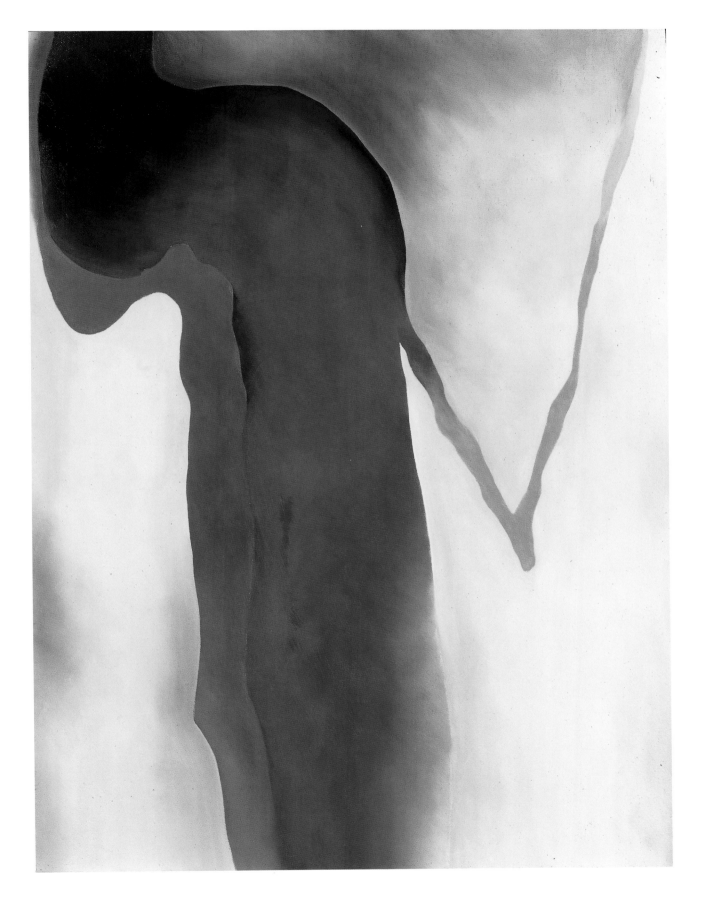

PLATE 30
Blue Black and Grey
1960
Oil on canvas, 40 x 30 (101.6 x 76.2)
Promised gift, The Burnett Foundation

CR 1440

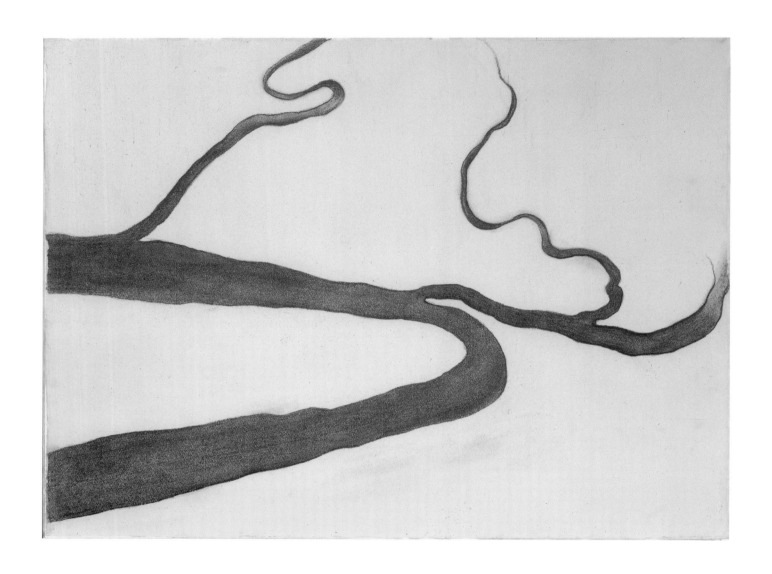

PLATE 31

Drawing IX
1959
Charcoal on paper, 18⅝ x 24⅝ (47.3 x 62.5)
Gift, The Georgia O'Keeffe Foundation
CR 1348

46

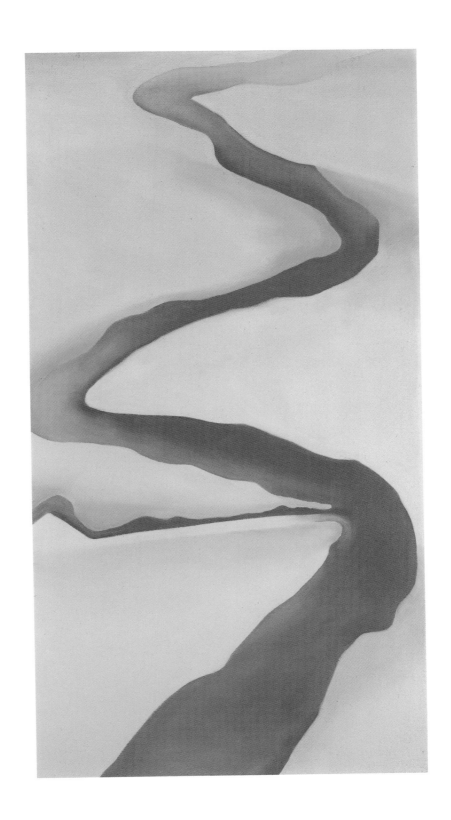

PLATE 32
Pink and Green
1960
Oil on canvas, 30 x 16 (76.2 x 40.6)
Gift, The Burnett Foundation
CR 1443

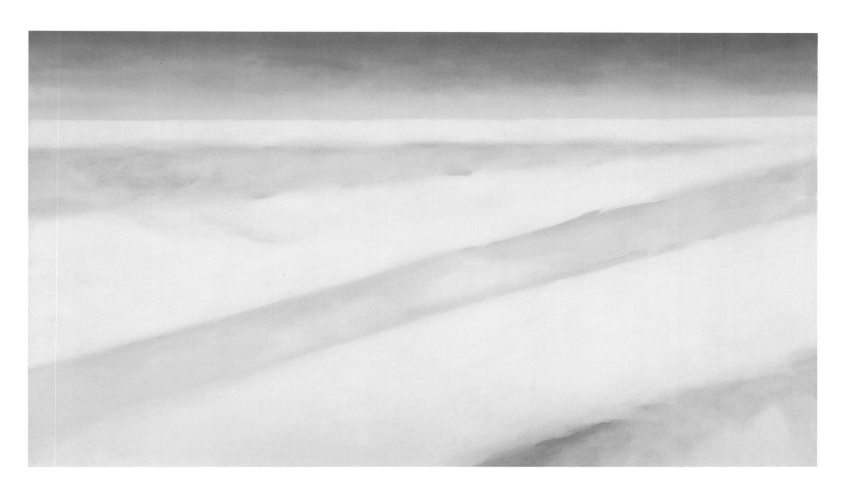

PLATE 35
Clouds 5 / Yellow Horizon and Clouds
1963/1964
Oil on canvas, 48 x 84 (121.9 x 213.4)
Gift, The Georgia O'Keeffe Foundation

CR 1484

PLATE 36
Untitled (Abstraction)
1963/1964
Black ball-point pen on paper, 2⅝ x 4⅜ (6.7 x 11.1)
Gift, The Georgia O'Keeffe Foundation

CR 1483

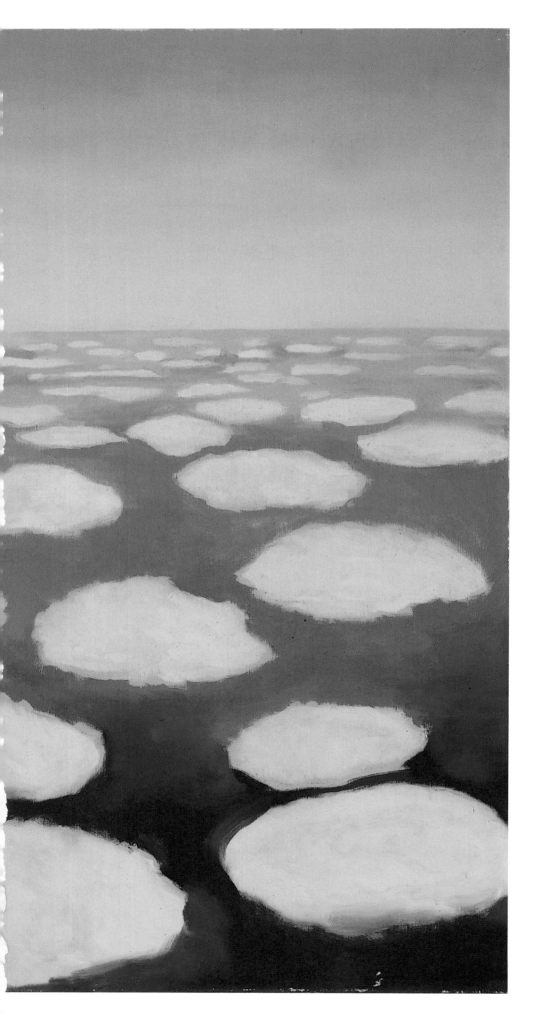

PLATE 38
Above the Clouds I
1962/1963
Oil on canvas, 36⅛ x 48¼ (91.8 x 122.6)
Gift, The Burnett Foundation and The Georgia O'Keeffe Foundation
CR 1474

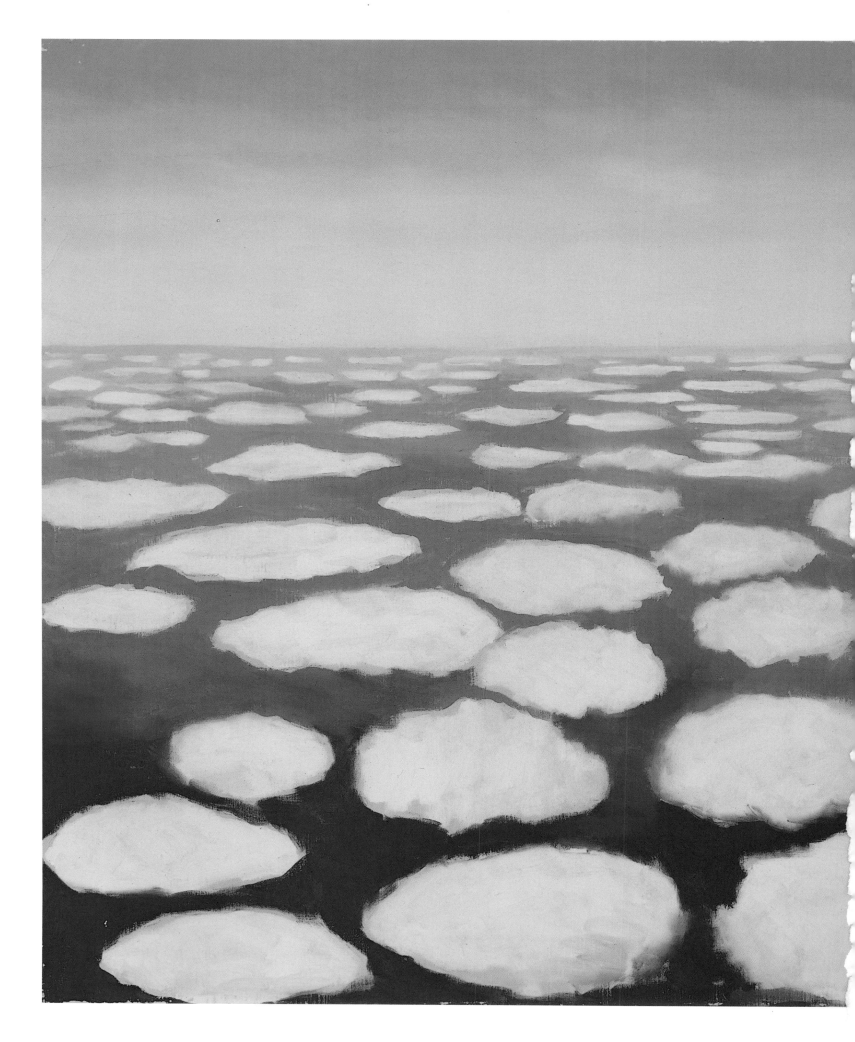

PLATE 37

Sky Above the Flat White Cloud II
1960/1964
Oil on canvas, 30 x 40 (76.2 x 101.6)
Gift, The Georgia O'Keeffe Foundation

CR 1460

PLATE 40
Sky Above Clouds / Yellow Horizon and Clouds
1976/1977
Oil on canvas, 48 x 84 (121.9 x 213.4)
Gift, The Georgia O'Keeffe Foundation

CR 1618

PLATE 41

Untitled (From a Day with Juan)

1976/1977

Charcoal on paper, 8⅞ x 11⅞ (22.5 x 30.2)

Gift, The Georgia O'Keeffe Foundation

CR 1621

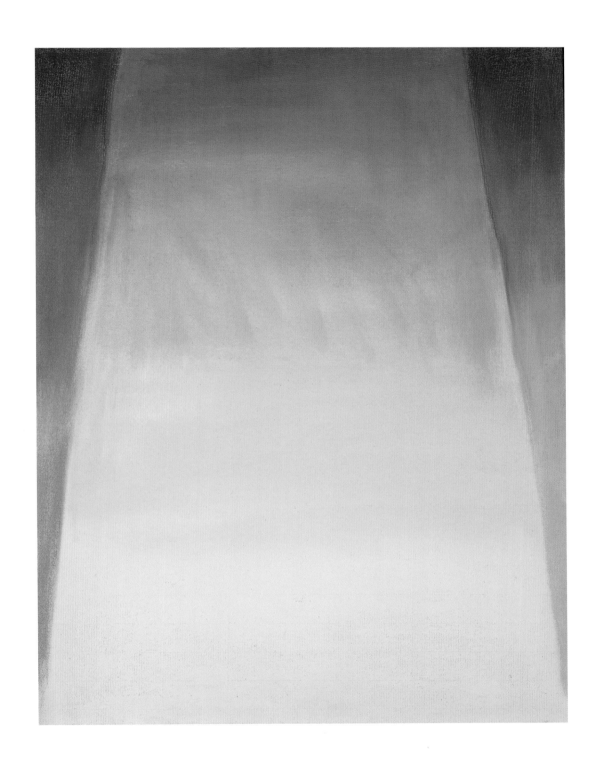

PLATE 42

Untitled (From a Day with Juan)
1976/1977
Pastel on paper, 25 x 19 (63.5 x 48.3)
Gift, The Georgia O'Keeffe Foundation
CR 1623

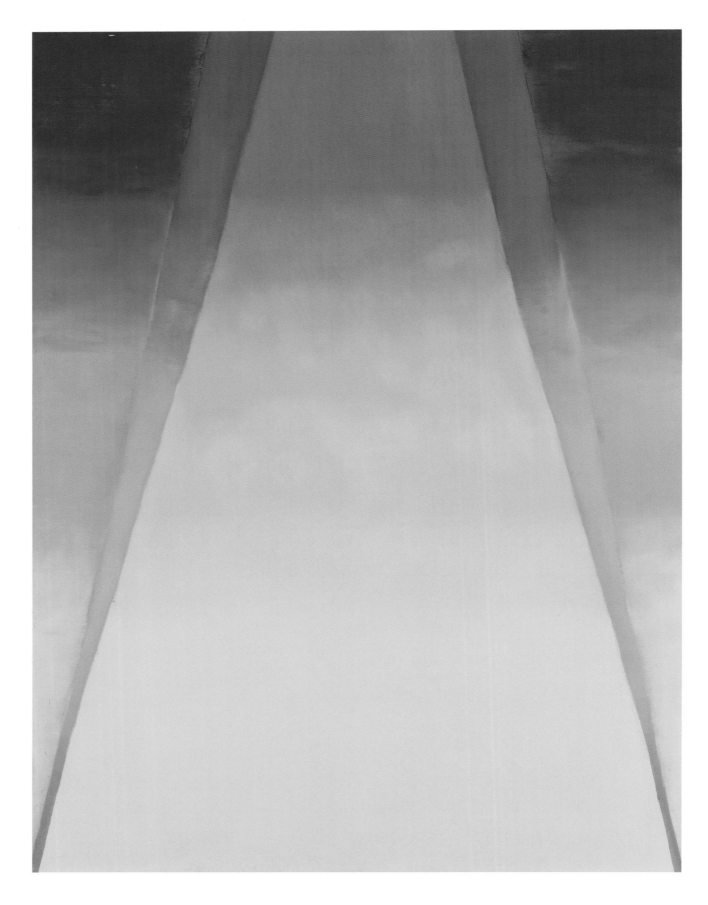

PLATE 43
Untitled (From a Day with Juan III)
1976/1977
Oil on canvas, 48 x 36 (121.9 x 91.4)
Gift, The Georgia O'Keeffe Foundation

CR 1625

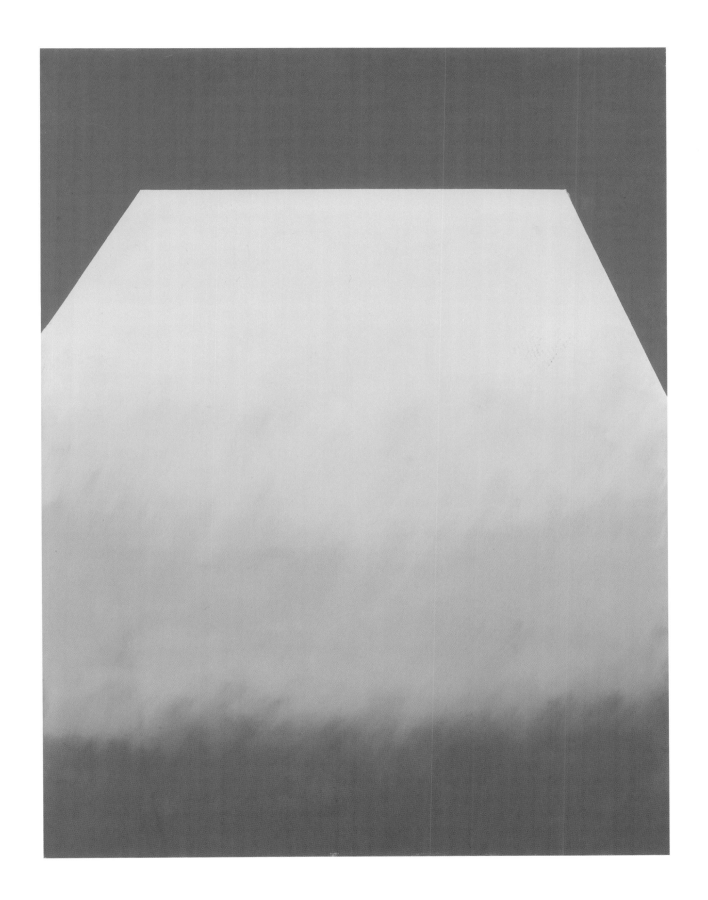

PLATE 44
From a Day with Juan A
1976/1977
Oil on canvas, 40 x 30 (101.6 x 76.2)
Gift, The Georgia O'Keeffe Foundation
CR 1628

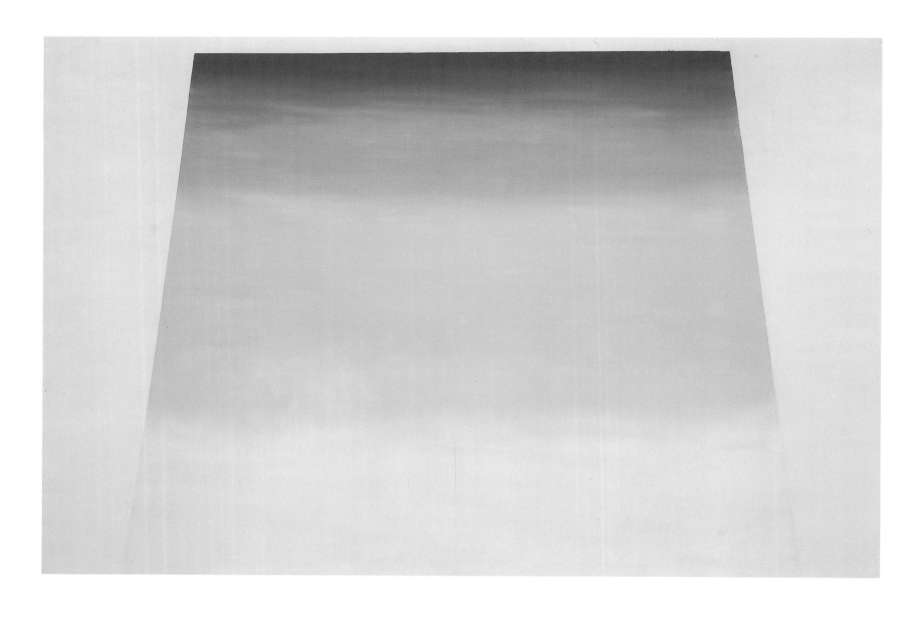

PLATE 45

Untitled (From a Day with Juan)
1976/1977
Oil on canvas, 48 x 72 (121.9 x 182.9)
Gift, The Georgia O'Keeffe Foundation

CR 1629

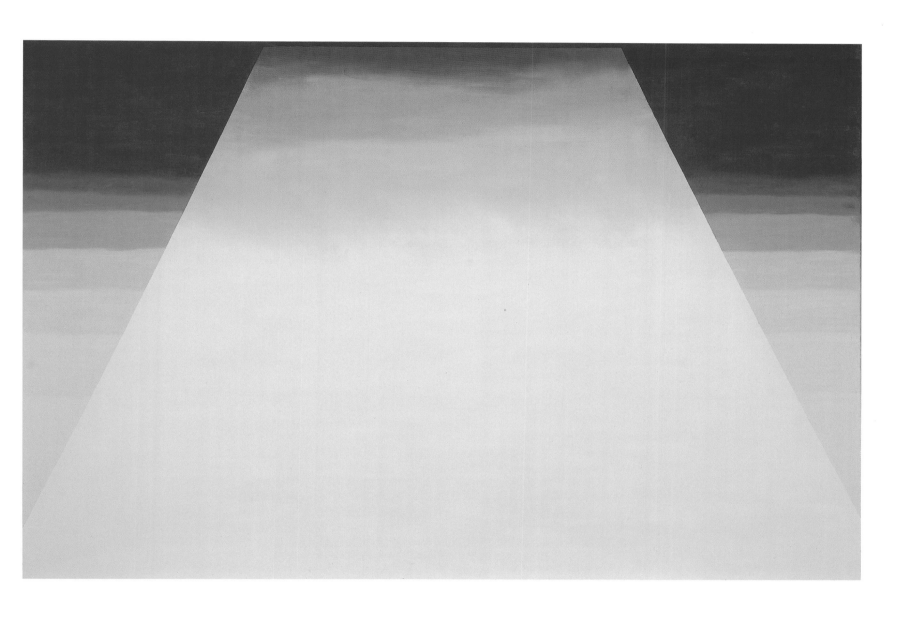

PLATE 46
Untitled (From a Day with Juan)
1976/1977
Oil on canvas, 48 x 72¼ (121.9 x 183.5)
Gift, The Georgia O'Keeffe Foundation
CR 1631

PLATES 47–52

O'Keeffe made her last unassisted oil painting in 1972 (see *The Beyond*, plate 39), but she continued to work in pencil, charcoal, or watercolor, sometimes with assistance, for the next 12 years. Among other things, during these years she completed a series of 39 watercolor abstractions that often recall the simple, organic shapes of her earliest abstractions. Such shapes were so fundamental to her thinking and had played such an important role in the development of her work that with a minimum of assistance she could re-create them with a sure hand in spite of being unable to see clearly. Six are reproduced here.

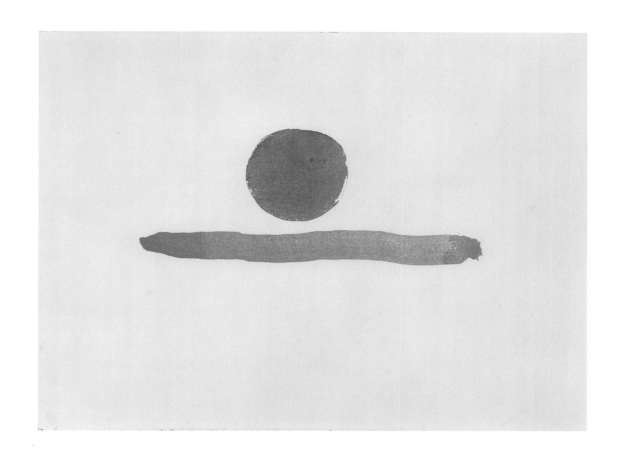

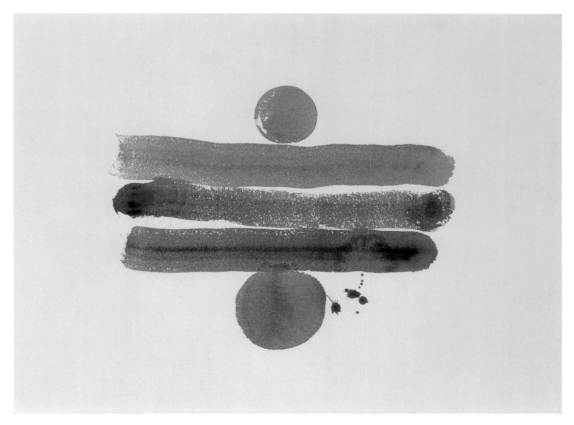



PLATE 47
Untitled (Abstraction Blue Circle and Line)
1976/1977
Watercolor on paper, 22½ x 29⅞ (57.2 x 75.9)
Gift, The Georgia O'Keeffe Foundation
CR 1611

PLATE 48
From a Day at Esther's
1976/1977
Watercolor on paper, 22½ x 29⅞ (57.2 x 75.9)
Gift, The Georgia O'Keeffe Foundation
CR 1612



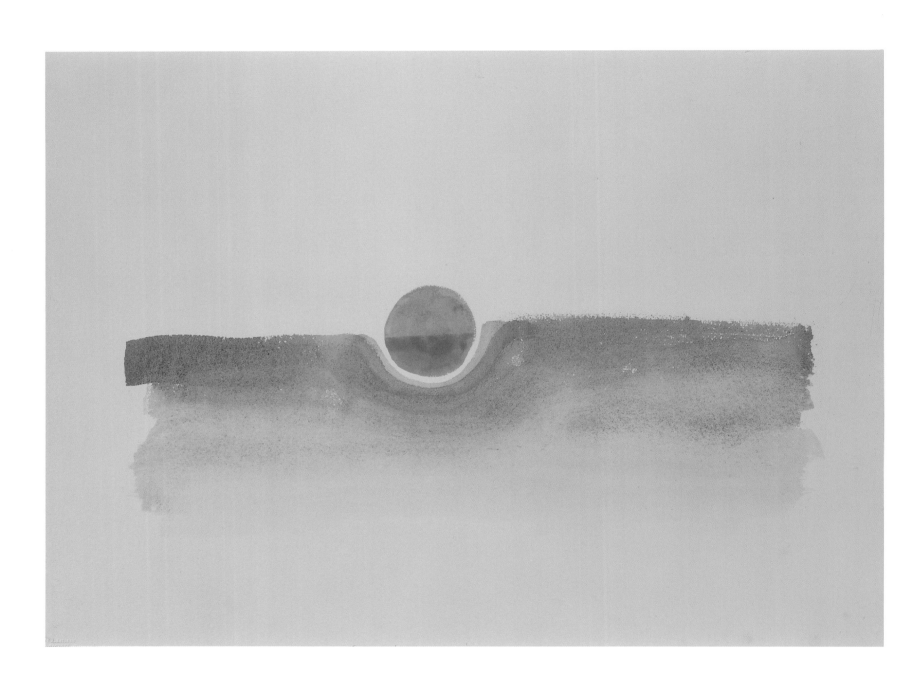

PLATE 49
Untitled (Abstraction Green Line and Red Circle)
1978
Watercolor on paper, 22 x 29⅞ (55.9 x 75.9)
Gift, The Georgia O'Keeffe Foundation

CR 1632

64

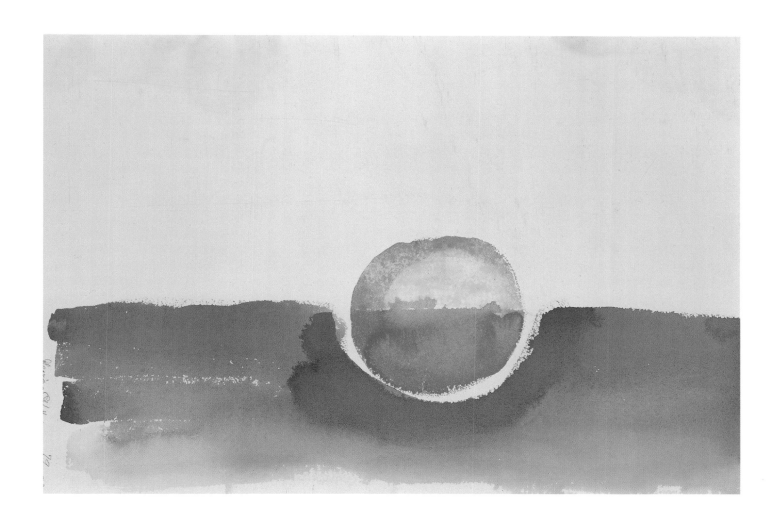

PLATE 50
Untitled (Abstraction Green Line and Red Circle)
1979
Watercolor on paper, 18⅞ x 27⅞ (47.9 x 70.8)
Gift, The Georgia O'Keeffe Foundation
CR 1640

65

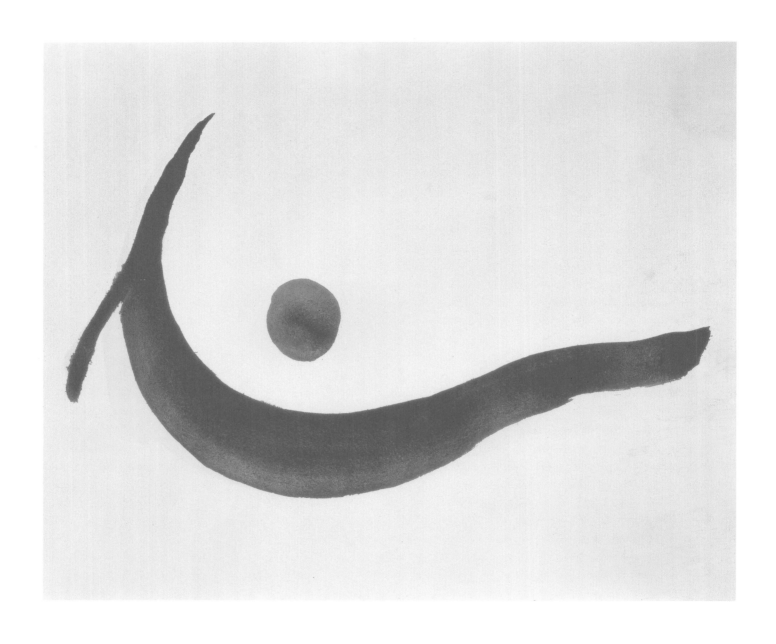

PLATE 51
Untitled (Abstraction Red Wave with Circle)
1979
Watercolor on paper, 22 x 26½ (55.9 x 67.3)
Gift, The Georgia O'Keeffe Foundation
CR 1638

66

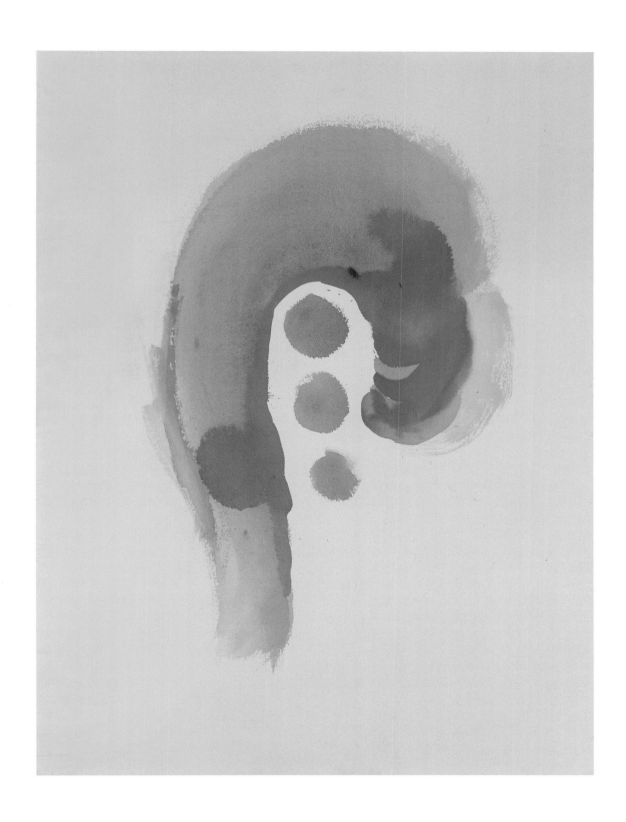

PLATE 52
Untitled (Abstraction Pink Curve and Circles)
1970s
Watercolor on paper, 30½ x 22 (77.5 x 55.9)
Gift, The Georgia O'Keeffe Foundation
CR 1674

Sculpture

O'Keeffe used a three-dimensional medium three times in her career. *Abstraction* was made to commemorate her mother's death in 1916 (plate 53). Its decidedly phallic shape, like many similar forms in O'Keeffe's work (see, for example, plates 2, 8, 10, 56–57, 66–67, 70, 73), seems incompatible with the early critical consensus that her art was a manifestation of the anatomical forms associated with her gender.

O'Keeffe intended the work (plate 53), which she first modeled in clay, as a *memento mori*, and her friend Anita Pollitzer refers to it as female in letters the two exchanged. As Pollitzer wrote: "Did you treat your Clay friend to a bus ride—Did she visit 291—Was the Man [Stieglitz] out—was the lady cast—did she smash." (Pollitzer to O'Keeffe, 18 June 1916, in *Lovingly Georgia* [1990] 158.) And O'Keeffe responded: "I did not take the thing to 291 but had it cast—the man sent me one but he has another—the way he fixed the pedestal is awful—I don't know about the rest of it—I have hardly looked at it." (O'Keeffe to Pollitzer, June 1916, in *Lovingly Georgia* [1990] 159.) This work, first cast in plaster in 1916, was also cast in 1979/1980 in white-lacquered bronze in an edition of 10.

O'Keeffe completed a second sculpture, *Abstraction*, in 1946 (plate 54). Its spiral forms relate to those in many of her earlier works, such as *Blue II*, 1916 (plate 3), and in particular to those in the pastel *Goat's Horn with Blue*, 1945 (fig. 2). She may have been inspired to transform this recurring motif in her work into a three-dimensional form through her association with her friend, sculptor Mary Callery, who stayed with O'Keeffe in New Mexico in the summer of 1945 and made a portrait bust of her then (see plate 328.)

Today, in addition to two original maquettes, this sculpture exists in three different mediums and sizes that were cast in 1979/1980 in four editions: 10 in white-lacquered bronze measuring 10 x 10 x 1½ (plate 54); 10 in white-lacquered bronze measuring 36 x 35 x 4½; three in epoxy measuring 36 x 35 x 4½; and three in aluminum measuring 118 x 115 x 57¾ (plate 55).

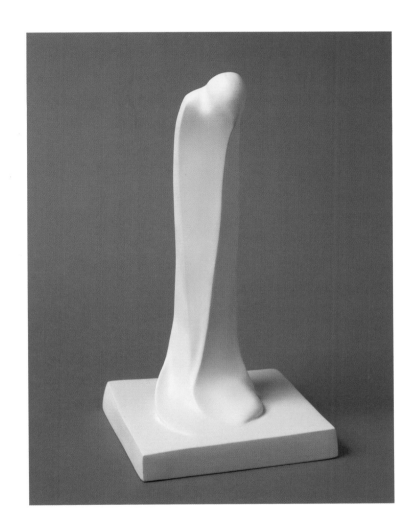

PLATE 53

Abstraction (7/10)

1916 (cast 1979/1980)

White-lacquered bronze, 10 x 5 x 5 (25.4 x 12.7 x 12.7)

Gift, The Burnett Foundation

© 1987 Private collection

CR 73

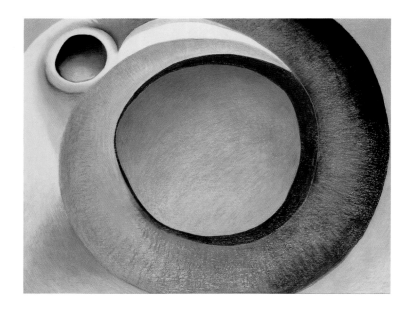

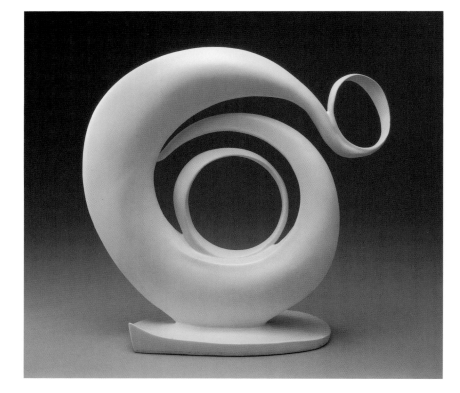

Figure 2
Goat's Horns with Blue
1945
Pastel on paper, 27¾ x 35 (70.5 x 88.9)
Private collection

CR 1109

PLATE 54
Abstraction (1/10)
1946 (cast 1979/1980)
White-lacquered bronze, 10 x 10 x 1½ (25.4 x 25.4 x 3.8)
Gift, The Georgia O'Keeffe Foundation

CR 1123

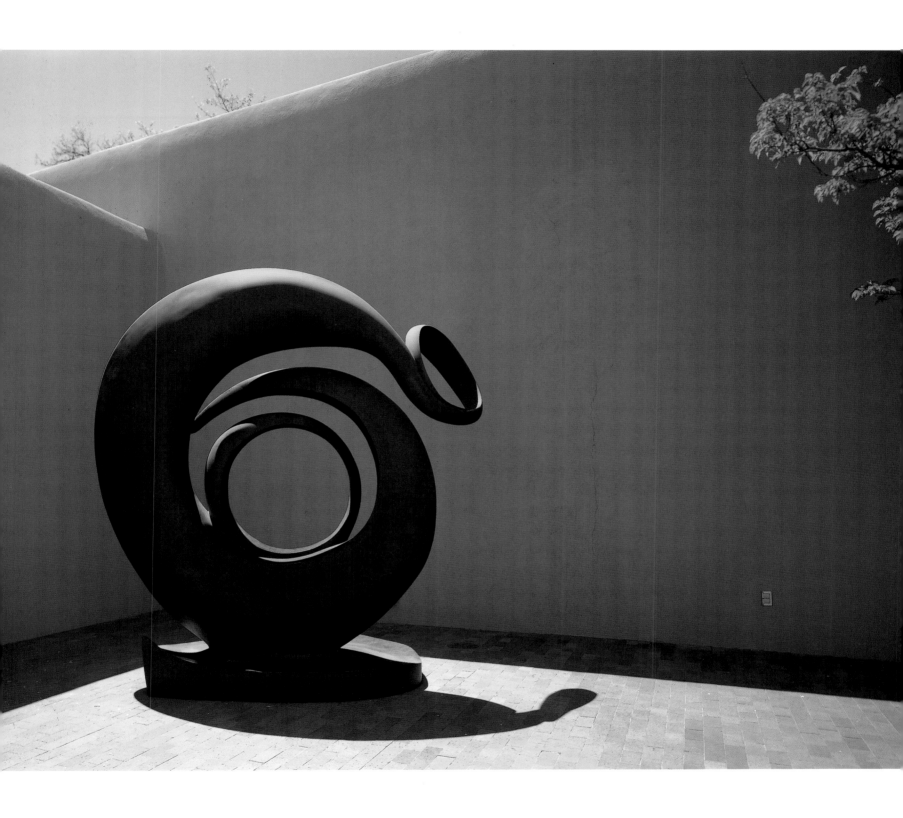

PLATE 55
Abstraction
1946 (cast 1979/1980)
Cast aluminum, 118 x 115 x 57¼ (299.7 x 292.1 x 146.7)
Gift, The Burnett Foundation and The Georgia O'Keeffe Foundation

CR 1141

PLATES 56–57

As O'Keeffe's vision increasingly deteriorated in the 1970s, she again began working with clay. In the following decade, she designed her last sculpture, which consisted of three elegant cone-like forms. All three were cast in black-lacquered bronze, and two of the three forms were cast in plain bronze. These were the last major works of a career that had begun almost 70 years earlier. In 1984, when O'Keeffe was 96 and in ill health, she stopped working in any medium.

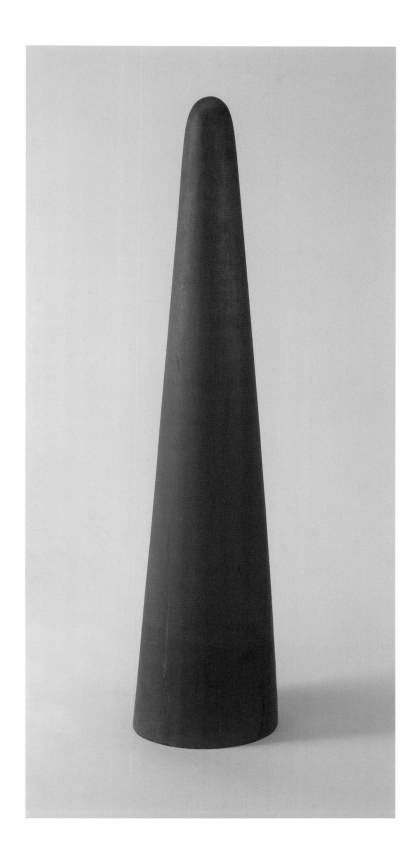

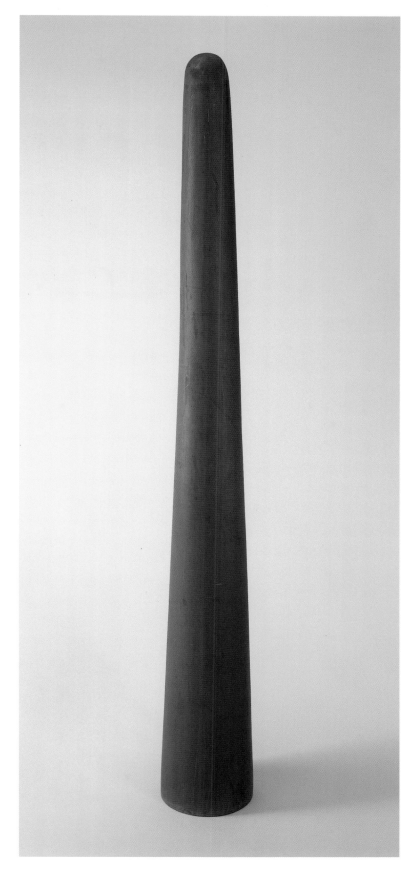

PLATE 56
Untitled (Abstraction)
1982
Bronze, 41 x 8½ x 8½ (104.1 x 21.6 x 21.6)
Gift, The Georgia O'Keeffe Foundation

CR 1705

PLATE 57
Untitled (Abstraction)
1982
Bronze, 78 x 17 x 17 (198.1 x 43.1 x 43.1)
Gift, The Georgia O'Keeffe Foundation

CR 1706

Architecture

O'Keeffe lived and worked in many different places, and, more often than not, one of her primary visual responses to a place was to its architecture. For example, shortly after arriving in New York in February of 1916 for course work at Teachers College, Columbia University, she completed the architecture-derived *Black Lines* (plate 2). That summer in Virginia, she made *Untitled (Houses and Landscape)*, and her arrival in Canyon, Texas, that fall led to several architecture-inspired watercolors, including *Morning Sky with Houses*, *Untitled (Windmill)*, and *Untitled (Windmills)*, 1916.

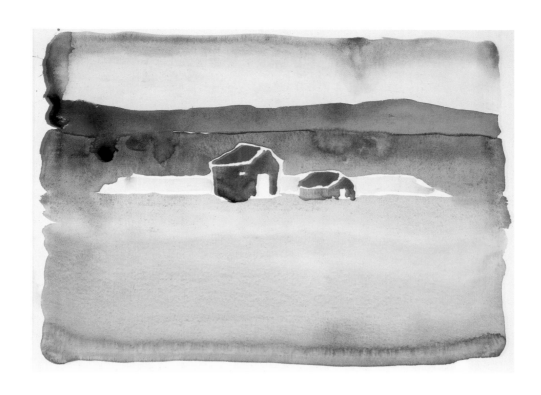

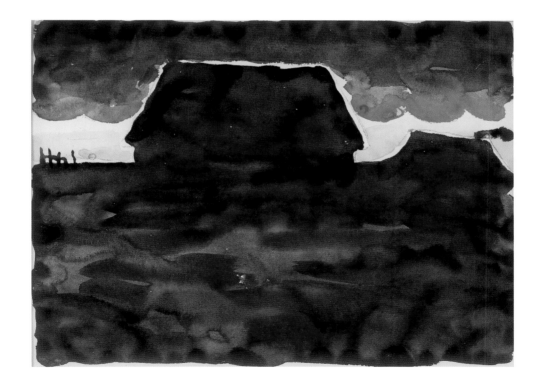

PLATE 58
Untitled (Houses and Landscape)
1916
Watercolor on paper, 8⅞ x 12 (22.5 x 30.5)
Gift, The Georgia O'Keeffe Foundation
CR 96

PLATE 59
Morning Sky with Houses
1916
Watercolor and graphite on paper, 8⅞ x 12 (22.5 x 30.5)
Gift, The Georgia O'Keeffe Foundation
CR 127

77

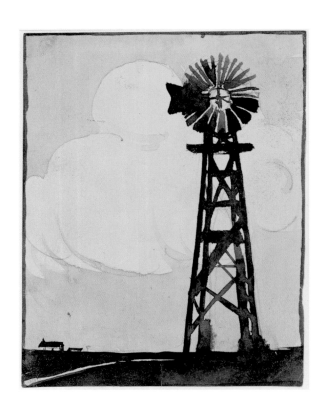

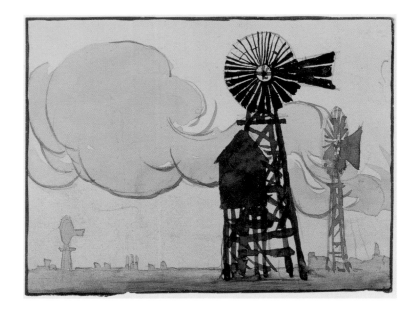

PLATE 60
Untitled (Windmill)
1916
Watercolor and graphite on paper, 4¼ x 3⅜ (12.1 x 9.2)
Promised gift, The Burnett Foundation
© 1987 Private collection

CR 122

PLATE 61
Untitled (Windmills)
1916
Watercolor and graphite on paper, 3⅝ x 4¼ (9.2 x 12.1)
Promised gift, The Burnett Foundation
© 1987 Private collection

CR 123

Other works made as initial responses to the architectural forms of particular locations include *Church Bell, Ward, Colorado, 1917*, which she made in response to vacationing in Colorado. *Untitled (Tree with Green Shade)* and *Window—Red and Blue Sill* were made in 1918 when she was living in San Antonio, Texas. Later that year, when she moved to Waring, Texas, she painted *House with Tree—Green.*

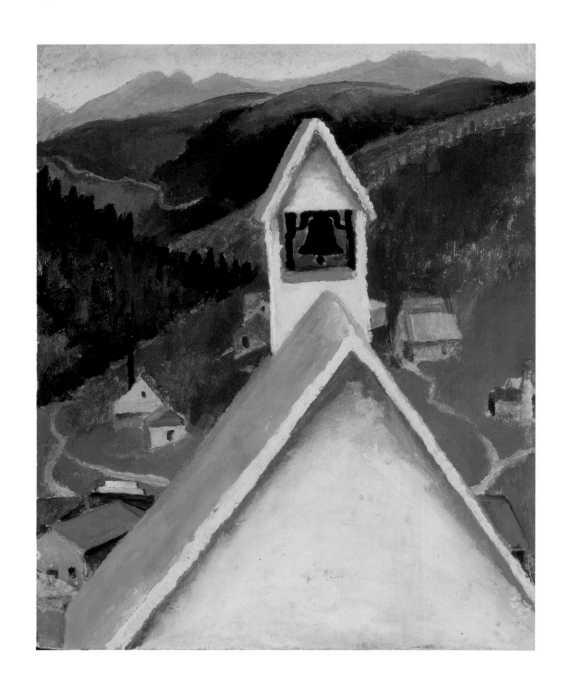

PLATE 62
Church Bell, Ward, Colorado
1917
Oil on board, 17 x 14 (43.2 x 35.6)
Gift, The Georgia O'Keeffe Foundation
CR 213

80

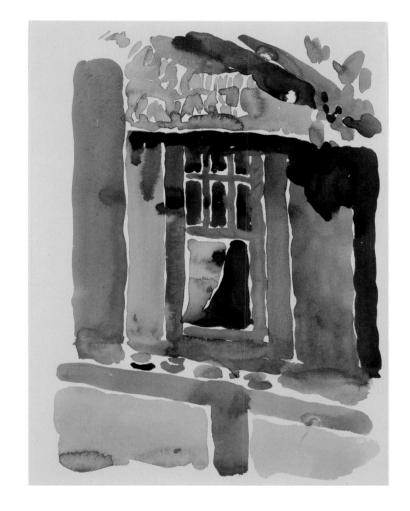

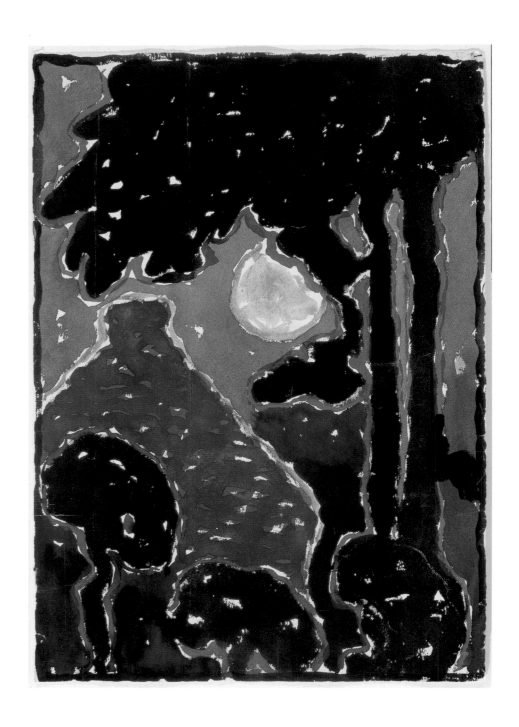

PLATES 66–67

From 1918 through 1929, O'Keeffe worked summer and fall primarily at the Stieglitz family compound at Lake George. *Flagpole* depicts a building there in which Stieglitz developed and printed his photographs: "At Lake George there was a small square house that had been the wooden part of the large greenhouse. Two electric wires ran to it from the farmhouse and there was a fine weathervane on top of it. In front of the little house was a tall white flagpole and there were rows of lavender and white lilacs that ran around it. Stieglitz used the little house as a darkroom for his photographic work so the door, when open, was always black." (In *Georgia O'Keeffe*, 1976, unpaginated text accompanying entry 36.) Thirty-four years later, when O'Keeffe was living in New Mexico, she revisited this subject in *Flagpole and White House*. Curiously, in the later work the weathervane is pointed toward the flagpole, rather than away from it, as in the 1925 painting.

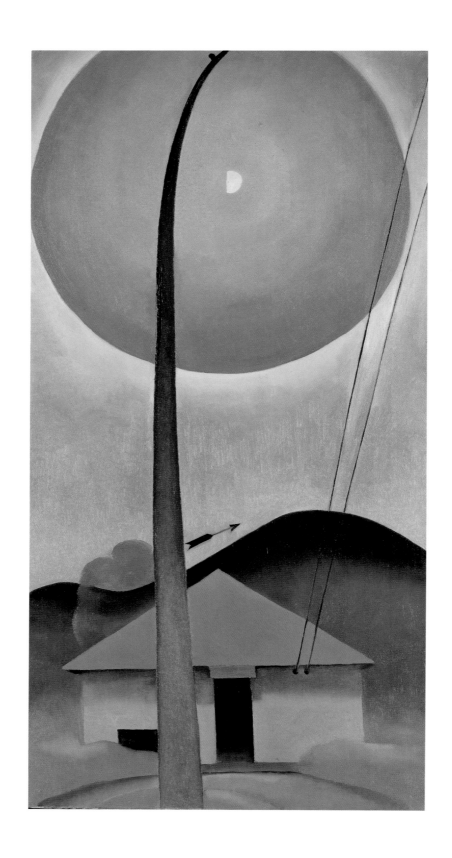

PLATE 66

Flagpole

1925

Oil on canvas, 35 x 18⅛ (88.9 x 46)

Gift, The Burnett Foundation and an anonymous donor

CR 481

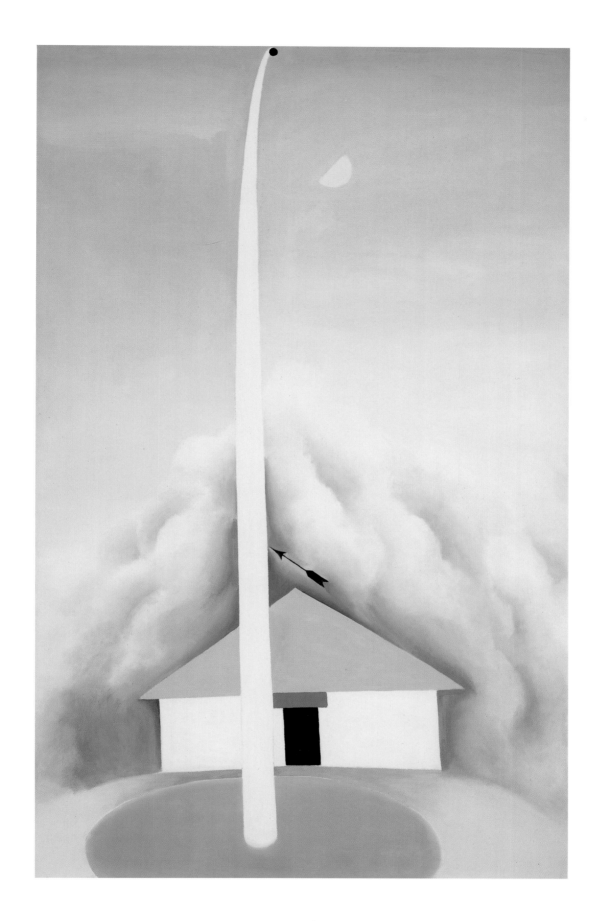

PLATE 67
Flag Pole and White House
1959
Oil on canvas, 48 x 30 (121.9 x 76.2)
Gift, Emily Fisher Landau

CR 1369

PLATES 68–69

On a trip to Wisconsin in the summer of 1928, O'Keeffe responded to the area's distinctive barns, just as earlier, when she and Stieglitz moved from a brownstone to the Shelton Hotel, then the tallest residential hotel in the city, her interest in depicting New York buildings had been rekindled. As she pointed out: "When I came to live at the Shelton . . . I couldn't afford it. But I can now, so of course I'm going to stay. Yes, I realize it's unusual for an artist to want to work way up near the roof of a big hotel in the heart of the roaring city but I think that's just what the artist of today needs for stimulus. He has to have a place where he can behold the city as a unit before his eyes but at the same time have enough space left to work. Yes, contact with the city this way has certainly helped me as no amount of solitude in the country [Lake George] could." (In B. Vladimir Berman, "She Painted the Lily and Got $25,000 and Fame for Doing It! Not in a Rickety Atelier but in a Hotel Suite on the 30th Floor, Georgia O'Keefe [*sic*], New Find of Art World, Sets Her Easel," *New York Evening Graphic* [12 May 1928], 3M.)

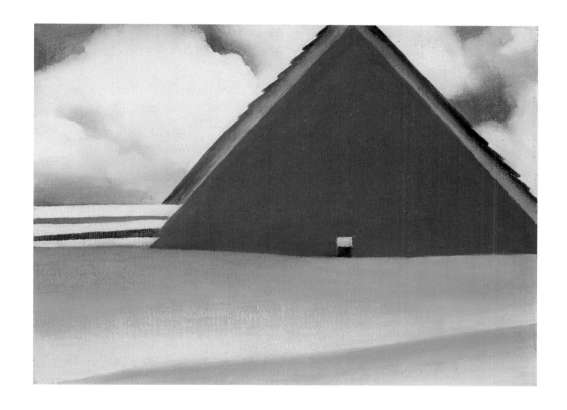

PLATE 68

Red Barn in Wheatfield

1928

Oil on canvas-covered board, 9 x 12 (22.9 x 30.5)

Gift, The Burnett Foundation

CR 617

87

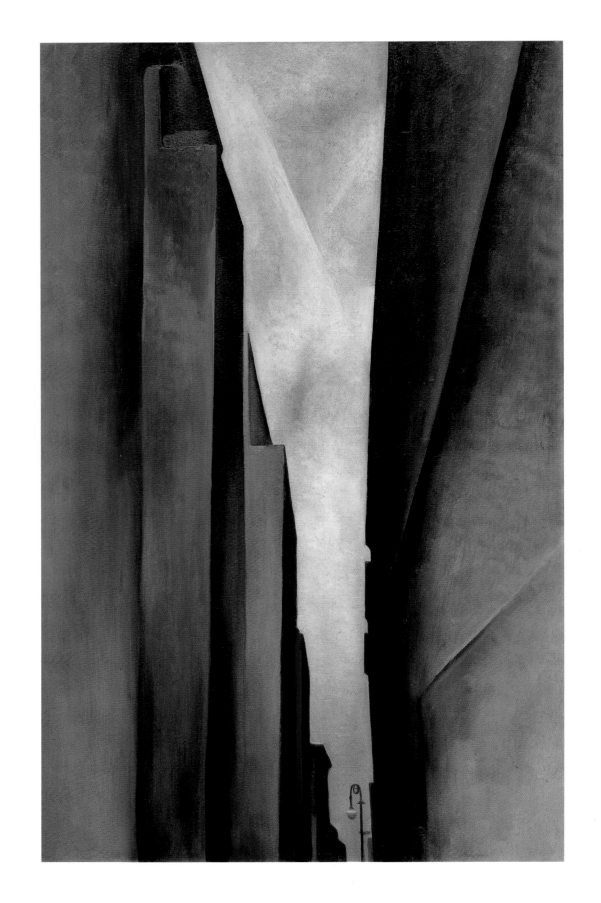

PLATE 69

A Street

1926

Oil on canvas, 48⅛ x 29⅞ (122.2 x 75.9)

Gift, The Burnett Foundation

CR 528

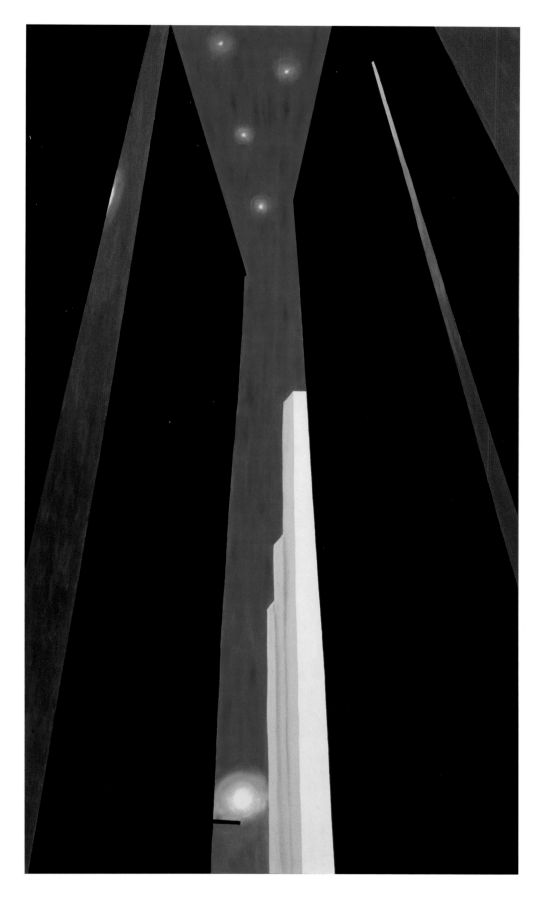

In the 1920s, depicting the city was considered a subject reserved for male artists. As O'Keeffe later explained: "The men decided they didn't want me to paint New York. . . . They told me to 'leave New York to the men.' I was furious!"

But they changed their minds in 1926, when one of her New York paintings was exhibited and sold. As she explained: "It sold on the very first day of the show: the very first picture sold. From then on they *let* me paint New York." (Both O'Keeffe comments in Ralph Looney, "Georgia O'Keeffe," *The Atlantic* 215, no. 4 [April 1965]: 108.)

She not only continued to depict New York structures through the 1930s, but did so many years after she had moved from the city to New Mexico in 1949. In the 1970s, with assistance, she painted *Untitled (City Night)* (plate 70), a restatement of what must have been one of her favorite paintings of the subject, *City Night*, 1926.

PLATE 71

Untitled (New York)

1925/1932

Graphite on paper, 6 x 7⅞ (15.2 x 20)

Gift, The Georgia O'Keeffe Foundation

CR 521

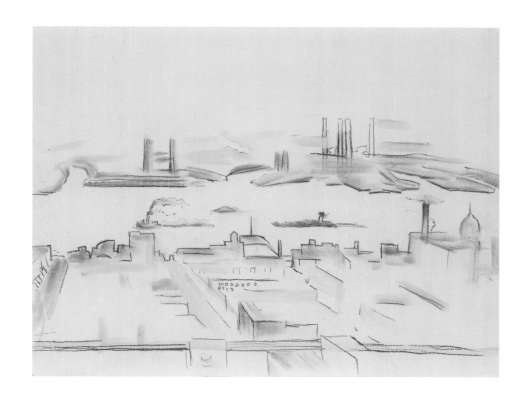

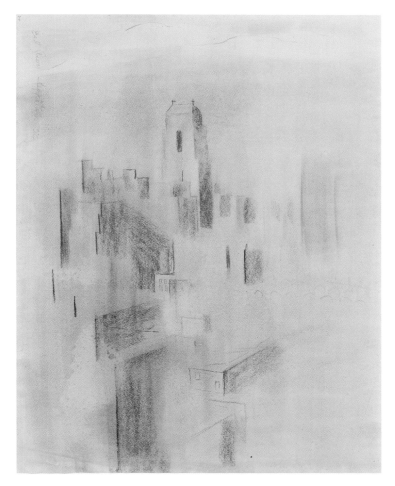

PLATES 74–76

In 1929, O'Keeffe spent her first summer working in northern New Mexico and immediately made its architecture an important subject in her work. She also made drawings and paintings of the crosses that dot the desert landscape. In talking about the area's crosses, she pointed out: "For me, painting the crosses was a way of painting the country." (In Katherine Kuh, "Georgia O'Keeffe by Georgia O'Keeffe," *Saturday Review* [22 January 1977]: 45.) "I saw the crosses so often—and often in unexpected places—like a thin dark veil of the Catholic Church spread over the New Mexico landscape." (In Celia Weisman, "O'Keeffe's Art: Sacred Symbols and Spiritual Quest," *Woman's Art Journal* 3, no. 2 [Fall 1982/Winter 1983]: 14.)

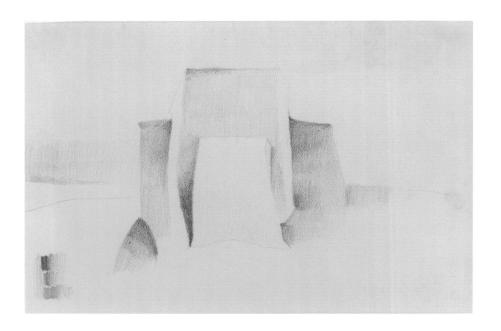

PLATE 74
Untitled (Ranchos Church)
1929
Graphite on paper, 6⅝ x 10 (16.8 x 25.4)
Gift, The Burnett Foundation
CR 663

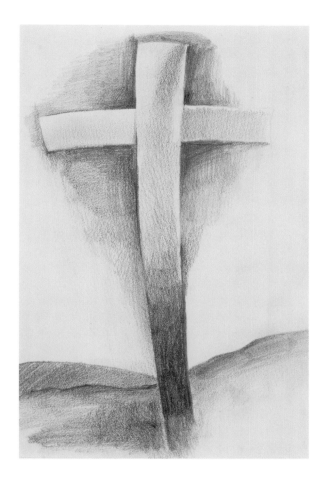

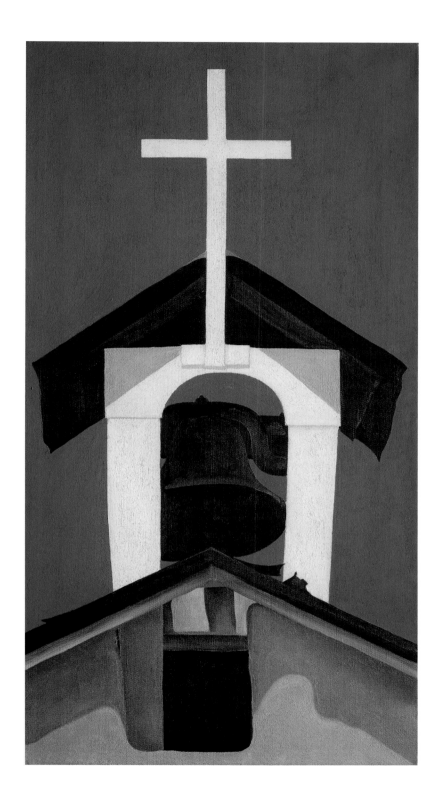

PLATE 75
Untitled (Cross)
1929
Graphite on paper, 10 x 6⅝ (25.4 x 16.8)
Gift, The Burnett Foundation
CR 670

PLATE 76
Church Steeple
1930
Oil on canvas, 30 x 16 (76.2 x 40.6)
Gift, The Burnett Foundation
CR 706

PLATES 77–78

O'Keeffe purchased a house north of Española at Ghost Ranch in 1940 and another in nearby Abiquiu in 1945, and often used the forms of these structures in her paintings. In *Untitled (Patio Door)*, she depicted the opening on the north side of the Abiquiu house patio.

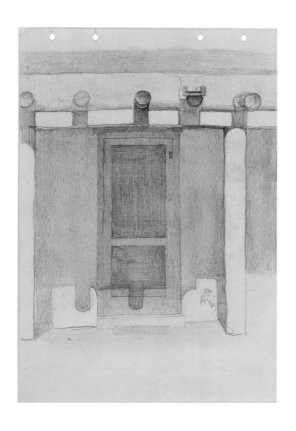

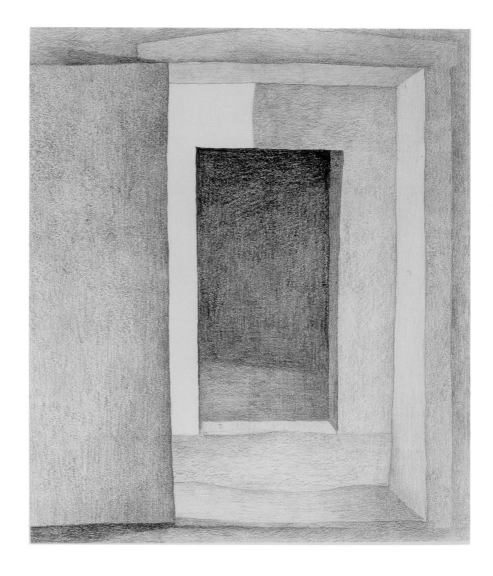

PLATE 77
Untitled (Ghost Ranch Patio)
c. 1940
Graphite on paper, 9 x 6 (22.9 x 15.2)
Gift, The Georgia O'Keeffe Foundation

CR 1000

PLATE 78
Untitled (Patio Door)
c. 1946
Graphite on paper, 17 x 14 (43.2 x 35.6)
Gift, The Burnett Foundation
© 1987 Private collection

CR 1154

O'Keeffe frequently claimed that her fascination with the wooden door on the south side of the Abiquiu house patio was one of the primary reasons she bought the property, and from 1945 through the mid-1970s, she made an extensive series of paintings of it. In *In the Patio VIII*, 1950 (plate 81), the door nearly disappears in the shadows cast on the wall surrounding it, and in *Door Through Window* (plate 82), the shape of the patio door is seen as a reflection on the glass panes of the doors on the west side of the patio that opened into her living room.

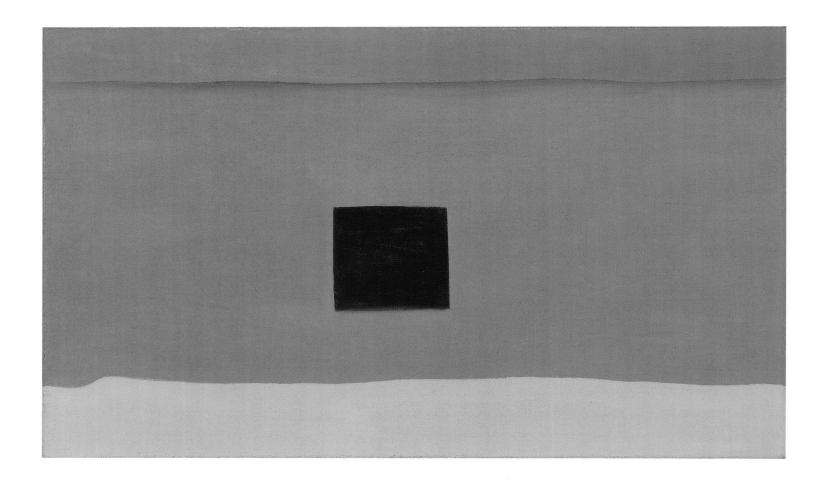

PLATE 79
In the Patio III
1948
Oil on canvas, 18 x 30 (45.7 x 76.2)
Gift, The Georgia O'Keeffe Foundation
CR 1160

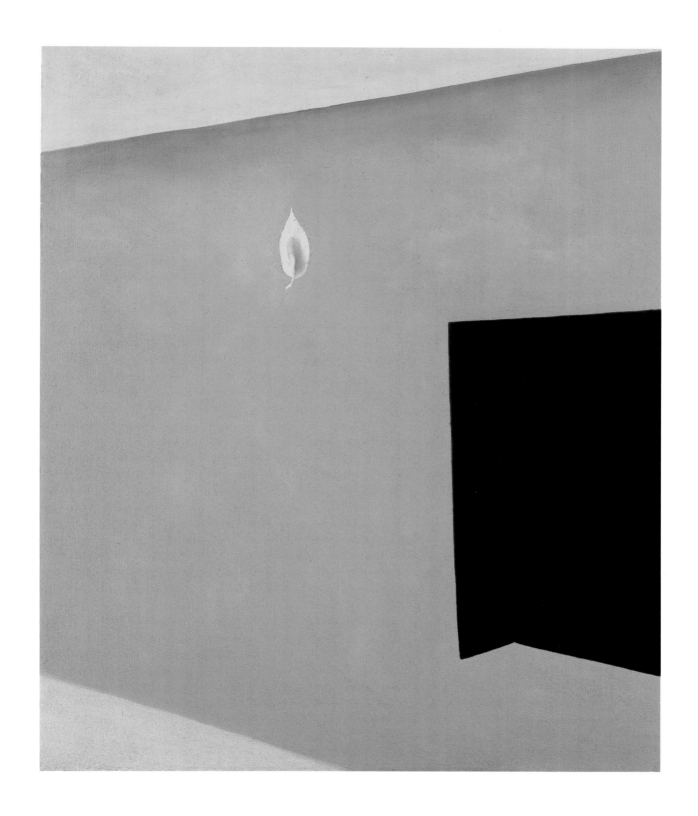

PLATE 80
Patio Door with Green Leaf
1956
Oil on canvas, 36 x 30 (91.4 x 76.2)
Gift, The Burnett Foundation and The Georgia O'Keeffe Foundation
CR 1292

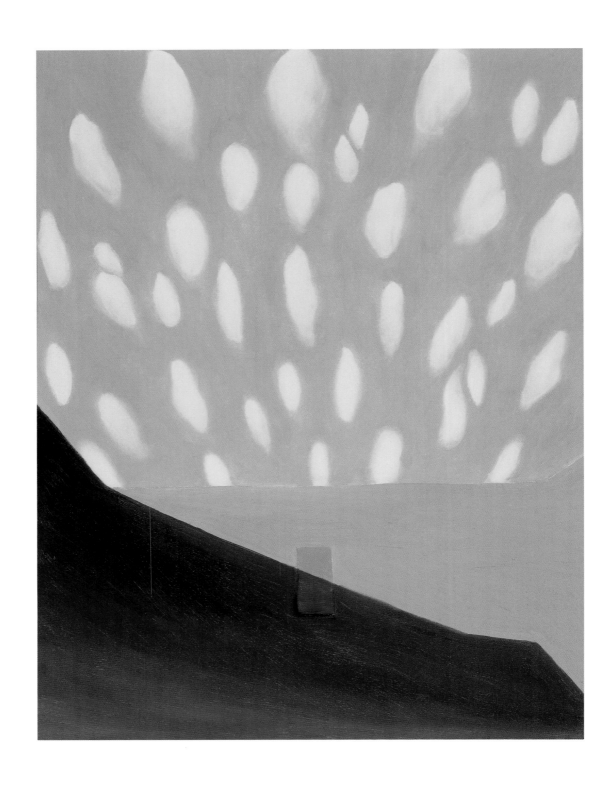

PLATE 81

In the Patio VIII

1950

Oil on canvas, 26 x 20 (66 x 50.8)

Gift, The Burnett Foundation and The Georgia O'Keeffe Foundation

CR 1211

98

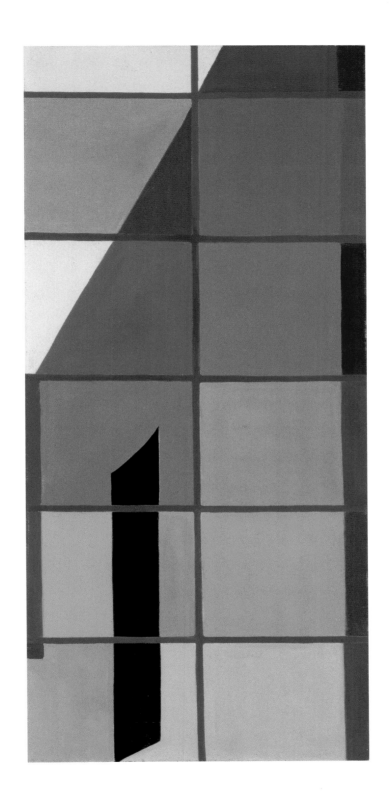

PLATE 82

Door Through Window

1956

Oil on canvas, 30 x 14 (76.2 x 35.6)

Gift, The Georgia O'Keeffe Foundation

CR 1293

PLATE 83–84

Some of O'Keeffe's paintings of patio door openings and doors could be read as pure abstractions, as in the case of *My Last Door*, but each element in it derives directly from what O'Keeffe saw: a thin area of sky, the wooden, rectangular patio door, the adobe wall surrounding it, the stone steps in front of it, and, occasionally, the shadow of another element of the building that was thrust into the scene. In talking about the painting, O'Keeffe pointed out: "Those little squares in the door paintings are tiles in front of the door; they're really there, so you see the painting is not abstract. It's quite realistic." (In Katherine Kuh, *The Artist's Voice: Talks with Seventeen Artists* [New York: Harper & Row, 1960], 190.) Moreover, after moving into the Abiquiu house, O'Keeffe made photographs of the various doors of the patio, and most of the elements of her painting of the south door are evident in the photograph she made of this subject (plate 298).

In *Untitled (Sacsayhuaman)* (plate 84), O'Keeffe was inspired by the Inca stonework of the fortress built above Cuzco, Peru, which she visited in 1956.

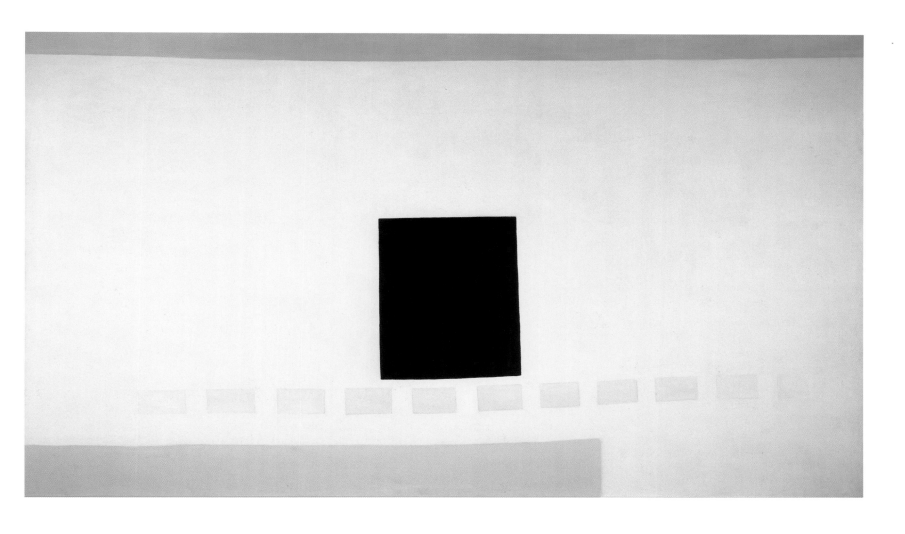

PLATE 83

My Last Door

1952/1954

Oil on canvas, 48 x 84 (121.9 x 213.4)

Gift, The Burnett Foundation

CR 1263

101

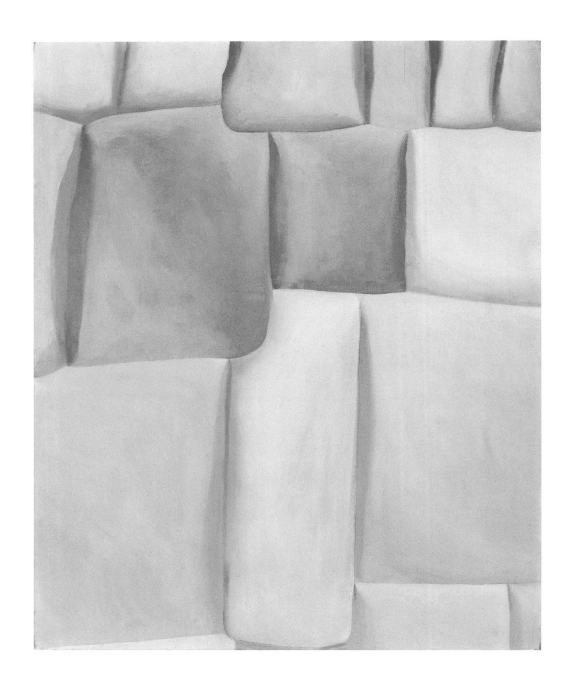

PLATE 84
Untitled (Sacsayhuaman)
1957
Oil on canvas, 20 x 16 (50.8 x 40.6)
Gift, The Georgia O'Keeffe Foundation

CR 1310

PLATES 85–86

She returned to the patio door motif in her work in the mid-1970s, when increasingly poor
eyesight meant that she could only paint with assistance. The resulting watercolors suggest
that this subject—then embedded in her memory—was one of the most important of her
late career.

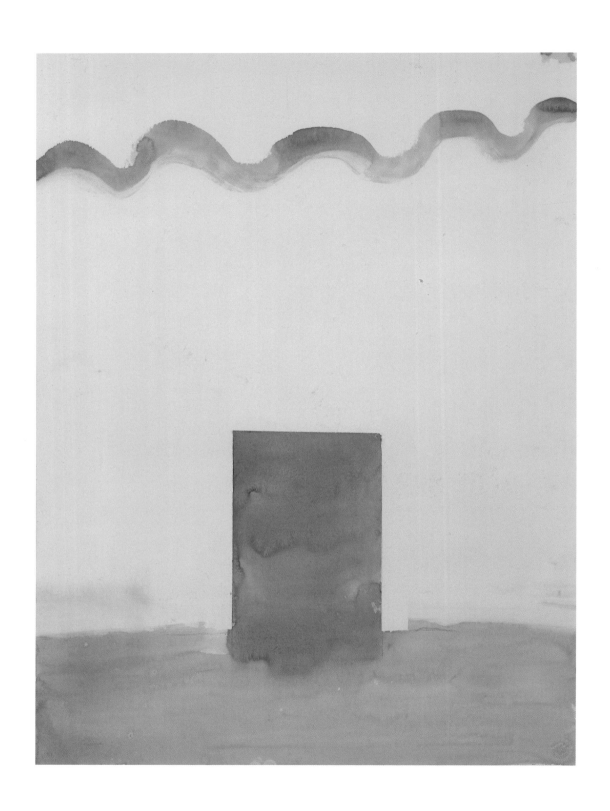

PLATE 85
Untitled (Patio Door)
1970s
Watercolor and charcoal on paper, 30 x 22 (76.2 x 55.9)
Gift, The Georgia O'Keeffe Foundation

CR 1687

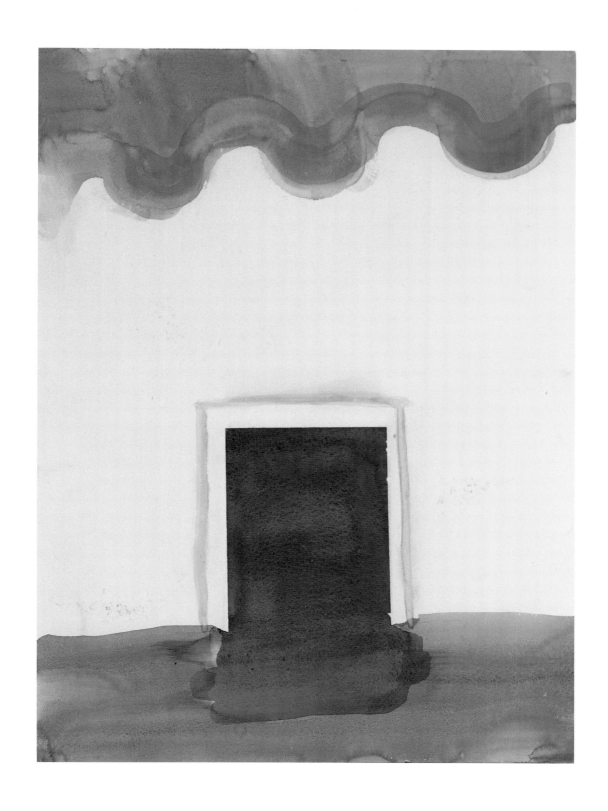

PLATE 86
Untitled (Patio Door)
1970s
Watercolor and charcoal on paper, 30 x 22 (76.2 x 55.9)
Gift, The Georgia O'Keeffe Foundation
CR 1688

Animal and Human Forms

PLATE 87

Before 1910, O'Keeffe's sketch books occasionally included depictions of animals, but she did not address animal subjects again until many decades later. In the 1950s, in addition to some drawings of horses, she also made a series of sketches of her chow puppies.

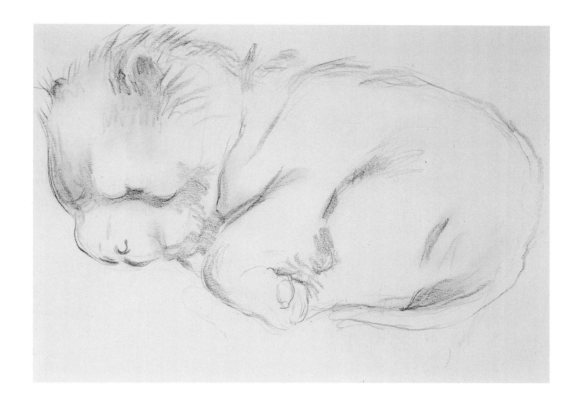

PLATE 87

Untitled (Dog)

1952

Graphite on paper, 10 x 13¾ (25.4 x 34.9)

Gift, The Georgia O'Keeffe Foundation

CR 1229

In her mature work, O'Keeffe did not concentrate on depictions of the human form, but they were often the subjects of her early work, as in her earliest-known pencil drawing of 1901. In the 1900s, she also made numerous portraits of members of her family.

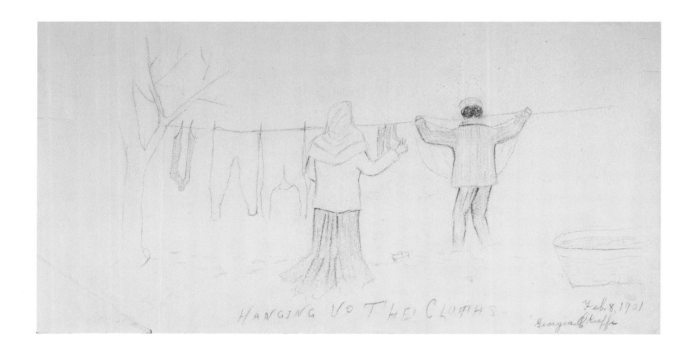

PLATE 88

Hanging Up the Clothes

1901

Graphite on paper, 7¾ x 15 (19.7 x 38.1)

Gift, The Georgia O'Keeffe Foundation

CR 1

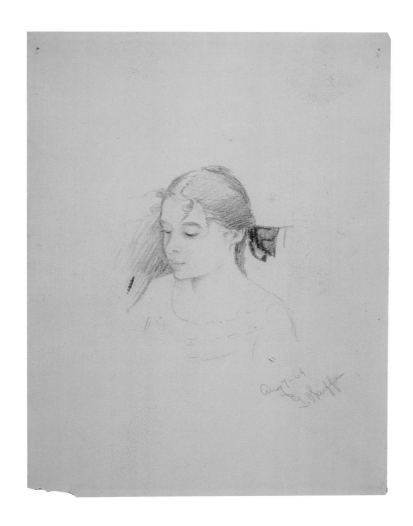

PLATE 89
Untitled (Catherine O'Keeffe)
1904
Graphite on paper, 12 x 9 (30.5 x 22.9)
Gift, The Georgia O'Keeffe Foundation

CR 14

111

PLATES 90–91

These are works that O'Keeffe made as a high school student in Madison, Wisconsin, or at The Art Institute of Chicago, where her training included drawing from plaster casts.

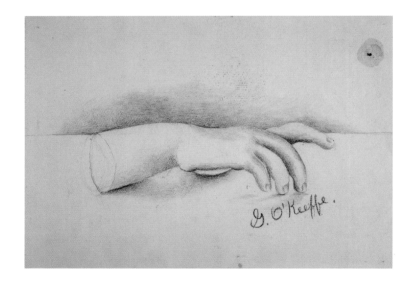

PLATE 90
Untitled (Hand)
c. 1902
Graphite on paper, 6½ x 9¼ (16.5 x 23.5)
Gift, The Georgia O'Keeffe Foundation
CR 3

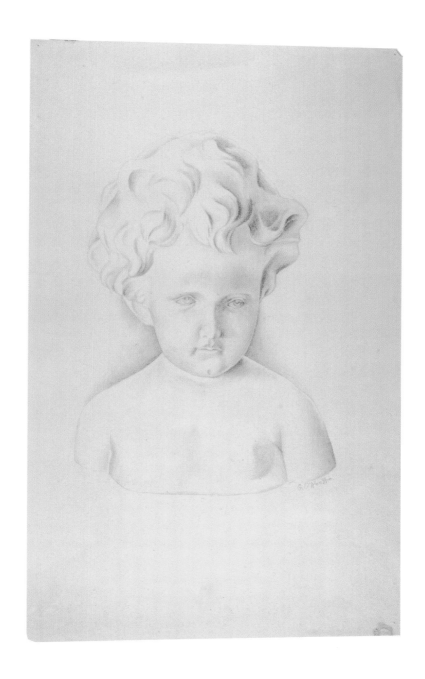

PLATE 91

Untitled (Bust)
1905/1906
Graphite on paper, 17⅝ x 10⅝ (44.8 x 27)
Gift, The Georgia O'Keeffe Foundation

CR 27

Over a decade later, when she was living in Virginia, two children captured her attention and inspired these watercolors.

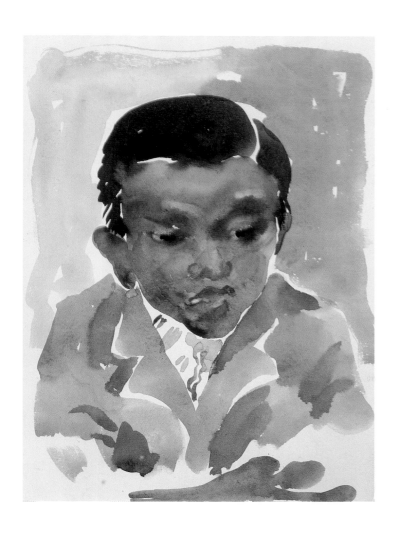

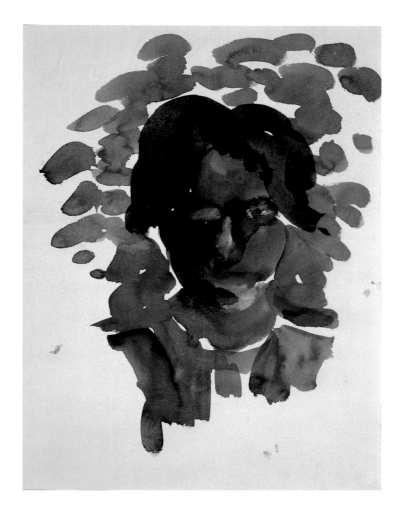

PLATE 92
Untitled (Boy)
1916
Watercolor on paper, 12 x 8⅞ (30.5 x 22.5)
Gift, The Georgia O'Keeffe Foundation

CR 100

PLATE 93
Untitled (Girl)
1916
Watercolor on paper, 12 x 8⅞ (30.5 x 22.5)
Gift, The Georgia O'Keeffe Foundation

CR 101

PLATES 94–101

In Texas, O'Keeffe completed a series of 13 nude self-portraits in watercolor. As she explained in a letter to Stieglitz, "Don't know whether to tell you or not—I couldn't get what I wanted any other way so I've been painting myself—no clothes." (O'Keeffe to Stieglitz, 1 July 1917, Alfred Stieglitz/Georgia O'Keeffe Archive, Collection of American Literature, Beinecke Rare Book and Manuscript Library, Yale University, New Haven.)

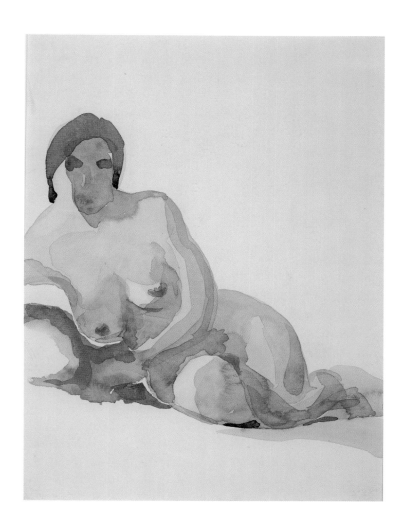

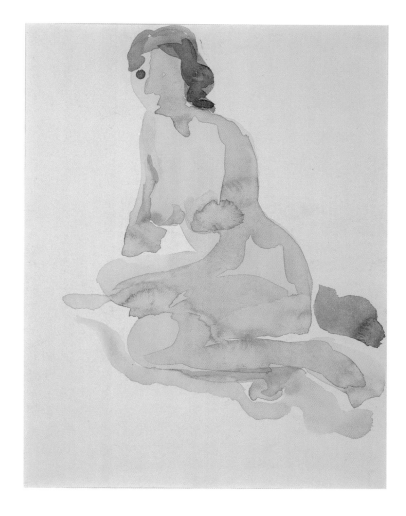

PLATE 94
Nude No. I
1917
Watercolor on paper, 12 x 8⅞ (30.5 x 22.5)
Gift, The Georgia O'Keeffe Foundation
CR 176

PLATE 95
Nude Series II
1917
Watercolor on paper, 12 x 8⅞ (30.5 x 22.5)
Gift, The Georgia O'Keeffe Foundation
CR 177

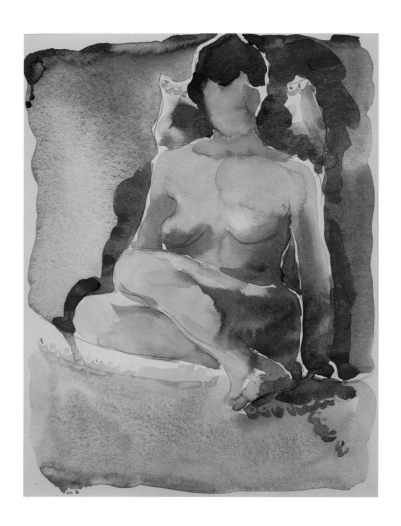

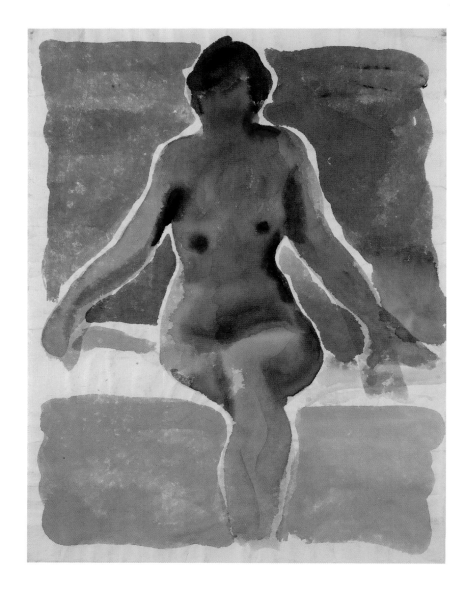

PLATE 96
Nude Series IX
1917
Watercolor and graphite on paper, 12 x 8⅞ (30.5 x 22.5)
Gift, The Georgia O'Keeffe Foundation

CR 178

PLATE 97
Nude Series VII
1917
Watercolor on paper, 17¼ x 13½ (45.1 x 34.3)
Gift, The Burnett Foundation and The Georgia O'Keeffe Foundation

CR 181

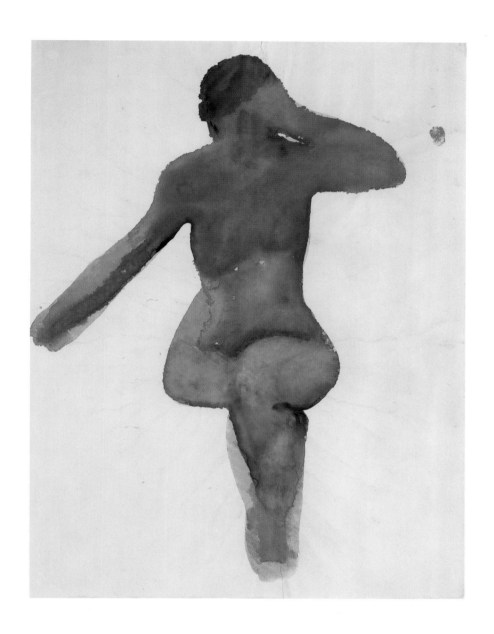

PLATE 98
Nude Series, VIII
1917
Watercolor on paper, 18 x 13½ (45.7 x 34.3)
Gift, The Burnett Foundation and The Georgia O'Keeffe Foundation
CR 182

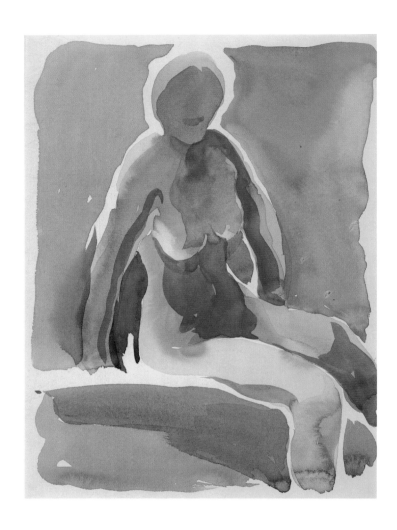

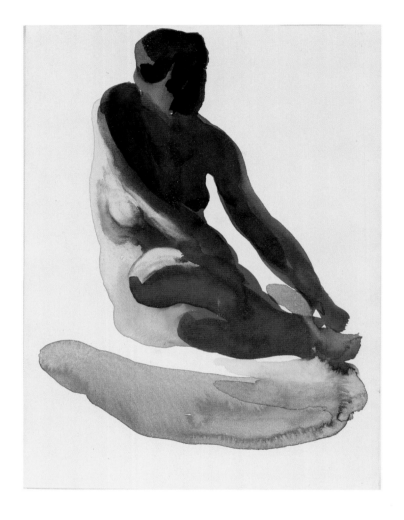

PLATE 99
Nude No. VI
1917
Watercolor on paper, 12 x 8⅞ (30.5 x 22.5)
Gift, The Georgia O'Keeffe Foundation
CR 183

PLATE 100
Nude Series
1917
Watercolor on paper, 12 x 8⅞ (30.5 x 22.5)
Gift, The Burnett Foundation and The Georgia O'Keeffe Foundation
CR 186

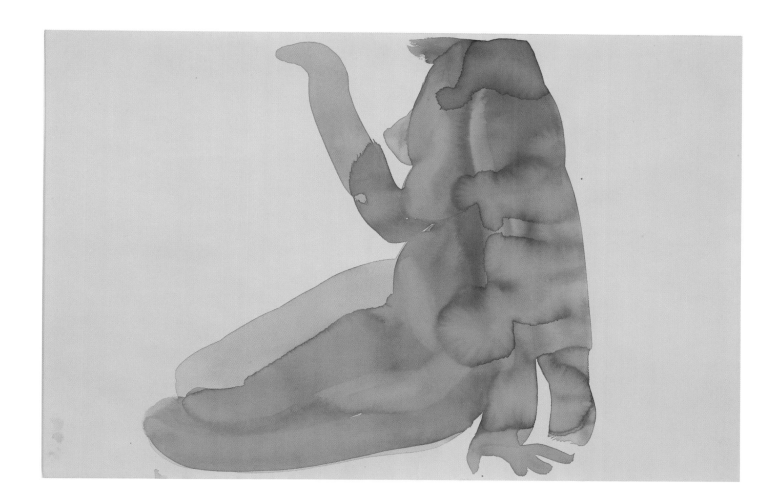

PLATES 102–7

O'Keeffe also used figures as subjects in six of the watercolors she made in San Antonio in 1918.

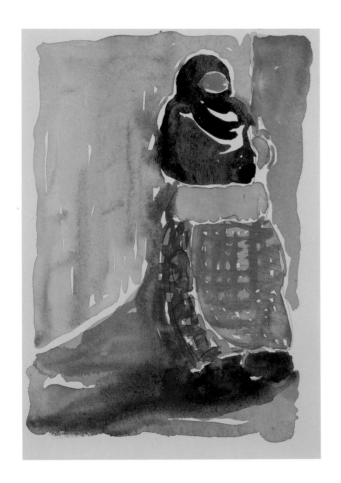

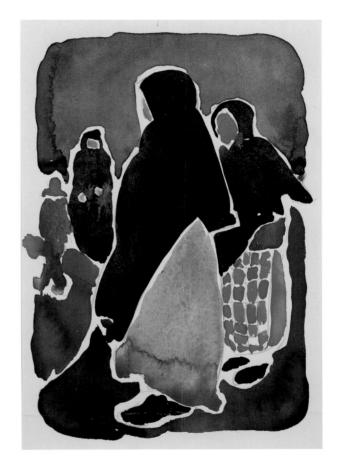

PLATE 102

Woman with Apron

1918

Watercolor and graphite on paper, 8¾ x 6 (22.2 x 15.2)

Gift, The Burnett Foundation

© 1987 Private collection

CR 236

PLATE 103

Three Women

1918

Watercolor and graphite on paper, 8⅞ x 6 (22.5 x 15.2)

Gift, Gerald and Kathleen Peters

© 1987 Private collection

CR 237

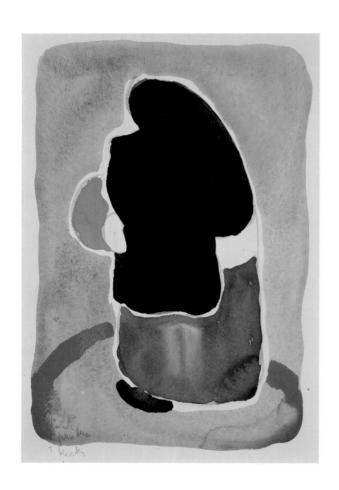

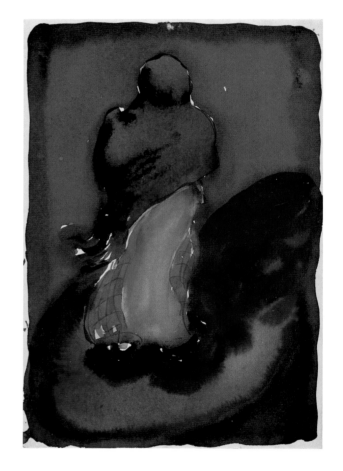

PLATE 104
Untitled (Woman with Black Shawl)
1918
Watercolor and graphite on paper, 8⅞ x 6 (22.5 x 15.2)
Gift, The Georgia O'Keeffe Foundation

CR 238

PLATE 105
Woman with Blue Shawl
1918
Watercolor, graphite, and charcoal on paper, 8⅞ x 6 (22.5 x 15.2)
Promised gift, The Burnett Foundation
© 1987 Private collection

CR 239

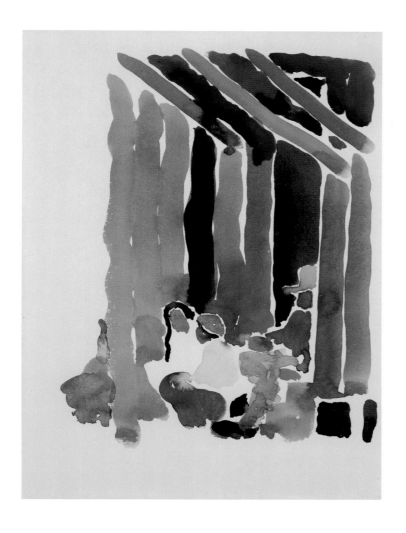

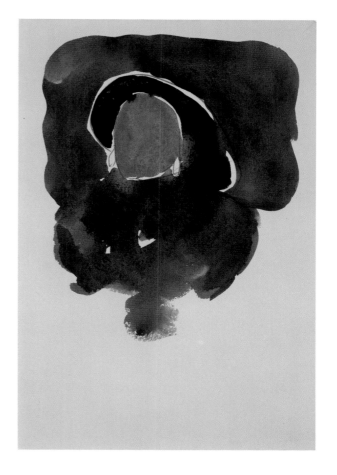

PLATE 106

Figures Under Rooftop

1918

Watercolor on paper, 12 x 9 (30.5 x 22.9)

Gift, Gerald and Kathleen Peters

© 1987 Private collection

CR 229

PLATE 107

Figure in Black

1918

Watercolor and graphite on paper, 8⅞ x 6 (22.5 x 15.2)

Promised gift, The Burnett Foundation

© 1987 Private collection

CR 235

PLATES 108–9

There is no evidence that O'Keeffe concerned herself with the human figure between the 1910s and early 1940s, when she made portraits of Dorothy Schubart, a relative, and of a friend, artist Beauford Delaney. Both of these works make it clear that her lack of interest in using the figure as a subject in her later work had nothing to do with any inability to render human forms accurately.

PLATE 108
Dorothy Schubart
1940
Charcoal on paper, 23¼ x 17⅞ (60.3 x 45.4)
Gift, The Georgia O'Keeffe Foundation

CR 989

PLATE 109
Untitled (Beauford Delaney)
1943
Charcoal on paper, 24⅞ x 18⅞ (63.2 x 47.9)
Gift, The Georgia O'Keeffe Foundation

CR 1041

Natural and Still Life Forms

I have used these things to say what is to me the wideness and wonder of the world as I live in it. (In Daniel Catton Rich, "The New O'Keeffes," *Magazine of Art* 37, no. 3 [March 1944]: 111.)

PLATES 110—11

There are a number of still-life studies in O'Keeffe's very early sketchbooks, but one of the few paintings picturing found objects she completed in the 1910s is the double-sided *Untitled (Horse)*, dating from 1914, when she was a student in New York. Her technique here makes it clear that she had studied reproductions of paintings by European Impressionists and Post-Impressionists.

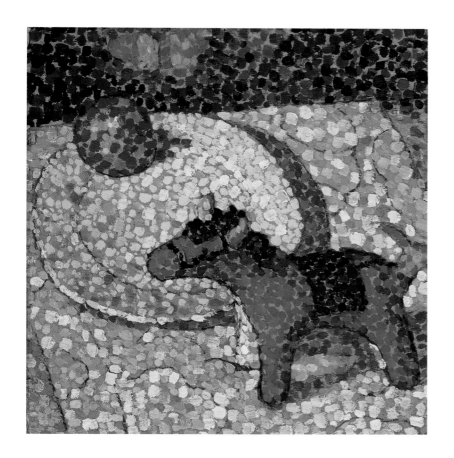

PLATE 110
Untitled (Horse)
1914
Oil on cardboard, 12½ x 11½ (31.7 x 29.2)
Gift, The Georgia O'Keeffe Foundation

CR 42

PLATE 111
Untitled (Horse)
1914
Oil and graphite on cardboard, 11½ x 10½ (29.2 x 26.7)
Gift, The Georgia O'Keeffe Foundation

CR 43

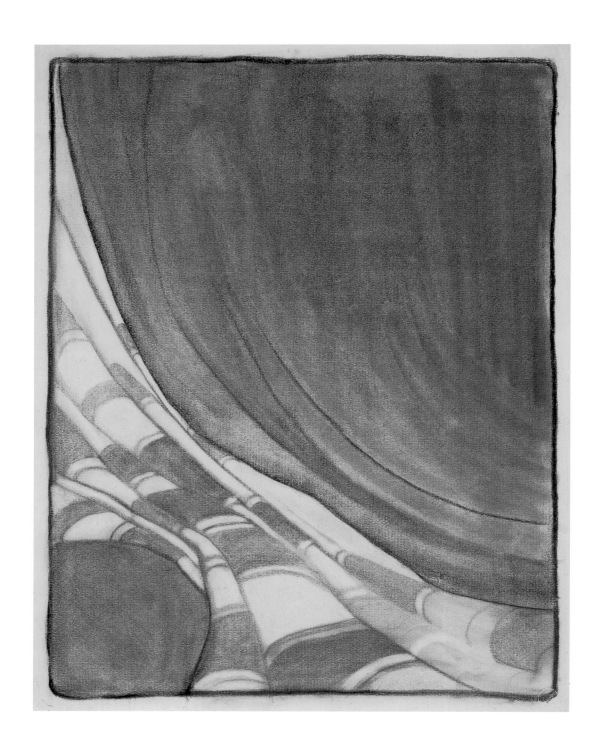

PLATE 112

Drawing

c. 1915/1916

Charcoal on paper, 24¼ x 18½ (62.9 x 47)

Gift, The Georgia O'Keeffe Foundation

CR 59

PLATE 113

Although O'Keeffe became well known as a flower painter in the mid-1920s, she first painted flowers two decades earlier, when she was in high school at the Chatham Episcopal Institute in Virginia. The extreme simplicity of this intuitively realized watercolor presages O'Keeffe's self-conscious involvement with Asian art a decade later.

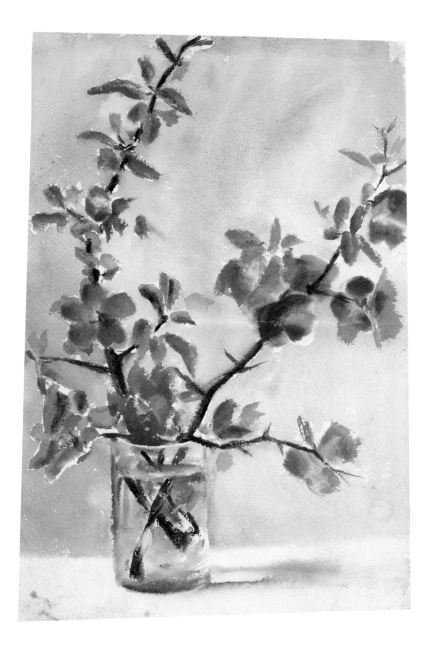

PLATE 113
Untitled (Vase of Flowers)
1903/1905
Watercolor on paper, 17¼ x 11½ (45.1 x 29.2)
Gift, The Georgia O'Keeffe Foundation
CR 6

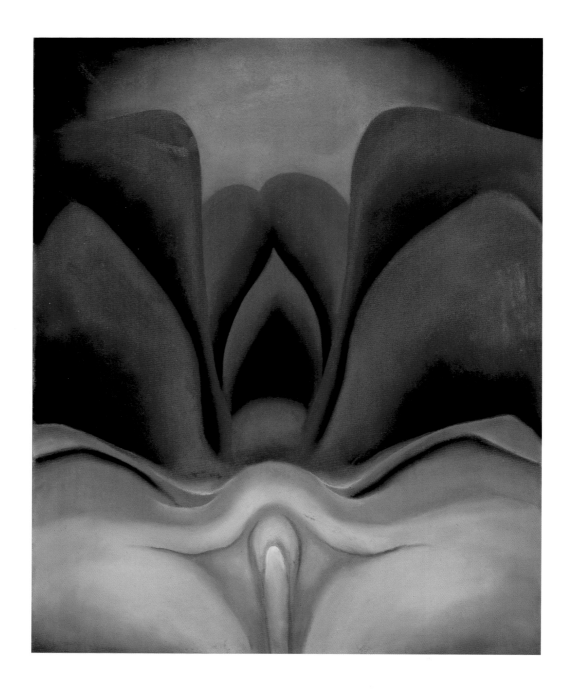

PLATE 114

Blue Flower

1918

Pastel on paper, 20 x 16 (50.8 x 40.6)

Promised gift, The Burnett Foundation

© 1987 Private collection

CR 259

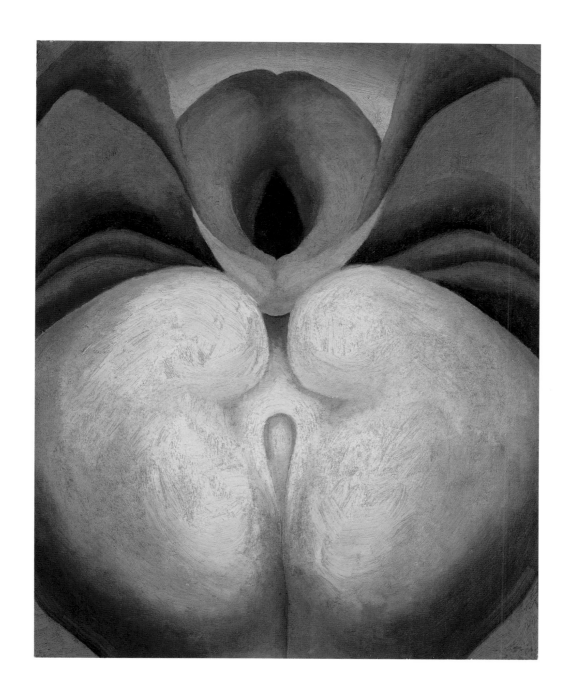

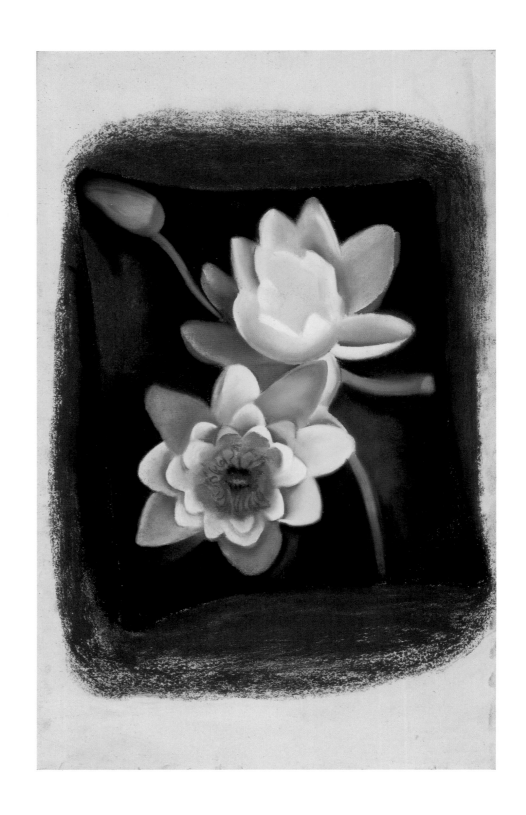

PLATE 116

Water Lily

1921
Pastel on paper, 28¼ x 17½ (71.7 x 44.5)
Gift, The Georgia O'Keeffe Foundation

CR 350

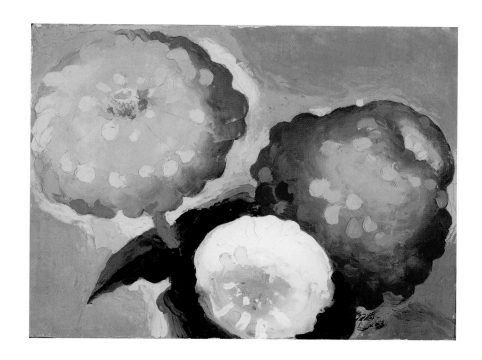

PLATE 117

3 Zinnias

1921

Oil on canvas, 6 x 8 (15.2 x 20.3)

Gift, The Georgia O'Keeffe Foundation

CR 353

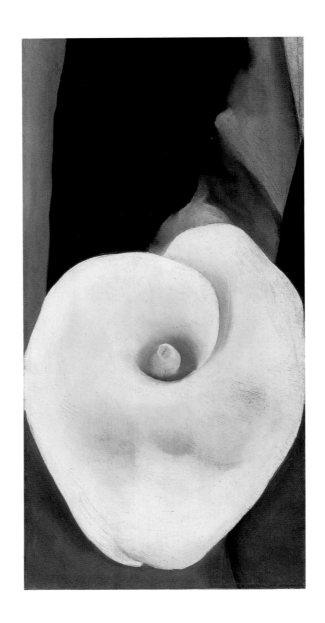

PLATE 119

Calla Lily for Alfred
1927
Oil on canvas-covered board, 12 x 6 (30.5 x 15.2)
Gift, Mr. and Mrs. Eugene V. Thaw

CR 587

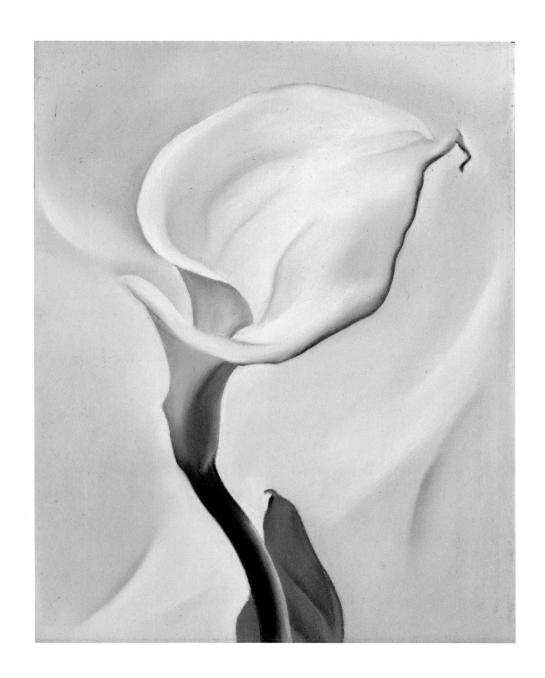

PLATE 118
Calla Lily Turned Away
1923
Pastel on cardboard, 14 x 10⅞ (35.6 x 27.6)
Gift, The Burnett Foundation

CR 423

By the early 1920s, when O'Keeffe turned her attention to representational painting, she had used flowers as subject matter for almost two decades and had been exposed to advanced photographic techniques for at least half a decade. Thus, it is not surprising that what she did with flowers in the 1920s and thereafter was largely the result of combining the principles she learned from photography with those of the composition-based thinking of Arthur Wesley Dow that she had first learned about in the 1910s and would subsequently explore through course work with Dow at Teachers College. His modernist ideas had derived from his study of world art, in particular that of Asia, and he believed that the study of composition was the most important consideration of an artist.

To one degree or another, this synthesis informs all of O'Keeffe's mature art. For example, among the flower paintings of the 1920s is a series depicting calla lilies as subject. In *Calla Lily for Alfred* (plate 119), for example, O'Keeffe pictured a single bloom seen as if through a close-up lens and very self-consciously placed it off center. Furthermore, she cropped the blossom on the left and right and emphasized the extreme contrast between its lightness and the darkness of the painting's background.

Of her use of the calla lily she wrote: "People think I must have a passion for the calla lily because I have used it so much in my work. . . . As a matter of fact, I haven't at all. I started to paint it out of curiosity, because I wanted to find out why some people hated it so much and others love it. Of course, I went at it with a very realistic approach. I always do seven or eight different versions of the same thing, until I evolve the final product. . . ." (In Isabel Ross, "Bones of Desert Blaze Art Trail of Miss O'Keeffe: Transition from Calla Lilies to Bleached Skulls Seems Natural Step to Painter—Blends Them with Lilies—Together, They Express Her Feelings, She Explains," *New York Herald Tribune* [29 December 1931], 3.)

In her flower pictures, as in many other works, O'Keeffe employed photographic devices to attract the kind of attention she wanted. She cropped forms, eliminated or distorted relationships between foreground and background elements, compressed space, and forced her subjects forward, as if seen through a close-up lens. She denied the association between her work and photography until several years after Stieglitz's death, when she began taking photographs of, among other things, architectural and landscape forms, and referred to how some of her photographs had influenced her work. (See *Georgia O'Keeffe*, 1976, unpaginated text accompanying entry 104.)

Yet her debt to photography in earlier decades is clear, and although only one photograph that she made then has survived (see plate 297), it is more than likely that she made as many photographs prior to the 1950s as she did after 1950.

In 1924, O'Keeffe began to make paintings in various sizes, all of which focused on the centers of flowers, and she continued making them for decades. As she later explained: "A flower is relatively small. Everyone has many associations with a flower—the idea of flowers. You put out your hand to touch the flower—lean forward to smell it—maybe touch it with your lips almost without thinking—or give it to someone to please them. Still—in a way—nobody sees a flower—really—it is so small—we haven't time—and to see takes time, like to have a friend takes time. If I could paint the flower exactly as I see it no one would see what I see because I would paint it small like the flower is small. So I said to myself—I'll paint what I see—what the flower is to me but I'll paint it big and they will be surprised into taking time to look at it—I will make even busy New Yorkers take time to see what I see of flowers." (In *Georgia O'Keeffe*, 1976, unpaginated text accompanying entry 23.)

Petunia No. 2 (plate 122) was not only one of her first large-scale flower paintings, but also among the first to be exhibited. Included with several other similar flower paintings in the celebrated "Seven Americans" show that Stieglitz organized in 1925, this work—along with many to follow—presented the sexual anatomy of the flower in sharp focus. By drawing attention to the inherent androgyny of this subject, O'Keeffe could have been attempting to contradict the critical notion that her subject matter was related exclusively to her gender.

But if so, the critics in 1925 missed O'Keeffe's point (as most still do). They interpreted her flowers as they had interpreted her earlier abstractions, as expressions of her sexuality. In 1943, O'Keeffe finally responded: "Well—I made you take time to look at what I saw and when you took time to really notice my flowers you hung all your own associations with flowers on my flower and you write about my flower as if I think and see what you think and see of the flower—and I don't." (In Ernest W. Watson, "Georgia O'Keeffe," *American Artist* [June 1943]: 10.)

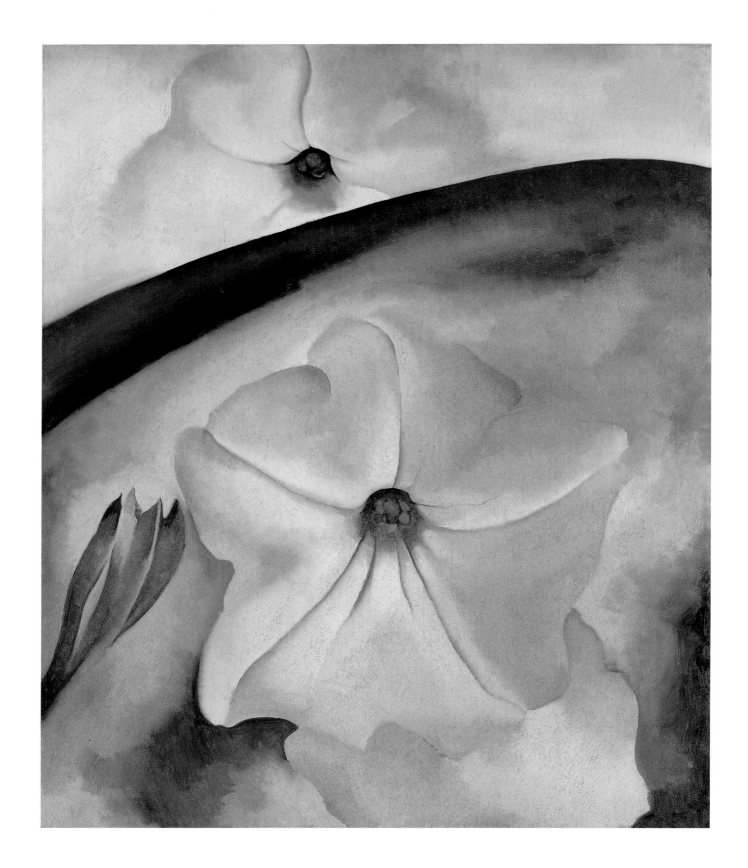

PLATE 122

Petunia No. 2

1924

Oil on canvas, 36 x 30 (91.4 x 76.2)

Gift, The Burnett Foundation and Gerald and Kathleen Peters

CR 462

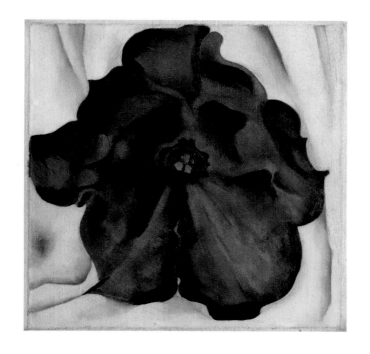

PLATE 123

Untitled (Purple Petunia)

1925

Oil on canvas, 7¼ x 7¼ (18.4 x 18.4)

Gift, The Burnett Foundation

CR 493

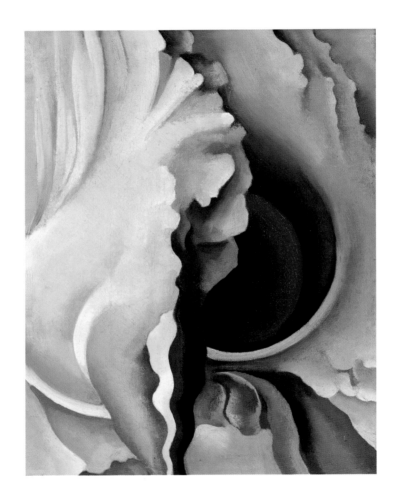

PLATE 124
The Black Iris
1926
Oil on canvas, 9 x 7 (22.9 x 17.8)
Promised gift, The Burnett Foundation
CR 558

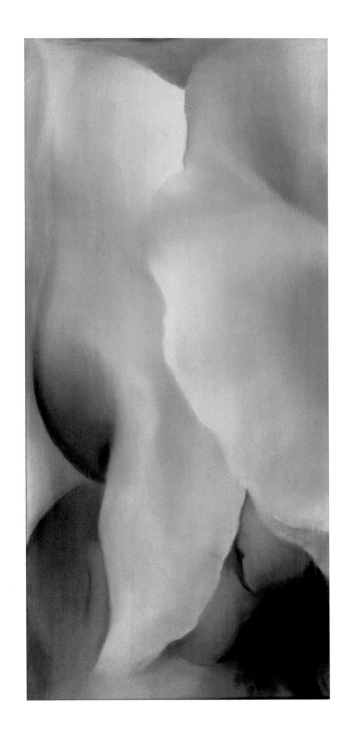

PLATE 125
Dark Iris No. III
1927
Pastel on paper, 20¼ x 9 (51.4 x 22.9)
Gift, The Burnett Foundation and The Georgia O'Keeffe Foundation
CR 602

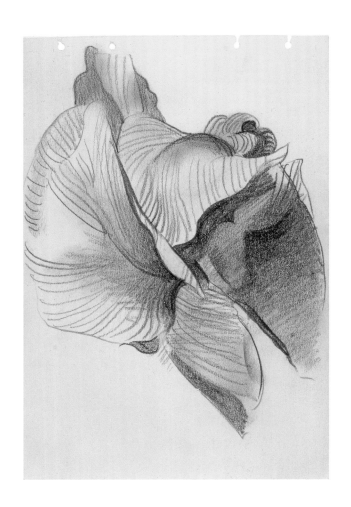

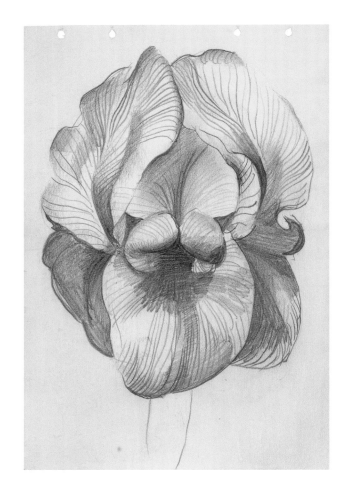

PLATE 126

Untitled (Iris)

c. 1936

Graphite on paper, 9 x 6 (22.9 x 15.2)

Gift, Juan and Anna Marie Hamilton

© Private collection

CR 903

PLATE 127

Untitled (Iris)

1936

Graphite on paper, 9 x 6 (22.9 x 15.2)

Gift, Juan and Anna Marie Hamilton

© Private collection

CR 884

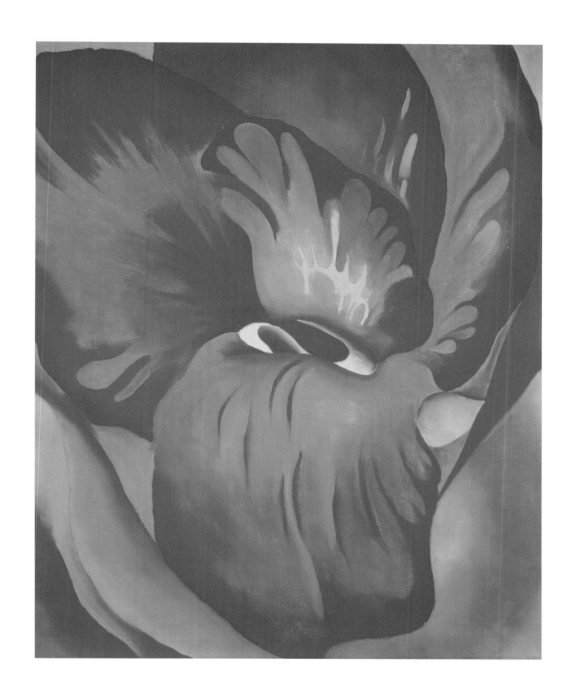

PLATE 128
Canna Red and Orange
1926
Oil on canvas, 20 x 16 (50.8 x 40.6)
Gift, The Burnett Foundation
CR 563

149

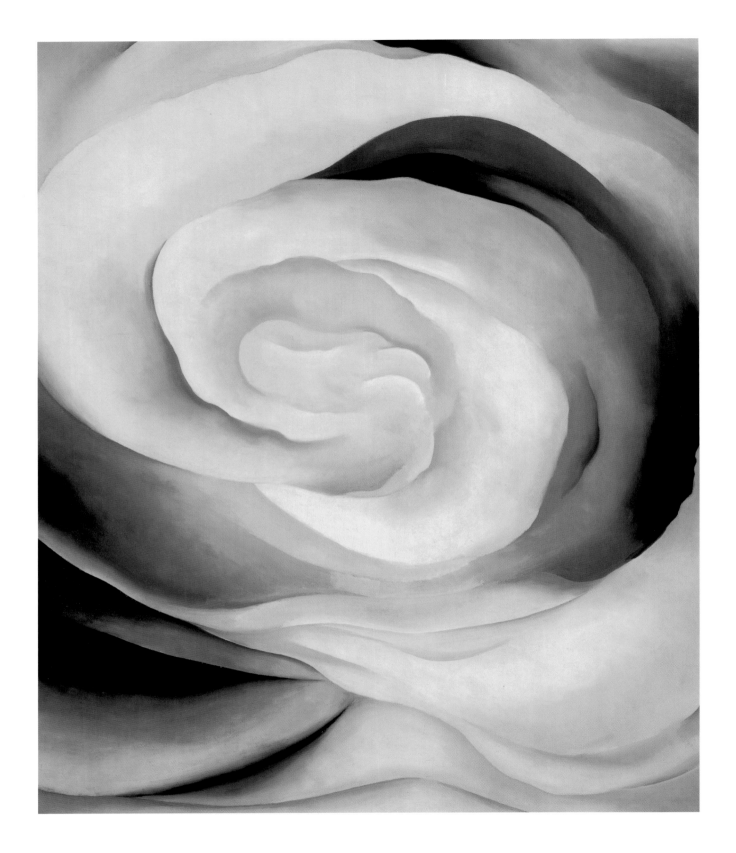

PLATE 129

Abstraction White Rose

1927

Oil on canvas, 36 x 30 (91.4 x 76.2)

Gift, The Burnett Foundation and The Georgia O'Keeffe Foundation

CR 599

PLATE 130
Small Poppy with Vine I
c. 1927
Charcoal on paper, 10⅞ x 8½ (27.6 x 21.6)
Gift, The Georgia O'Keeffe Foundation

CR 610

PLATE 131
Small Poppy with Vine II
c. 1927
Charcoal on paper, 10⅞ x 8½ (27.6 x 21.6)
Gift, The Georgia O'Keeffe Foundation

CR 611

PLATE 132

Regardless of their degree of abstraction, O'Keeffe's flower paintings derive directly from her experience of the blossoms. She described the source of *Black Hollyhock Blue Larkspur*, 1930: "When I was at Mabel [Dodge Luhan]'s at Taos . . . there was an alfalfa field like a large green saucer. On one side of the field was a path lined with flowers. . . . One day walking down the path I picked a large blackish red hollyhock and some bright dark blue larkspur that immediately went into a painting—and then another painting." (In *Georgia O'Keeffe*, 1976, unpaginated text accompanying entry 56.)

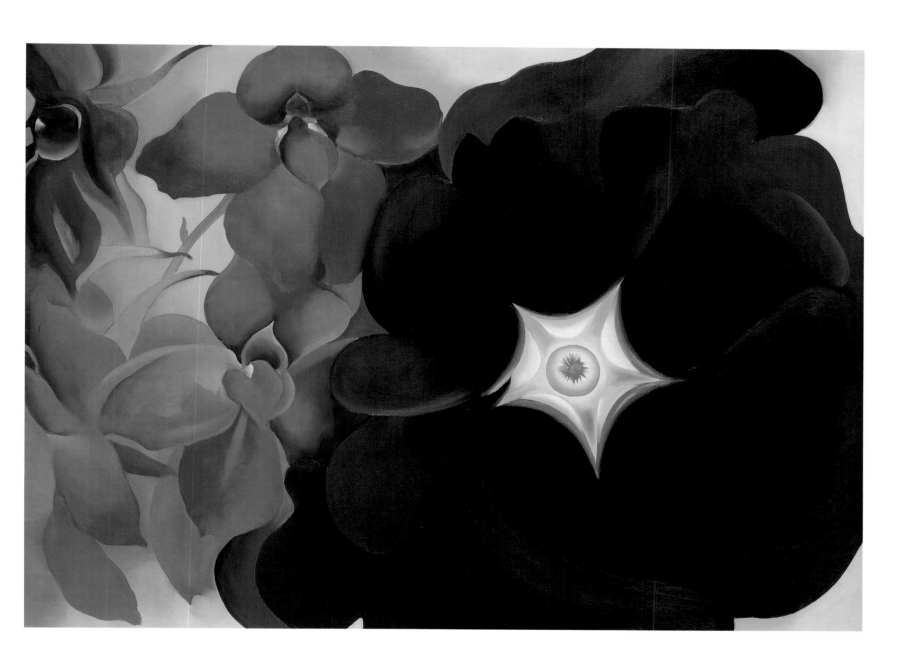

PLATE 132
Black Hollyhock Blue Larkspur
1930
Oil on canvas, 30⅛ x 40 (76.5 x 101.6)
Extended loan, private collection

CR 714

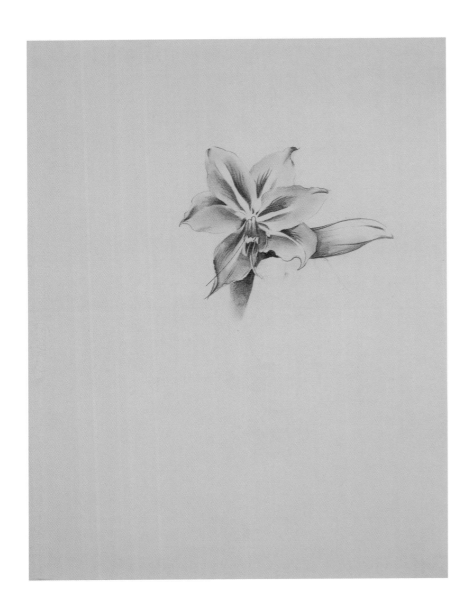

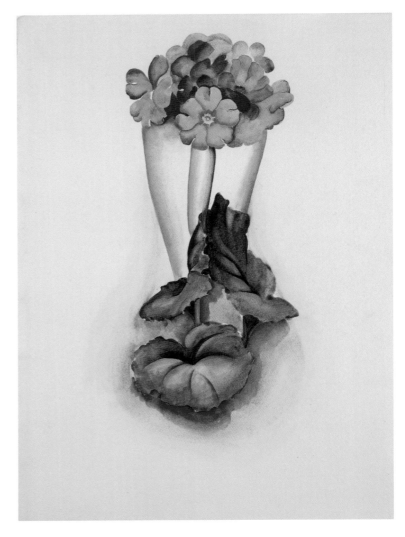

PLATE 133
Untitled (Lily)
c. 1930/1936
Graphite on paper, 24 x 18¼ (61 x 46.4)
Gift, The Georgia O'Keeffe Foundation

CR 756

PLATE 134
Untitled (Flowers in Vase)
c. 1930/1936
Watercolor and graphite on paper, 15¾ x 11¼ (40 x 28.6)
Gift, The Burnett Foundation

CR 763

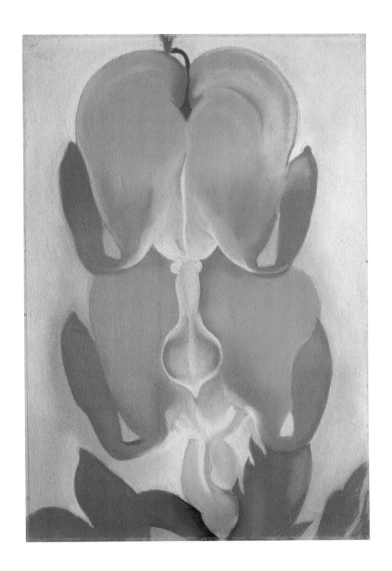

PLATE 135

Bleeding Heart

1932

Pastel on cardboard, 15⅛ x 10 (38.4 x 25.4)

Gift, Anne Windfohr Marion and Anne Windfohr Grimes

CR 814

155

PLATES 136–37

One of O'Keeffe's most interesting uses of flower subject matter came in 1938, when she made a detailed drawing of the jimson weed flower as part of a series of drawings by major artists commissioned by the Steuben Glass Company to be engraved on glass plates. The flower of this plant was also the subject of several large-format paintings, for example, *Jimson Weed*, 1932.

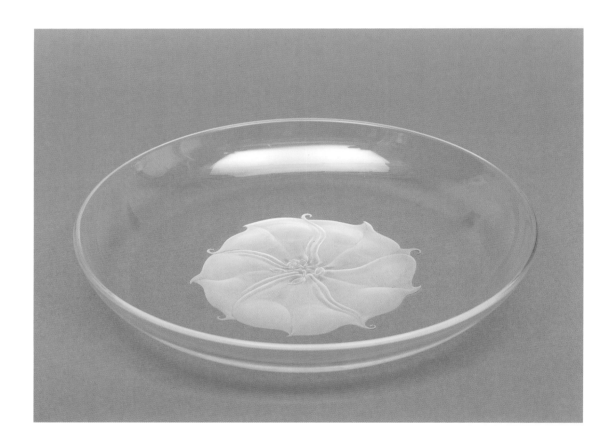

PLATE 136
Steuben glass plate engraved with O'Keeffe Jimson weed image
c. 1940
Glass, 14 (35.6) diameter
Gift, Mrs. Flora Crichton
see CR 947, *Design for a Glass Plate*, 1938

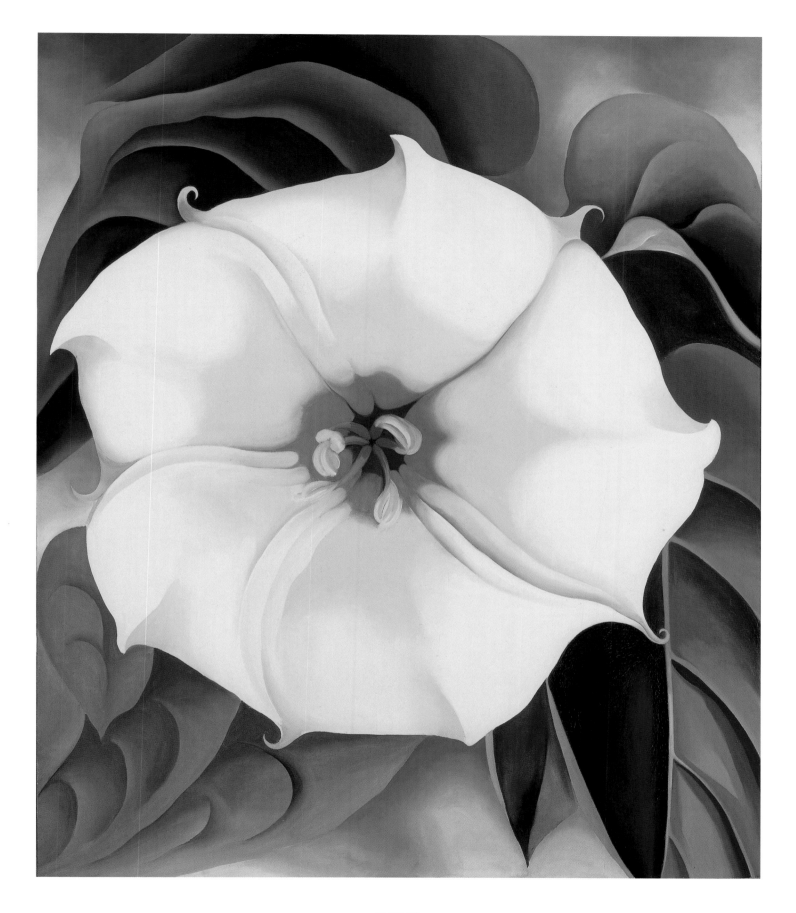

PLATE 137

Jimson Weed
1932
Oil on canvas, 48 x 40 (121.9 x 101.6)
Gift, The Burnett Foundation

CR 815

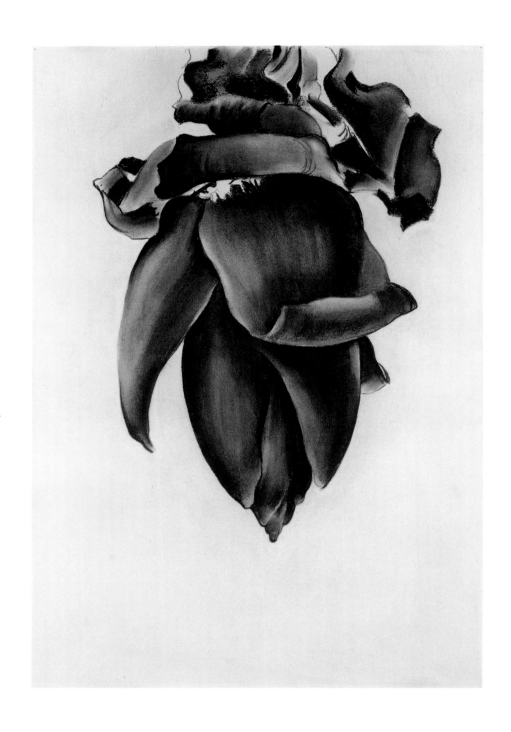

PLATE 138

Banana Flower No. II

1934

Charcoal on paper, 21⅞ x 14½ (55.6 x 36.8)

Gift, The Burnett Foundation

CR 831

158

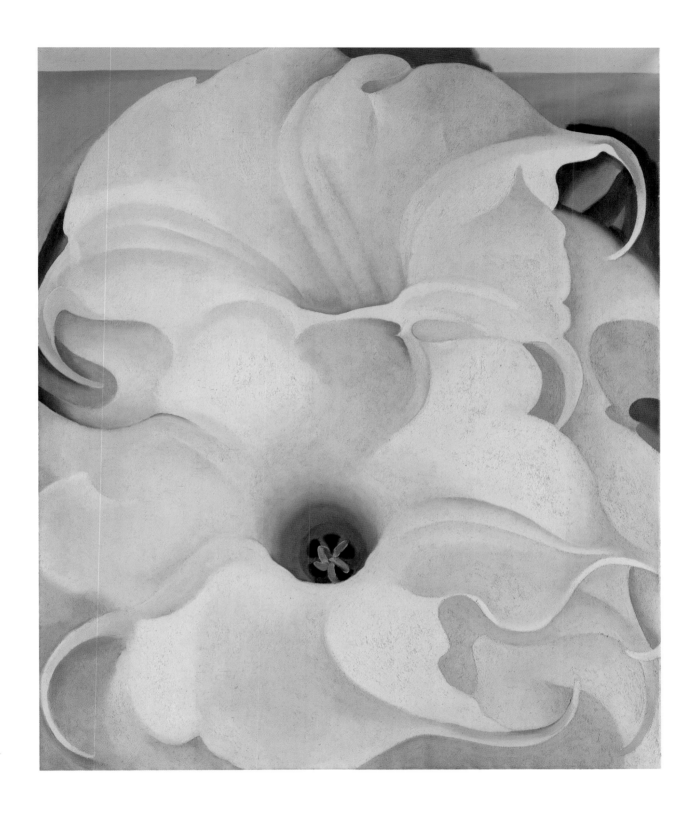

PLATE 139

Bella Donna

1939

Oil on canvas, 36¼ x 30⅛ (92.1 x 76.5)

Extended loan, private collection

CR 966

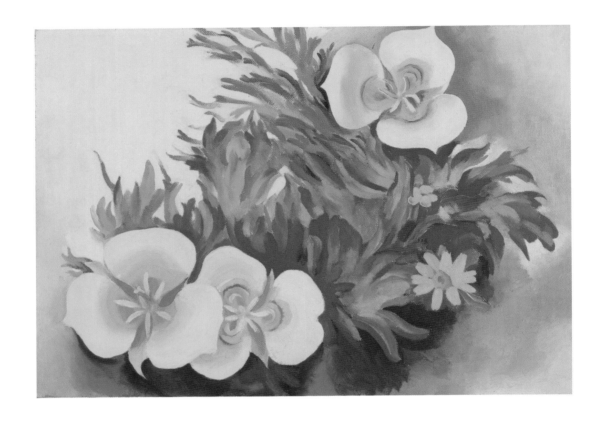

PLATE 140

Mariposa Lilies and Indian Paintbrush

1941

Oil on canvas, 10 x 14 (25.4 x 35.6)

Gift, The Georgia O'Keeffe Foundation

CR 1016

PLATE 141
Untitled (Bowl of Fruit)
1918
Graphite on paper, 4¼ x 2½ (10.8 x 6.3)
Gift, The Georgia O'Keeffe Foundation

CR 243

PLATE 142
Untitled (Bowl of Fruit)
1918
Watercolor and graphite on paper, 4½ x 3⅝ (11.4 x 9.2)
Gift, Juan and Anna Marie Hamilton
© 1987 Private collection

CR 244

PLATES 141–45

Like her flowers, O'Keeffe usually painted fruits and plants as forms isolated from their environments. In the 1920s, she made several paintings in series using apples, avocados, pears, or corn as subject matter. Apple trees grew in abundance at Lake George, and in *Apple Family—2*, 1920, she crowds the composition with 10 pieces of ripe fruit, which are cropped by three sides of the composition and, thus, brought close to the picture's surface.

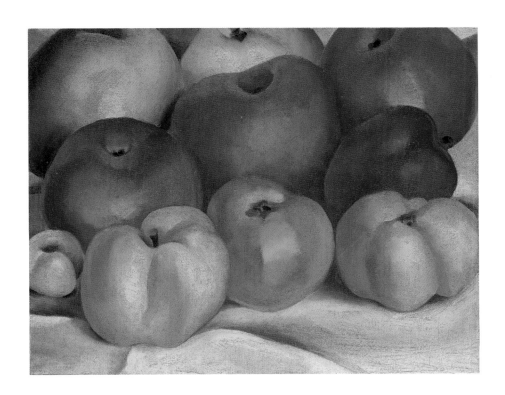

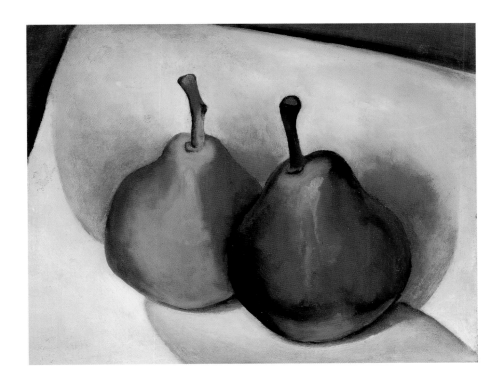

PLATE 143

Apple Family—2

1920

Oil on canvas, 8⅛ x 10⅛ (20.6 x 25.7)

Gift, The Burnett Foundation and The Georgia O'Keeffe Foundation

CR 315

PLATE 144

Untitled (Two Pears)

1921

Oil on board, 8⅞ x 10 (22.5 x 25.4)

Promised gift, The Burnett Foundation

CR 349

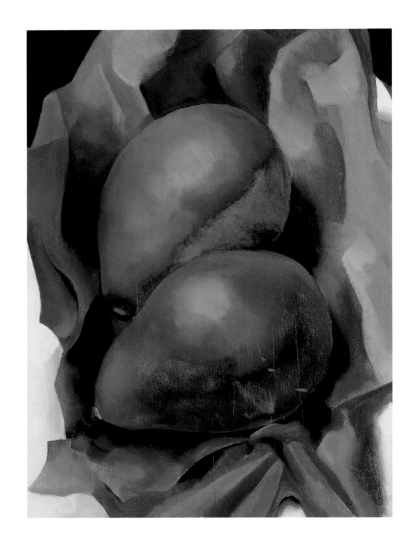

PLATE 145

Alligator Pears

1923

Oil on board, 13¼ x 9⅞ (34.9 x 25.1)

Gift, The Georgia O'Keeffe Foundation

CR 417

O'Keeffe said the following about two of her paintings of avocados: "I had an alligator-pears-in-a-large-dark-basket period. One painting is dark with a simplified white scalloped doily under the basket." (In *Georgia O'Keeffe*, 1976, unpaginated text accompanying entry 31.)

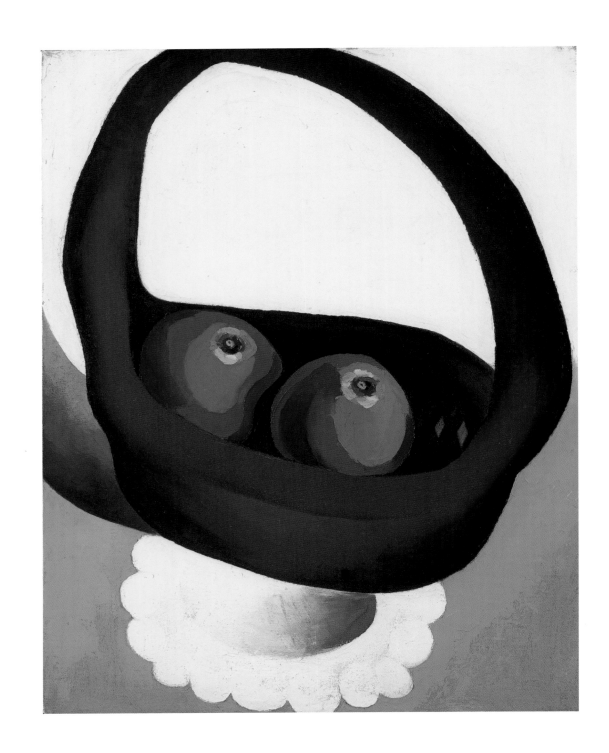

PLATE 146

Alligator Pear—No. 2
1920/1921
Oil on canvas, 23¼ x 18 (58.7 x 45.7)
Gift, The Georgia O'Keeffe Foundation
CR 337

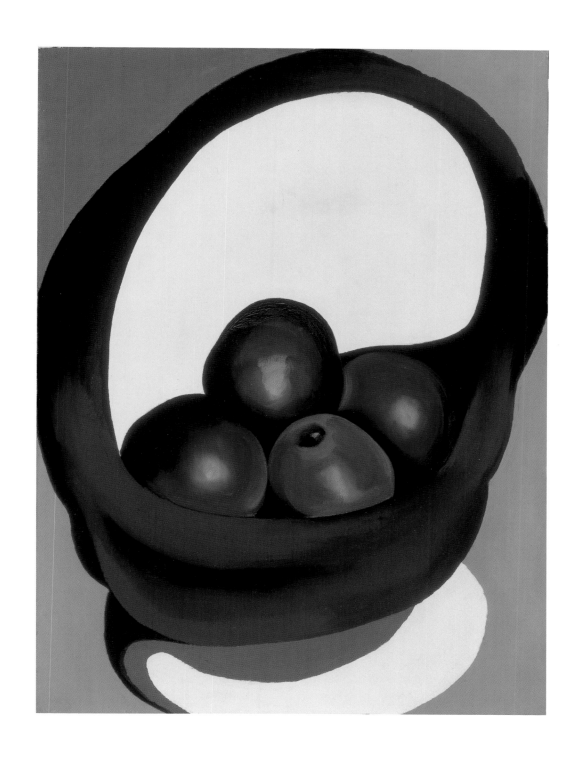

PLATE 147
Alligator Pears
1920/1921
Oil on canvas, 23 x 17 (58.4 x 43.1)
Gift, The Georgia O'Keeffe Foundation
CR 338

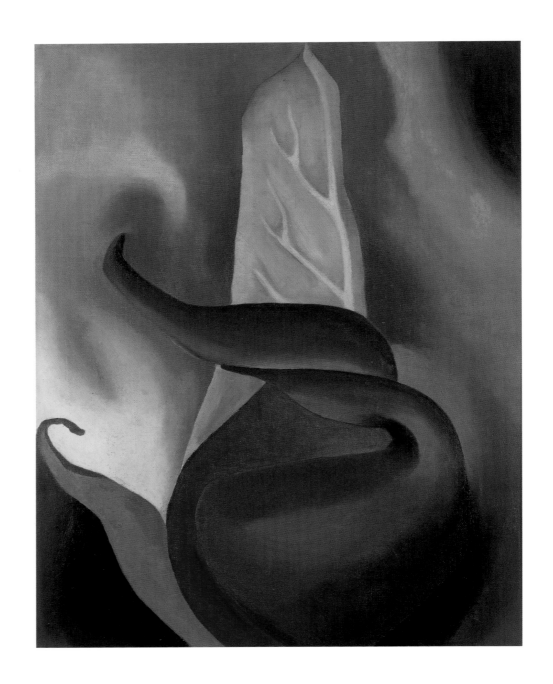

PLATE 148
Skunk Cabbage
1922
Oil on canvas, 18 x 14 (45.7 x 35.6)
Promised gift, The Burnett Foundation

CR 372

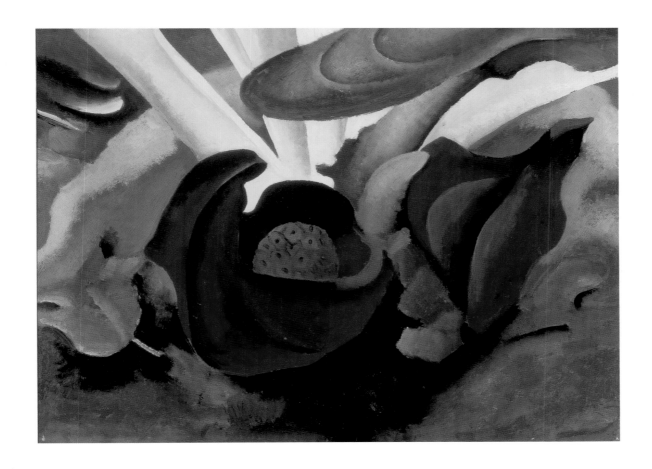

PLATE 149
Untitled (Skunk Cabbage)
c. 1927
Oil on board, 12 x 16 (30.5 x 40.6)
Promised gift, The Burnett Foundation
CR 613

169

PLATE 150

O'Keeffe explained the inspiration for the series that includes *Corn, No. 2*: "I had a garden at Lake George for some years. The growing corn was one of my special interests—the light colored veins of the dark green leaves reaching out in opposite directions. And every morning a little drop of dew would have run down the veins into the center of this plant like a little lake—all fine and fresh." (In *Georgia O'Keeffe*, 1976, unpaginated text accompanying entry 34.)

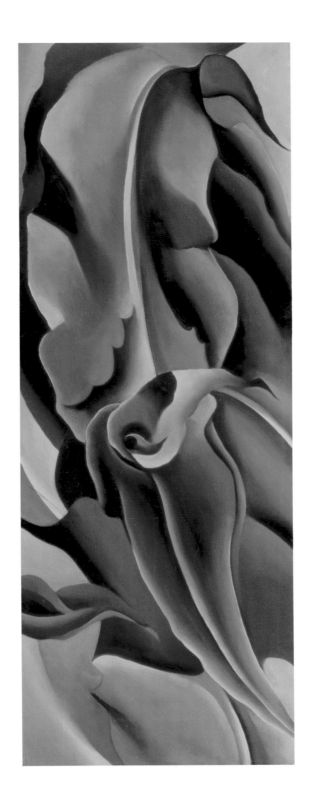

PLATE 150

Corn, No. 2

1924

Oil on canvas, 27¼ x 10 (69.2 x 25.4)

Gift, The Burnett Foundation and The Georgia O'Keeffe Foundation

CR 454

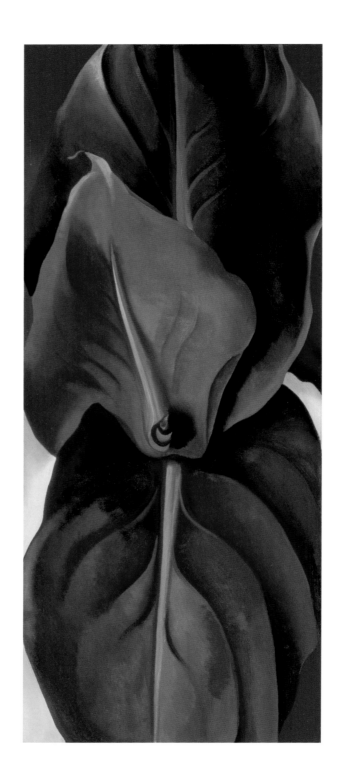

PLATE 151

Canna Leaves

1925

Oil on canvas, 26 x 11 (66 x 27.9)

Gift, The Burnett Foundation

CR 503

172

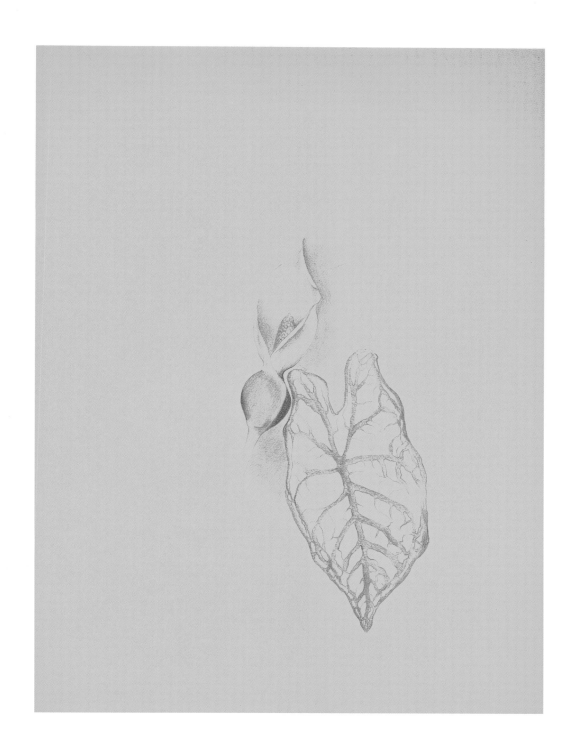

PLATE 152
Untitled (Leaf)
c. 1930/1936
Graphite on paper, 23¼ x 17¼ (58.7 x 45.1)
Gift, The Georgia O'Keeffe Foundation
CR 764

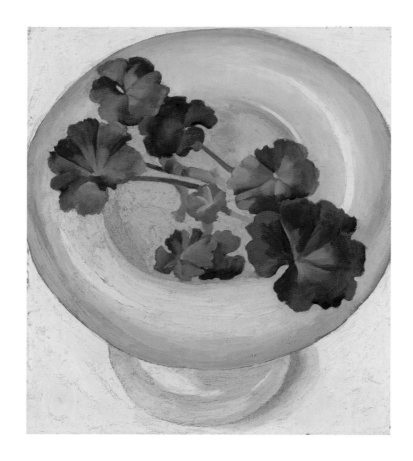

PLATE 153
Geranium Leaves in Pink Dish
1938
Oil on canvas, 8½ x 7½ (21.6 x 19.1)
Gift, The Georgia O'Keeffe Foundation

CR 953

PLATES 154–57

It is clear that O'Keeffe was fascinated with the world around her, and she collected objects whose particular qualities—color, shape, texture—symbolized for her the meaning of a specific place or experience. She often selected objects from her collections of feathers, rocks, shells, and bones for her paintings, and by isolating them from any environmental reference transformed simple and seemingly nondescript objects into centralized, monumental forms. In speaking of shells, she wrote: "I have picked up shells along the coast of Maine—farther south, in the Bermudas and Bahamas I found conch shells along the pure sandy beaches. . . . Each shell was a beautiful world in itself." (In *Georgia O'Keeffe*, 1976, unpaginated text accompanying entry 79.)

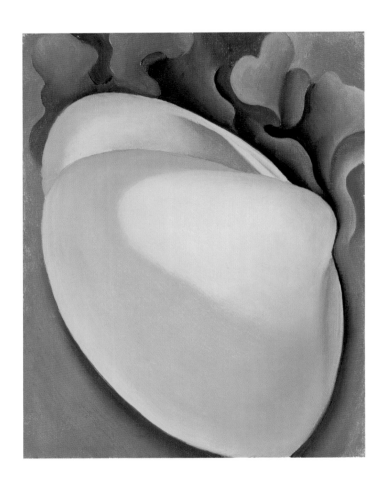

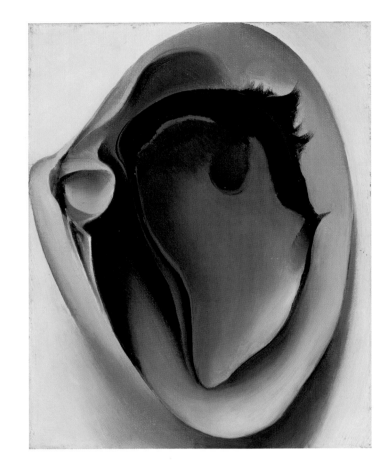

PLATE 154

Tan Clam Shell with Seaweed

1926

Oil on canvas, 9 x 7 (22.9 x 17.8)

Gift, The Georgia O'Keeffe Foundation

CR 535

PLATE 155

Clam and Mussel

1926

Oil on canvas, 9 x 7 (22.9 x 17.8)

Gift, The Georgia O'Keeffe Foundation

CR 534

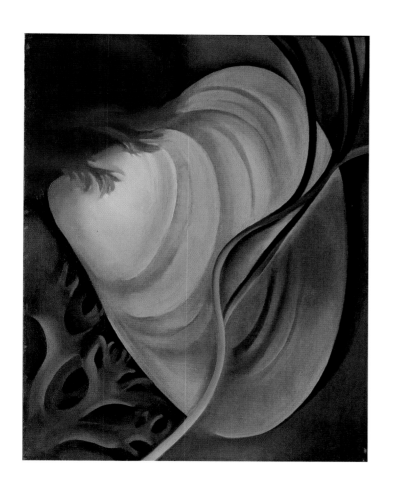

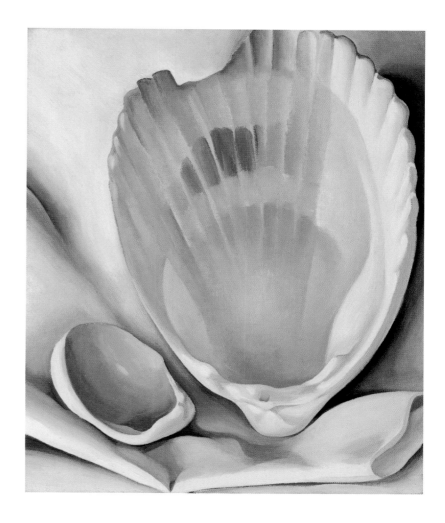

PLATE 156
Shell No. 2
1928
Oil on board, 9¼ x 7¼ (23.5 x 18.4)
Gift, The Burnett Foundation
CR 624

PLATE 157
Two Pink Shells / Pink Shell
1937
Oil on canvas, 12 x 10 (30.5 x 25.4)
Gift, The Burnett Foundation and The Georgia O'Keeffe Foundation
CR 920

In the early 1930s, when O'Keeffe first began making paintings of bones and skulls, critics viewed them as symbols of death. Yet her ideas about this subject were very different, as she later explained: "To me they are as beautiful as anything I know. To me they are strangely more living than the animals walking around—hair, eyes and all with their tails switching. The bones seem to cut sharply to the center of something that is keenly alive on the desert even though it is vast and empty and untouchable—and knows no kindness with all its beauty." (In Ernest W. Watson, "Georgia O'Keeffe," *American Artist* [June 1943]: 11.)

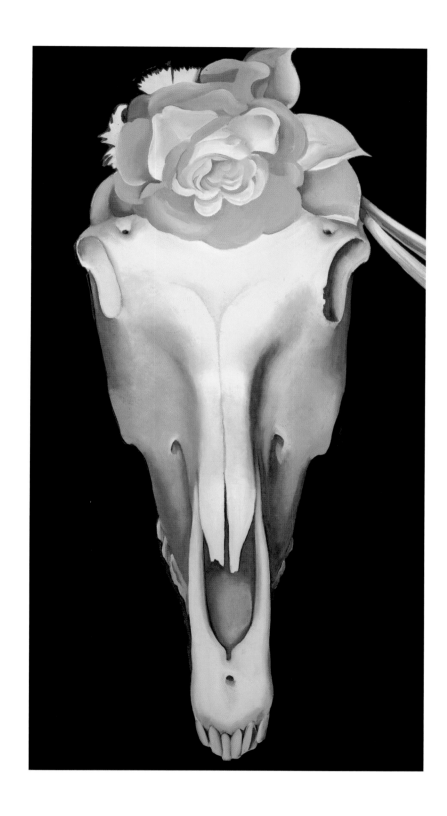

PLATE 158
Horse's Skull with White Rose
1931
Oil on canvas, 30 x 16⅛ (76.2 x 41)
Extended loan, private collection

CR 777

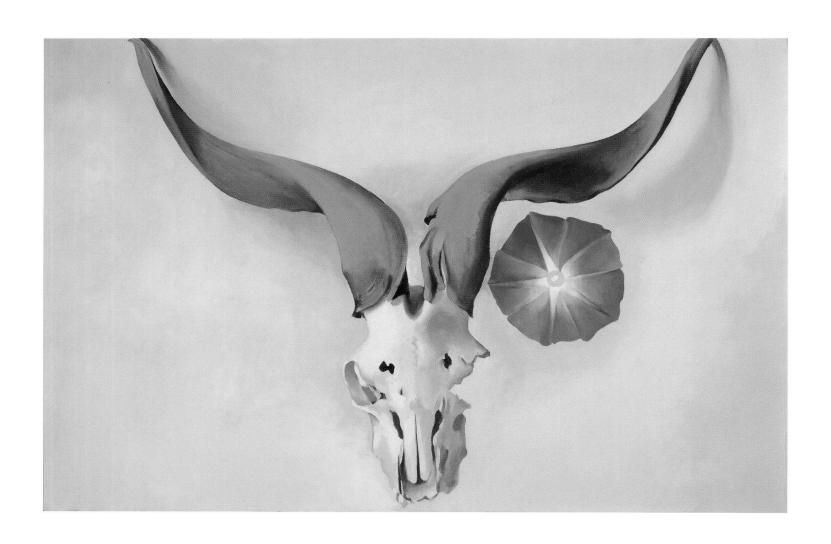

PLATE 159

Ram's Head, Blue Morning Glory

1938

Oil on canvas, 20 x 30 (50.8 x 76.2)

Promised gift, The Burnett Foundation

CR 940

180

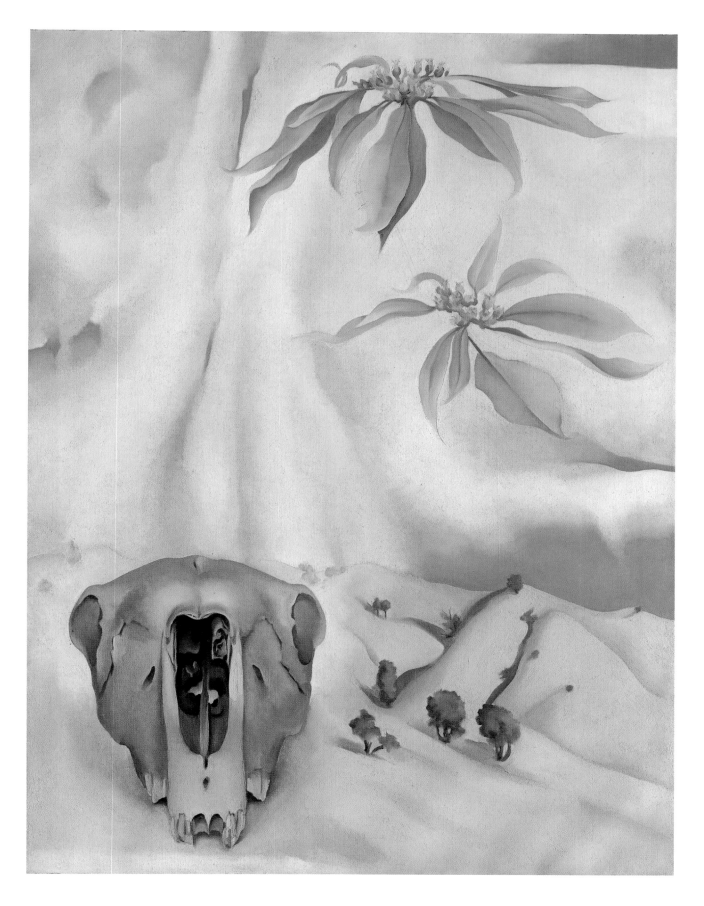

PLATE 160

Mule's Skull with Pink Poinsettia
1936
Oil on canvas, 40⅛ x 30 (101.9 x 76.2)
Gift, The Burnett Foundation

CR 876

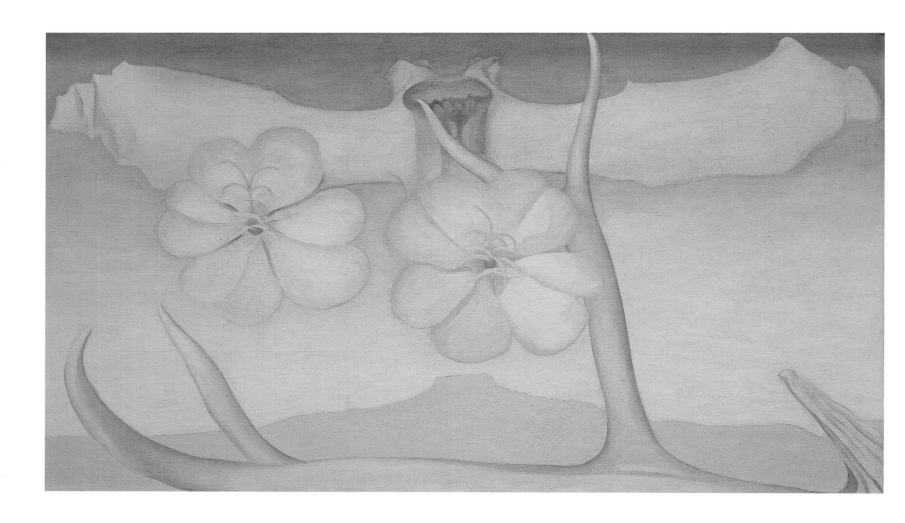

PLATE 161

Spring
1948
Oil on canvas, 48¼ x 84¼ (122.6 x 214)
Gift, The Burnett Foundation

CR 1163

182

PLATES 162–63

In the 1940s, O'Keeffe began to depict the sky as seen through the hole of a pelvis bone that she had found on the desert floor. In this series of paintings, she addressed the oppositions she saw around her: the finite and infinite, the tangible and intangible, the explicable and inexplicable. She explained: "For years in the country the pelvis bones lay about . . . always underfoot . . . seen and not seen as things can be. . . . I do not remember picking up the first one but I remember . . . knowing I would one day be painting them." (In "Horizons of a Pioneer," *Life* 64 [1 March 1968]: 46.)

She also pointed out: "When I started painting the pelvis bones I was most interested in the holes in the bones—what I saw through them—particularly the blue from holding them up in the sun against the sky as one is apt to do when one seems to have more sky than earth in one's world. . . . They were most wonderful against the Blue—that Blue that will always be there as it is now after all man's destruction is finished." (In Georgia O'Keeffe, "Desert Bones" [exhibition checklist], *Georgia O'Keeffe: Paintings, 1944*, 22 January–22 March, An American Place, n.p.)

Equally unrelated elements are brought together in other paintings, such as in *Horse's Skull with White Rose*, 1931, *Ram's Head, Blue Morning Glory*, 1938, *Mule's Skull with Pink Poinsettia*, 1936, and *Spring*, 1948 (plates 158–61). As she explained: "Bones and flowers run together in my mind when I think of the desert. The bones bleach such a beautiful white lying out in the sun. I have always admired them, and last summer I took to picking them up. Then I thought how well they went with the ridiculous artificial flowers that the women have all over the place. And so I have put them together—actually to express what I feel about the desert." (In Isabel Ross, "Bones of Desert Blaze Art Trail of Miss O'Keeffe: Transition from Calla Lilies to Bleached Skulls Seems Natural Step to Painter—Blends Them with Lilies—Together, They Express Her Feelings, She Explains," *New York Herald Tribune* [29 December 1931], 3.)

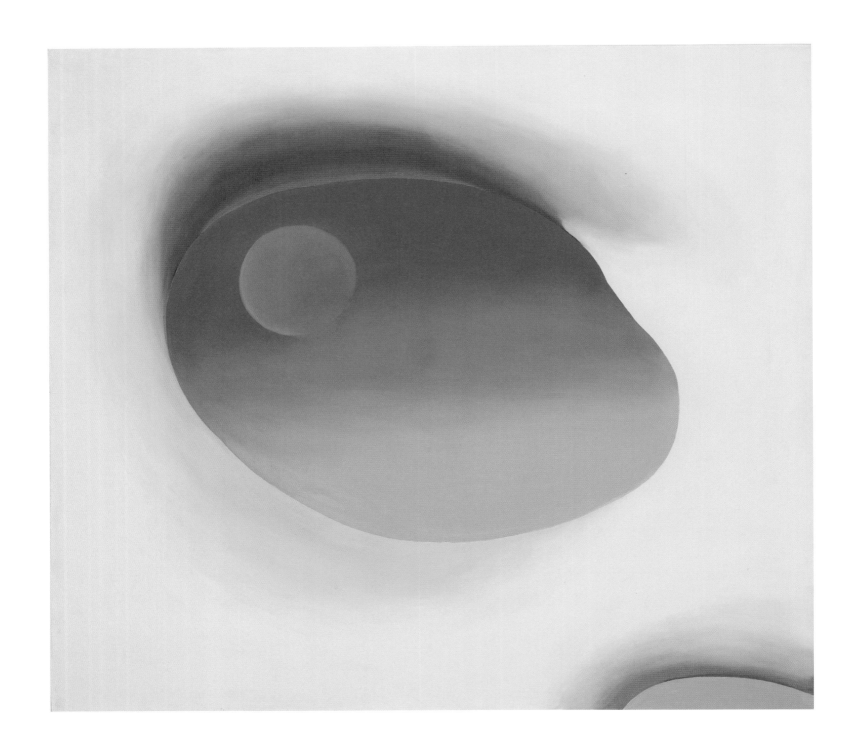

PLATE 162

Pelvis IV

1944
Oil on Masonite, 36 x 40 (91.4 x 101.6)
Gift, The Burnett Foundation
© 1987 Private collection

CR 1078

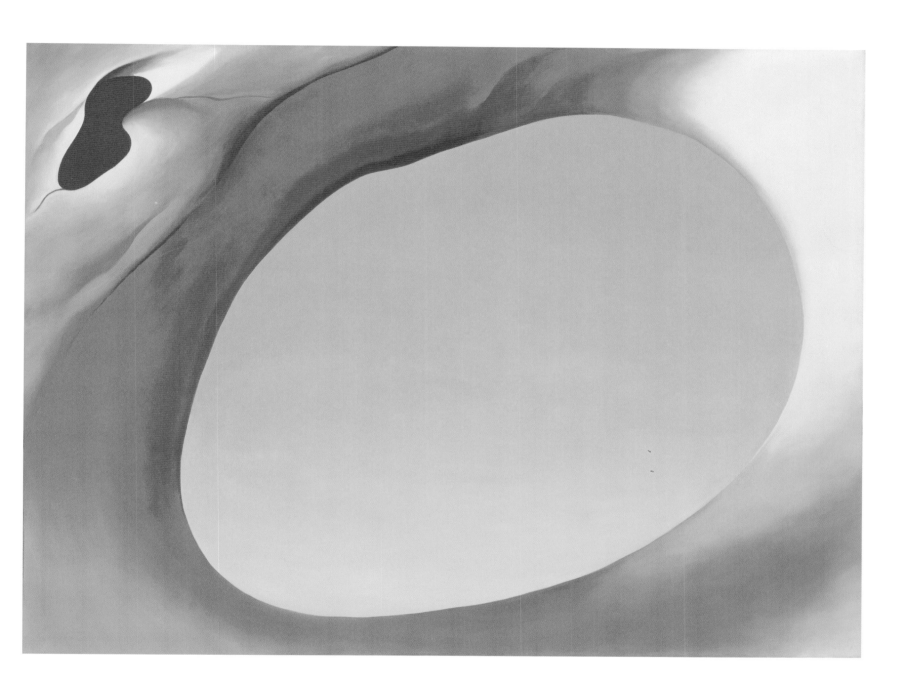

PLATE 163

Pelvis Series, Red with Yellow

1945

Oil on canvas, 36⅛ x 48⅛ (91.8 x 122.2)

Extended loan, private collection

CR 1106

PLATES 164–65

Over the years, O'Keeffe amassed an extensive collection of rocks from a variety of sources. Of some she gathered on a trip, she wrote: "The black rocks from the road to the Glen Canyon dam seem to have become a symbol to me—of the wideness and wonder of the sky and the world. They have lain there for a long time with the sun and wind and the blowing sand making them into something that is precious to the eye and hand—to find with excitement, to treasure and love." (In *Georgia O'Keeffe*, 1976, unpaginated text accompanying entry 107.)

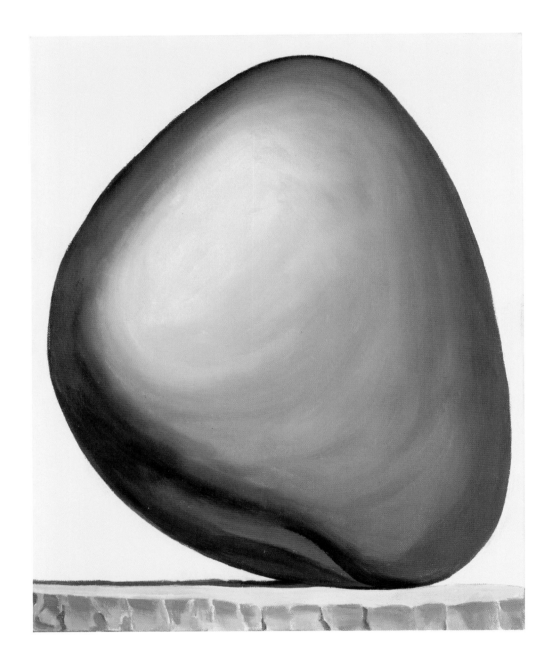

PLATE 164
Black Rock with White Background
1963/1971
Oil on canvas, 20 x 16 (50.8 x 40.6)
Gift, The Georgia O'Keeffe Foundation
CR 1485

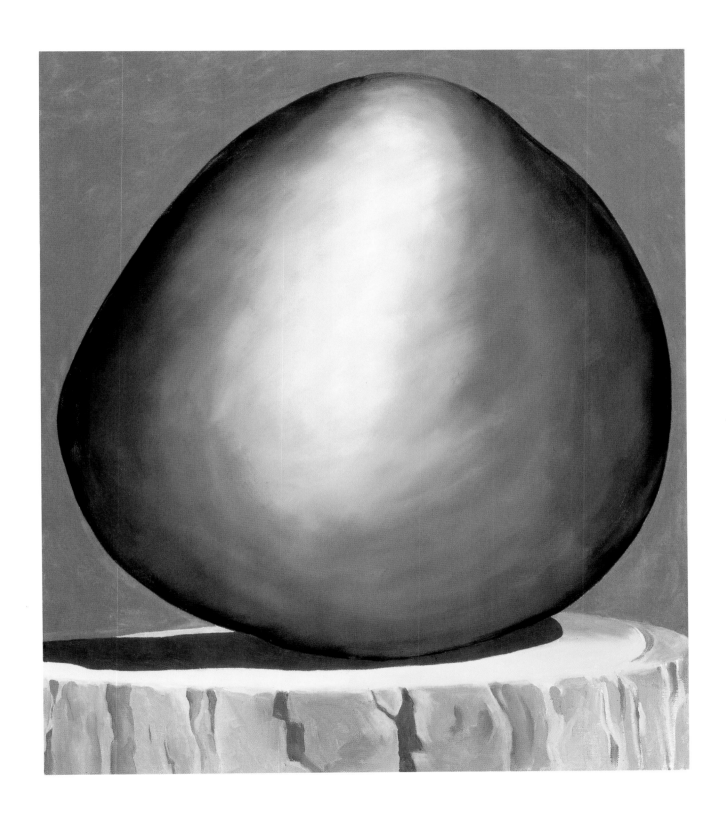

PLATE 165

Black Rock on Red

1971

Oil on canvas, 30 x 26 (76.2 x 66)

Gift, The Burnett Foundation and The Georgia O'Keeffe Foundation

CR 1579

PLATES 166–73

Some of the objects O'Keeffe depicted in still life paintings were not found by her but were gifts from friends. On and off, from the early 1930s to the mid-1940s, she made paintings and drawings of Native American kachina dolls.

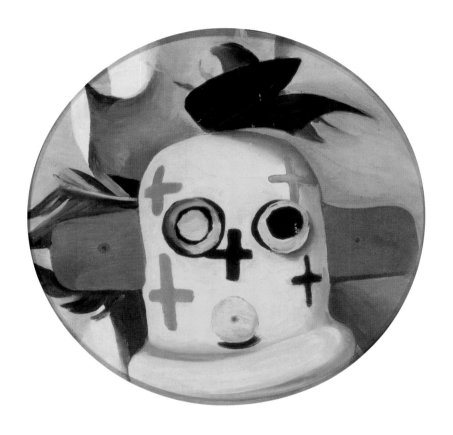

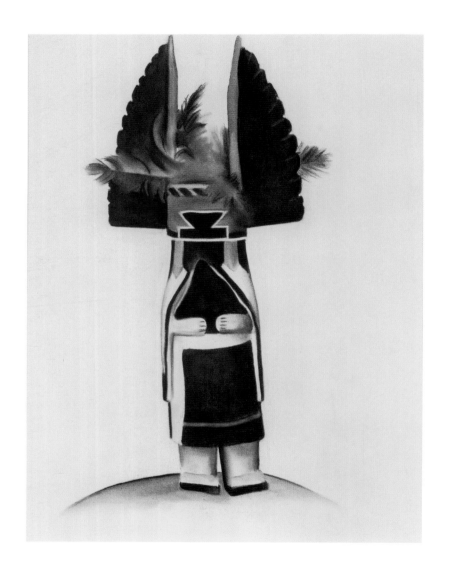

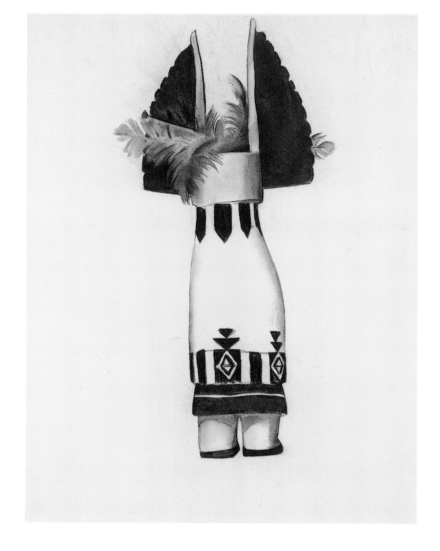

PLATE 167

Kachina

1934

Charcoal on paper, 23⅜ x 19 (60 x 48.3)

Gift, The Georgia O'Keeffe Foundation to honor the opening of
Georgia O'Keeffe Museum

CR 823

PLATE 168

Kachina

1934

Charcoal on paper, 23⅜ x 19 (60 x 48.3)

Gift, The Georgia O'Keeffe Foundation to honor the opening of
Georgia O'Keeffe Museum

CR 824

PLATE 169

Kachina with Horns from Back

1935

Graphite on paper, 8⅞ x 6 (22.5 x 15.2)

Gift, Juan and Anna Marie Hamilton

© Private collection

CR 858

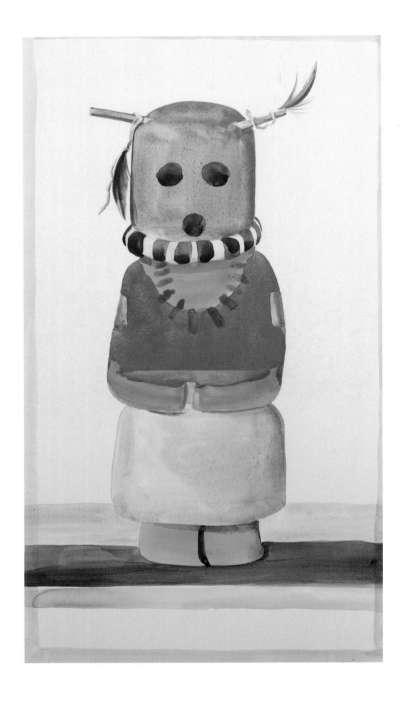

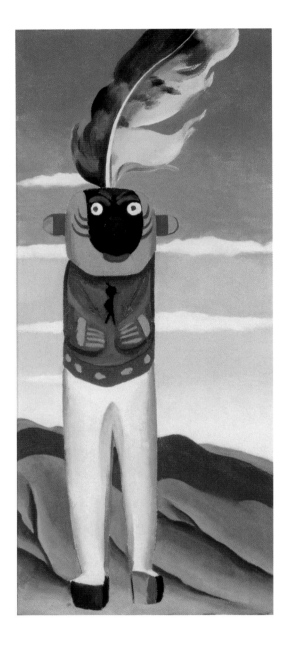

PLATE 170
Blue-Headed Indian Doll
1935
Watercolor and graphite on paper, 21 x 12⅛ (53.3 x 30.8)
Gift, The Burnett Foundation
CR 860

PLATE 171
A Man from the Desert
1941
Oil on canvas, 16 x 7 (40.6 x 17.8)
Gift, The Georgia O'Keeffe Foundation
CR 1015

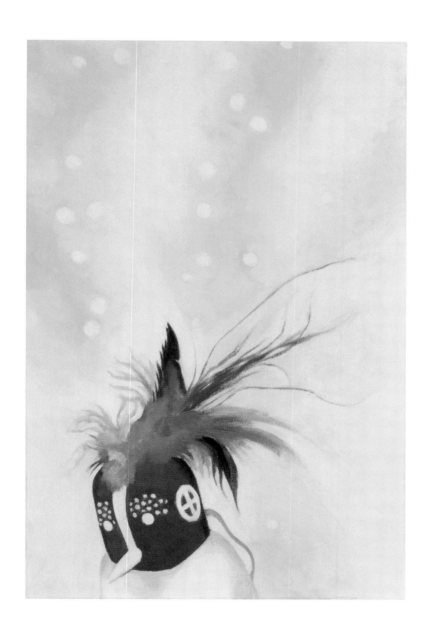

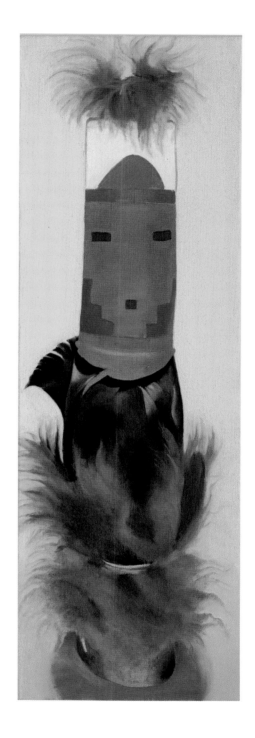

PLATE 172
Kokopelli with Snow
1942
Oil on board, 15⅛ x 10 (38.4 x 25.4)
Gift, The Burnett Foundation and The Georgia O'Keeffe Foundation
CR 1036

PLATE 173
Kachina
1945
Oil on canvas, 24 x 8 (61 x 20.3)
Gift, The Burnett Foundation
CR 1104

In 1942, photographer John Candelario gave O'Keeffe a human skull that she included in *Head with Broken Pot*, 1942. O'Keeffe explained: "[John] brought me a very fine human skull. I was a little shocked when I unwrapped it on the dining room table. It gave me the creeps last night but I feel quite accustomed to it now—washed it this morning made it much whiter and I'll bleach it in the sun." (O'Keeffe to Stieglitz, 20 August 1942, Georgia O'Keeffe/Alfred Stieglitz Archive, Collection of American Literature, Beinecke Rare Book and Manuscript Library, Yale University, New Haven.)

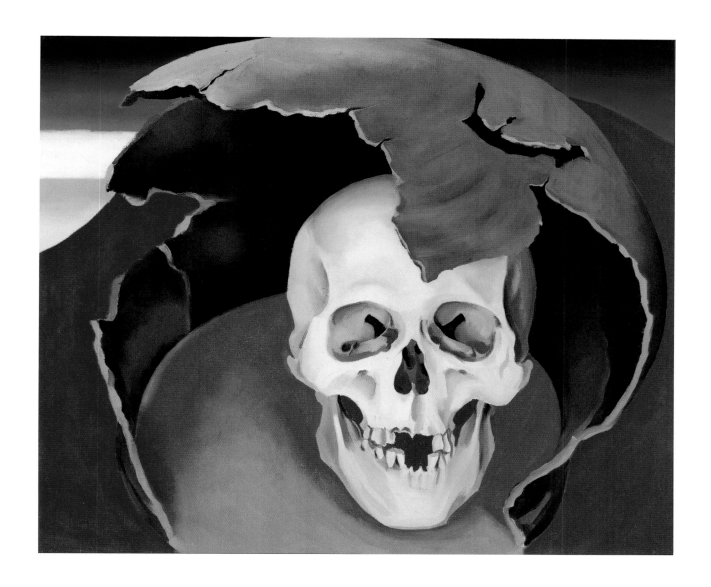

PLATE 174

Head with Broken Pot

1943

Oil on canvas, 16 x 19 (40.6 x 48.3)

Gift, The Stéphane Janssen Trust in memory of R. Michael Johns

CR 1046

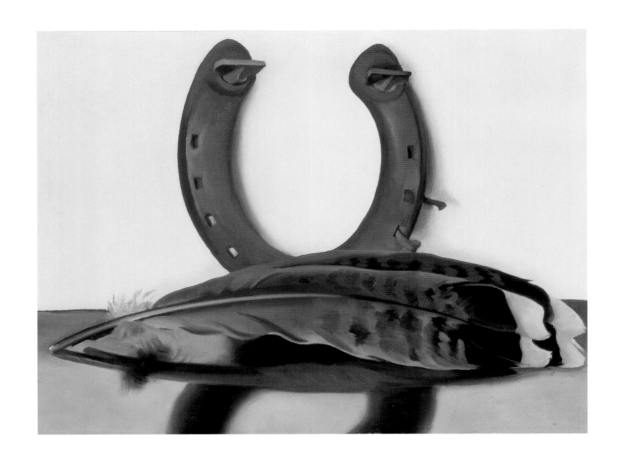

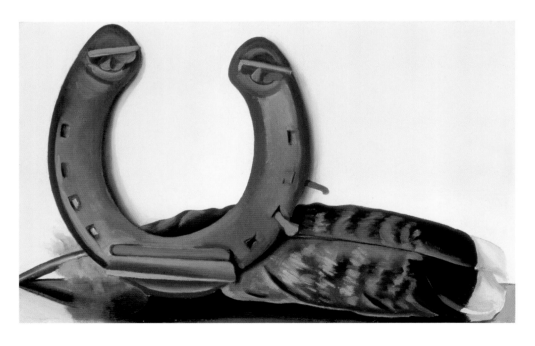




PLATE 175

Turkey Feather with Horseshoe, II

1935

Oil on canvas, 12⅛ x 16 (30.8 x 40.6)

Gift, The Georgia O'Keeffe Foundation

CR 856




PLATE 176

Horseshoe with Feather No. I

1935

Oil on canvas, 8½ x 13½ (21.6 x 34.3)

Gift, The Georgia O'Keeffe Foundation

CR 857




PLATE 177
White Feather
1941
Oil on canvas, 20 x 16 (50.8 x 40.6)
Gift, The Georgia O'Keeffe Foundation
CR 1013

PLATE 178
Feathers, White and Grey
1942
Oil on canvas, 16 x 12 (40.6 x 30.5)
Gift, The Georgia O'Keeffe Foundation
CR 1033

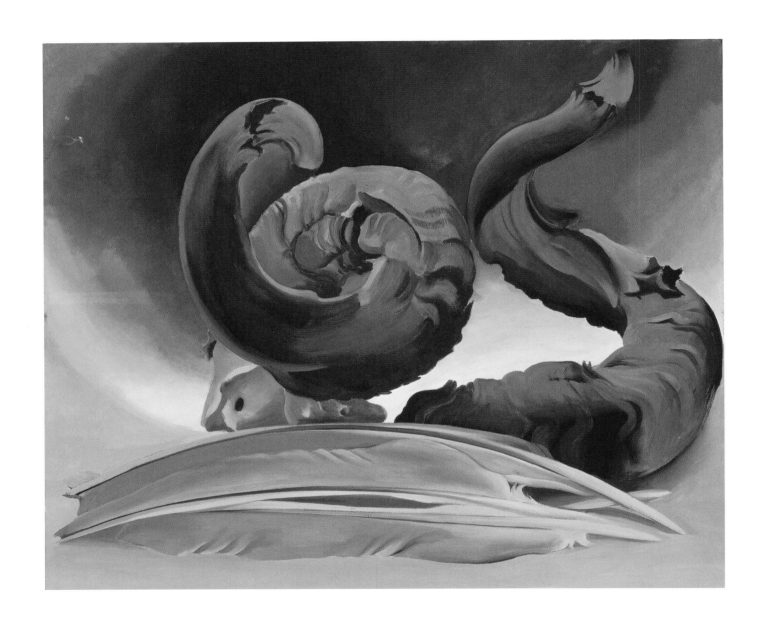

PLATE 179

Horn and Feathers

1937

Oil on canvas, 20 x 24 (50.8 x 61)

Gift, The Georgia O'Keeffe Foundation

CR 916

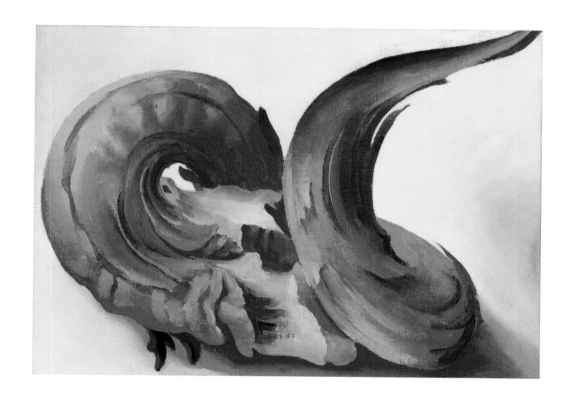

PLATE 180

Horns

1943

Oil on canvas, 9¾ x 13¾ (24.8 x 34.9)

Gift, The Georgia O'Keeffe Foundation

CR 1054

199

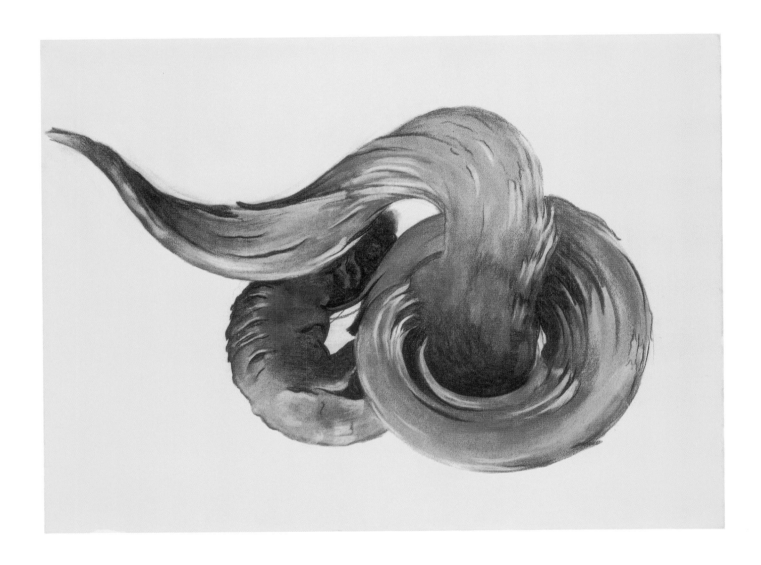

PLATE 181

Ram's Horns I

c. 1949

Charcoal on paper, 18⅞ x 24⅞ (47.3 x 63.2)

Gift, The Georgia O'Keeffe Foundation

CR 1176

200

PLATE 182
Untitled (Antelope Horns)
c. 1952
Graphite and charcoal on paper, 17⅞ x 23⅞ (45.4 x 60.6)
Gift, The Burnett Foundation
© 1987 Private collection

CR 1249

Landscapes

In 1977, O'Keeffe pointed out: "I used to think that somebody could teach me to paint a landscape. I hunted and hunted for that person and finally found that I had to do it myself." (In Tom Zito, "Georgia O'Keeffe: At Home on Ghost Ranch, the Iconoclastic Artist at 90," *Washington Post* [9 November 1977], C1.)

PLATES 183–85

Throughout her life, O'Keeffe depicted the landscape configurations of wherever she was, as if doing so put her in closer touch with the identity of a particular place. Some of her earliest landscapes were completed in Virginia in 1916. They characterize the relative softness of that environment, calling special attention to the contours of the area's rolling hills.

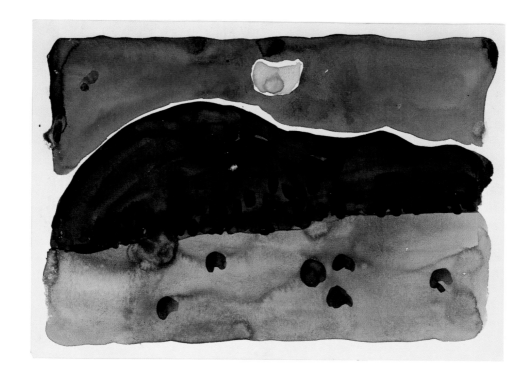

PLATE 183
Evening
1916
Watercolor on paper, 8⅞ x 12 (22.5 x 30.5)
Gift, The Burnett Foundation and The Georgia O'Keeffe Foundation
CR 104

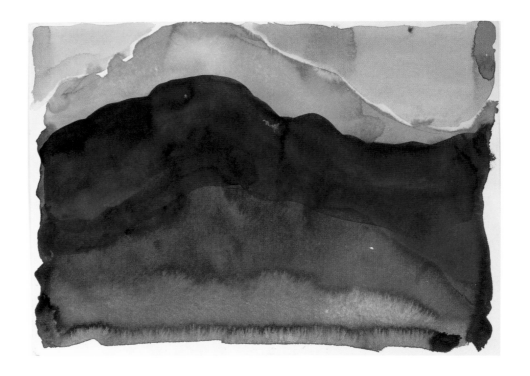

PLATE 184

Pink and Blue Mountain
1916
Watercolor on paper, 8⅞ x 12 (22.5 x 30.5)
Gift, The Burnett Foundation and The Georgia O'Keeffe Foundation
CR 106

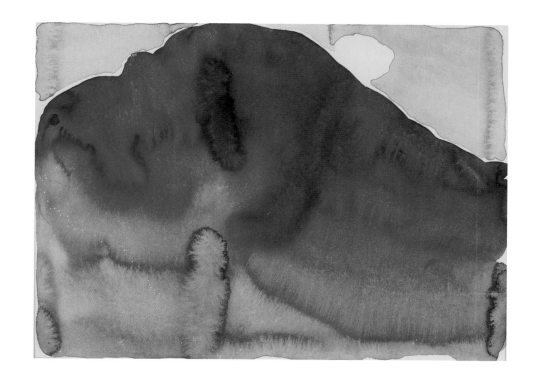

PLATE 185

Blue Hill No. II

1916

Watercolor on paper, 9 x 12 (22.9 x 30.5)

Gift, Dr. and Mrs. John B. Chewning

CR 109

PLATE 186

After her move to Texas that fall, the relationship between land and sky in her work changes. She immediately responded to the flatness of the land and the vastness of the sky, usually giving the sky a dominance not seen in her Virginia paintings. She loved Texas, as she later explained: "I couldn't believe Texas was real. When I arrived out there, there wasn't a blade of green grass or a leaf to be seen, but I was absolutely crazy about it. There wasn't a tree six inches in diameter at that time. For me Texas is the same big wonderful thing that oceans and the highest mountains are." (In Katharine Kuh, *The Artist's Voice: Talks with Seventeen Artists* [New York: Harper & Row, 1960], 189.)

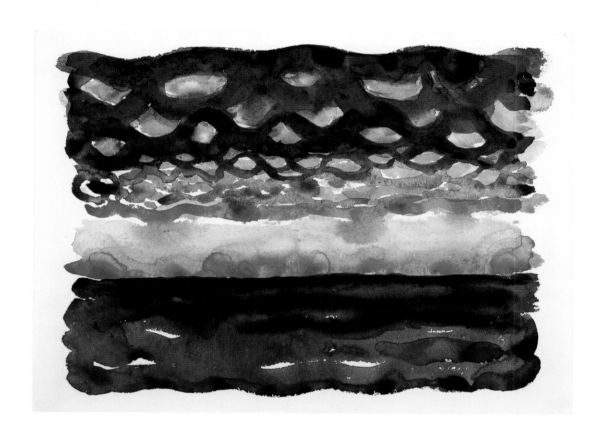

She was also drawn to the unusual configurations of the Palo Duro Canyon, a steep-sided valley not far from where she was living in Canyon, Texas. The canyon's extraordinary colored crevices and cliffs bear an uncanny likeness to those she later discovered at Ghost Ranch in New Mexico, and were a constant source of inspiration in this period.

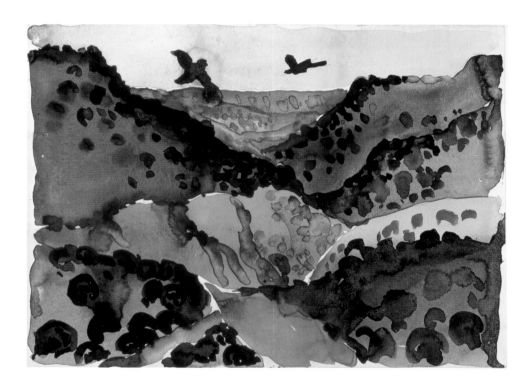

PLATE 187

Canyon with Crows

1917

Watercolor and graphite on paper, 8⅞ x 12 (22.5 x 30.5)

Promised gift, The Burnett Foundation

© 1987 Private collection

CR 197

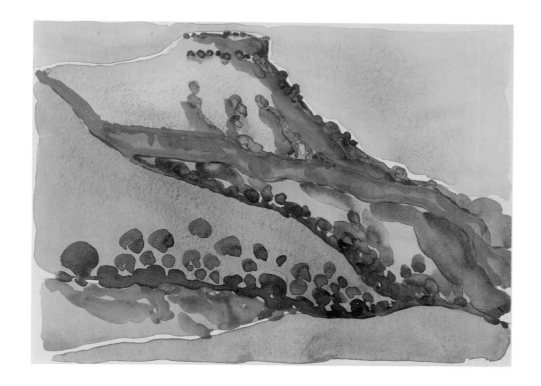

PLATE 188

Red Mesa

1917

Watercolor and graphite on paper, 8¾ x 12 (22.2 x 30.5)

Extended loan, Juan and Anna Marie Hamilton

© 1987 Private collection

CR 198

In Texas, O'Keeffe worked both in oil and watercolor, and the gestural brushwork and color in her oil paintings speak to her awareness of the work of modernist American and European painters who used active brushwork and color as expressive rather than descriptive devices.

PLATE 189
Untitled (Study for No. 24 — Special)
1916/1917
Graphite on paper, 4 x 5¼ (10.2 x 13.3)
Gift, The Georgia O'Keeffe Foundation
CR 163

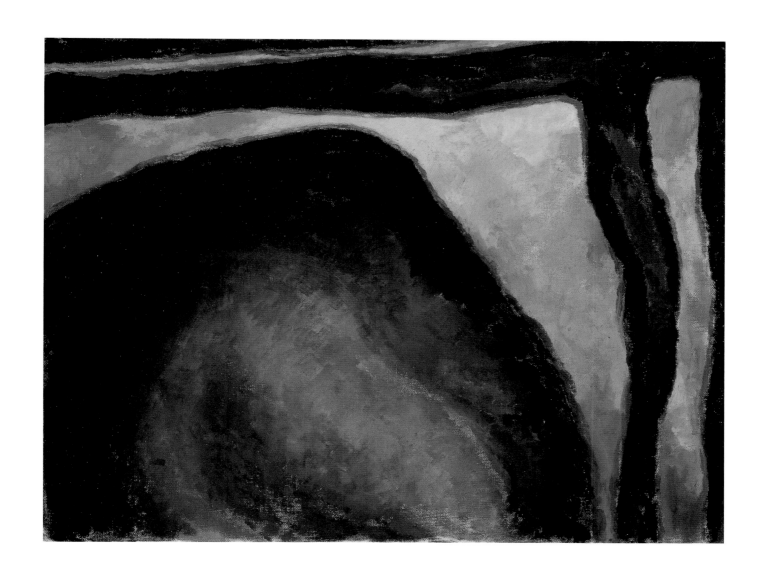

PLATE 190

No. 24 — Special/No. 24

1916/1917

Oil on canvas, 18¼ x 24 (46.3 x 61)

Gift, The Georgia O'Keeffe Foundation

CR 166

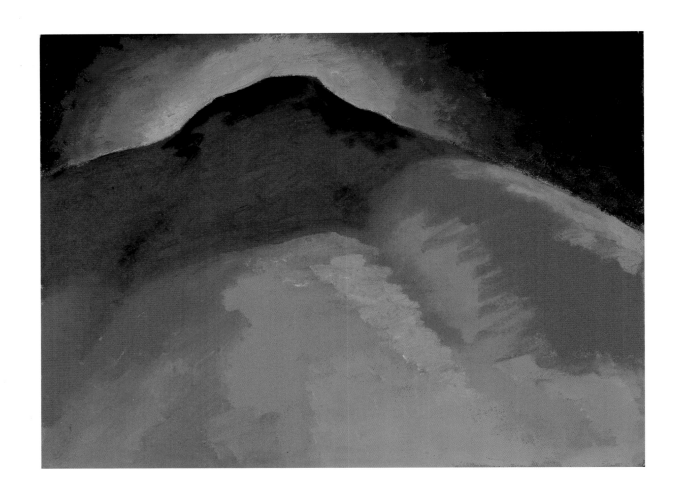

PLATE 191

No. 22 — Special
1916/1917
Oil on board, 13⅛ x 17¼ (33.3 x 43.8)
Gift, The Burnett Foundation and The Georgia O'Keeffe Foundation
CR 160

By the summer of 1917, O'Keeffe was working almost exclusively with watercolor, and in this period she produced some of the most astonishingly innovative paintings of her entire career. Using only primary colors or limiting her palette to a single hue, she pitted the fluidity of the medium against small areas of unpainted paper. The contrast between these two elements in the paintings creates dynamic rhythms that activate and enliven the pictorial surface.

These works are her response to starlight and waning sunlight in the Texas skies. As she pointed out: "The evening star would be high in the sunset sky when it was still broad daylight. That evening star fascinated me. . . . I had nothing but to walk into nowhere and the wide sunset space with the star. Ten watercolors were made from that star." (In *Georgia O'Keeffe*, 1976, unpaginated text accompanying entry 6.)

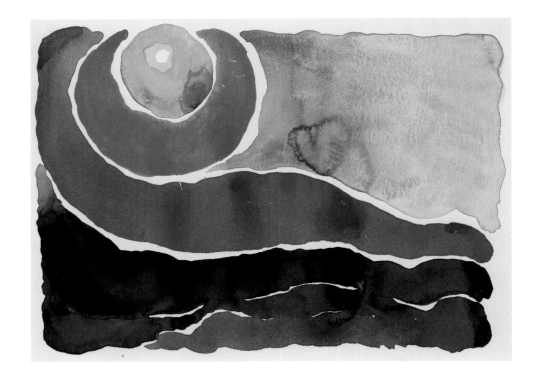

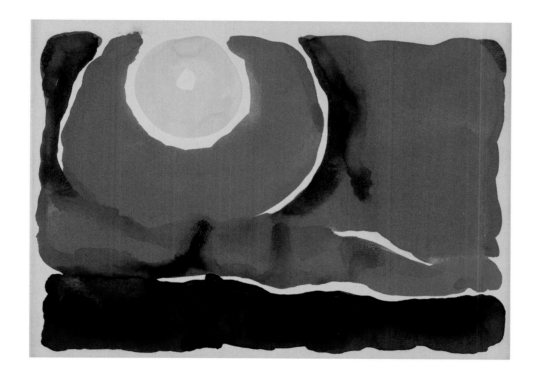

PLATE 193

Evening Star No. VI

1917

Watercolor on paper, 8⅞ x 12 (22.5 x 30.5)

Gift, The Burnett Foundation

CR 204

217

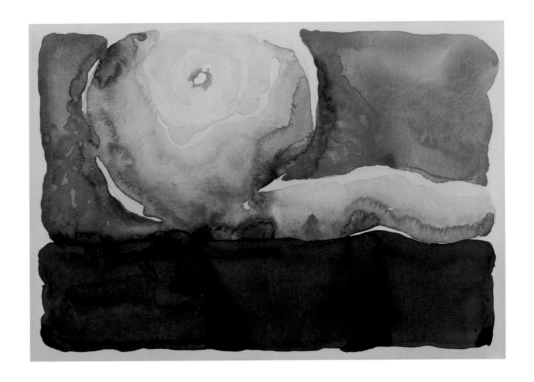

PLATE 194

Evening Star No. VII

1917

Watercolor on paper, 8⅞ x 11⅞ (22.5 x 30.2)

Gift, The Burnett Foundation

CR 205

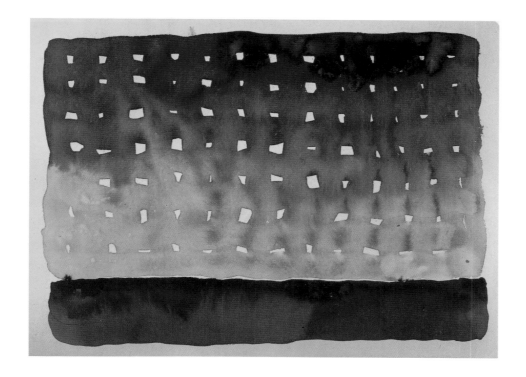

PLATE 195

Starlight Night

1917

Watercolor and graphite on paper, 8⅞ x 11¼ (22.5 x 29.8)

Promised gift, The Burnett Foundation

© 1987 Private collection

CR 207

PLATE 196

When O'Keeffe was living in New York between 1918 and 1929, she painted landscapes less frequently than when she was in Texas. *Storm Cloud, Lake George* is unusual in that O'Keeffe's paintings rarely address the phenomenon of weather. Here rolling clouds move across the sky to press down on the land and water, conveying a sense of closeness both characteristic of upstate New York and in direct contrast with the open landscapes of northwestern Texas.

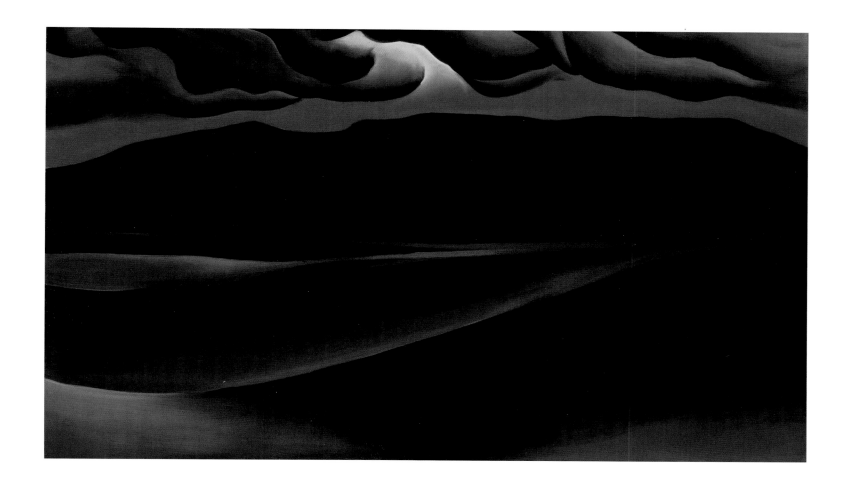

PLATE 196
Storm Cloud, Lake George
1923
Oil on canvas, 18 x 30⅛ (45.7 x 76.5)
Promised gift, The Burnett Foundation

CR 437

In early summer 1929, O'Keeffe traveled from New York to northern New Mexico, having first seen the area in 1917, when she returned to Texas from a vacation in Colorado. As she later explained: "When I got to New Mexico that was mine. As soon as I saw it that was my country. I'd never seen anything like it before, but it fitted to me exactly. It's something that's in the air, it's different. The sky is different, the wind is different. I shouldn't say too much about it because other people may be interested and I don't want them interested." (In Perry Miller Adato, *Georgia O'Keeffe*, film.)

O'Keeffe spent the summers of 1929 and 1930 in Taos, exploring areas to the south by car. She sketched and painted the sand hills and majestic mountains in and around Alcalde and Abiquiu, and in 1931, she stayed in Alcalde.



PLATE 197

Hill and Mesa—Alcalde III

1929

Graphite on paper, 8 x 11⅝ (20.3 x 29.5)

Gift, Juan and Anna Marie Hamilton

© Private collection

CR 681

PLATE 198

Hill—Alcalde I

1929/1930

Graphite on paper, 8 x 11⅝ (20.3 x 29.5)

Gift, Juan and Anna Marie Hamilton

© Private collection

CR 693



PLATE 199
Untitled (New Mexico Landscape)
1930
Graphite on paper, 12 x 17⅞ (30.5 x 45.4)
Gift, Mr. and Mrs. Eugene V. Thaw

CR 733

224

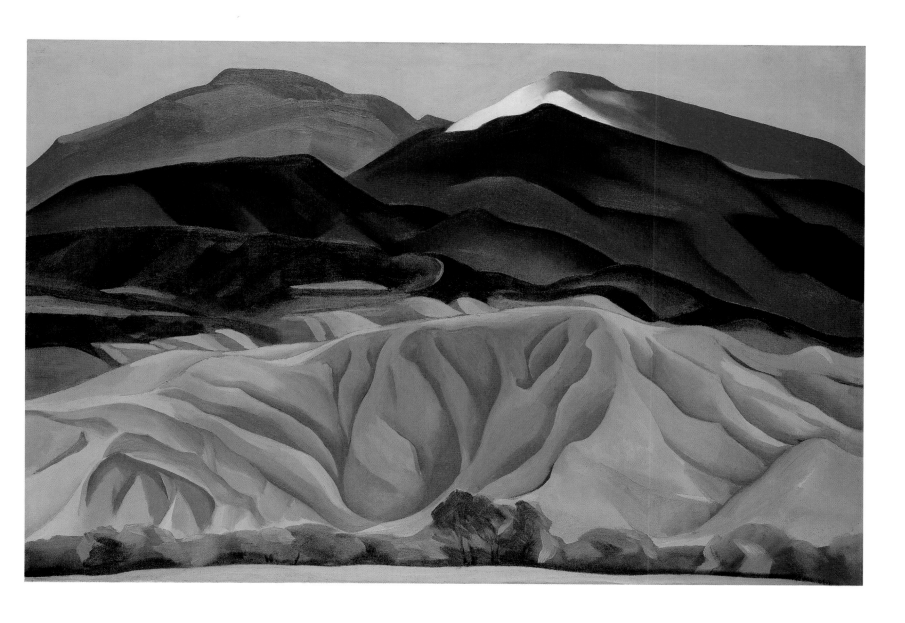

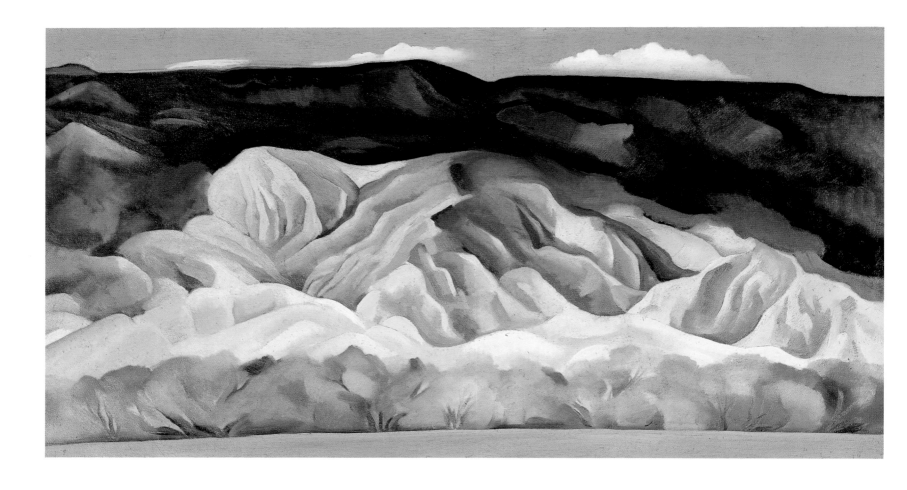

PLATE 201
Back of Marie's No. 4
1931
Oil on canvas, 16 x 30 (40.6 x 76.2)
Gift, The Burnett Foundation

CR 793

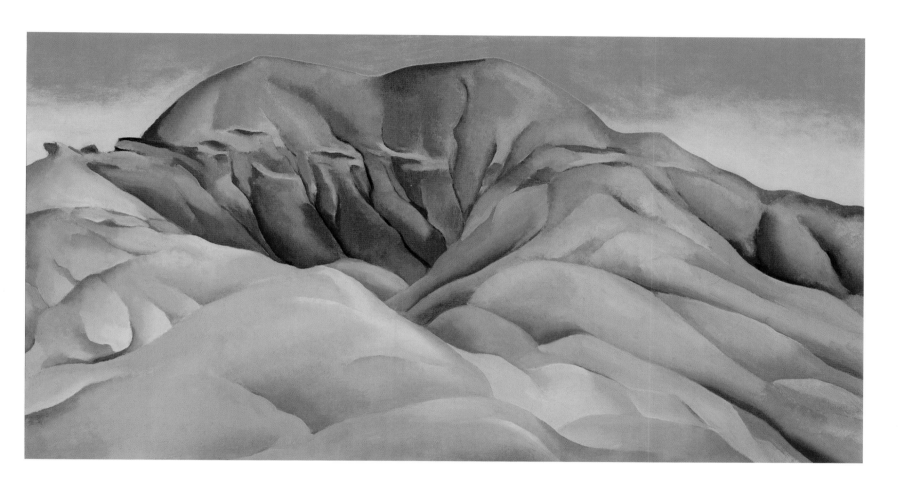

PLATE 202

On the Old Santa Fe Road

1930/1931

Oil on canvas, 16 x 30 (40.6 x 76.2)

Promised gift, The Burnett Foundation

CR 751

Illness and other concerns prevented O'Keeffe from returning to New Mexico in 1932 and 1933; in 1934 she discovered Ghost Ranch. She would live and work in rented accommodations there until 1940, when she purchased a house on the property from the owner which was surrounded by the extraordinary colors and dramatic landscape configurations that she often painted.

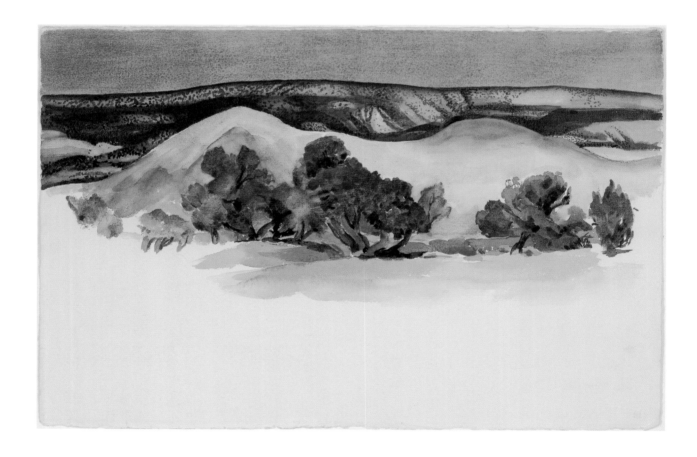

PLATE 203
Untitled (Ghost Ranch Landscape)
c. 1936
Watercolor on paper, 15 x 22¼ (38.1 x 57.8)
Gift, The Burnett Foundation
© 1987 Private collection
CR 910

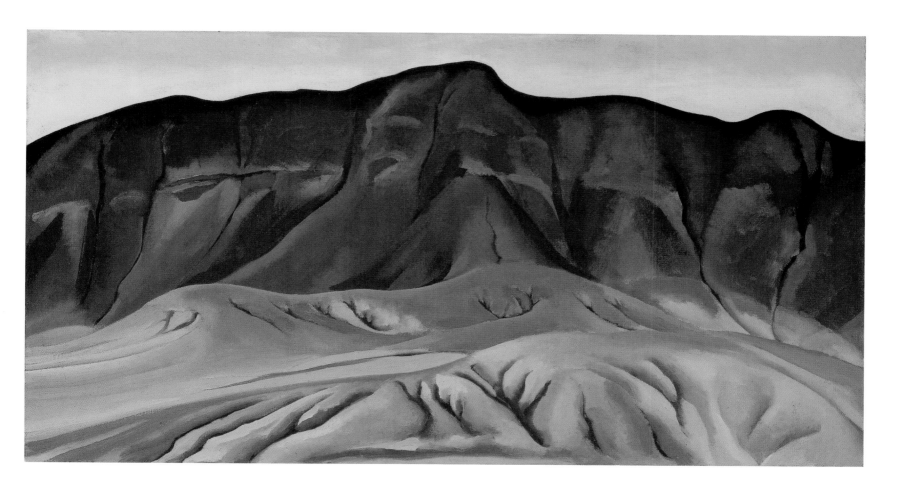

PLATE 205

As she pointed out: "A red hill doesn't touch everyone's heart as it touches mine . . . and I suppose there is no reason why it should. The red hill is a piece of the bad lands where even the grass is gone. Bad lands roll away from my door, hill after hill—red hills of apparently the same sort of earth that you mix with oil to make paint. All the earth colors of the painter's palette are out there in the many miles of bad lands. The light Naples yellow through the ochres—orange and red and purple earth—even the soft earth greens. You have no association with those hills—our waste land—I think our most beautiful country—you may not have seen it, so you want me always to paint flowers." (In Henry McBride, "The Palette Knife," *Creative Art* 8, no. 2 [February 1931]: supp. 45.)

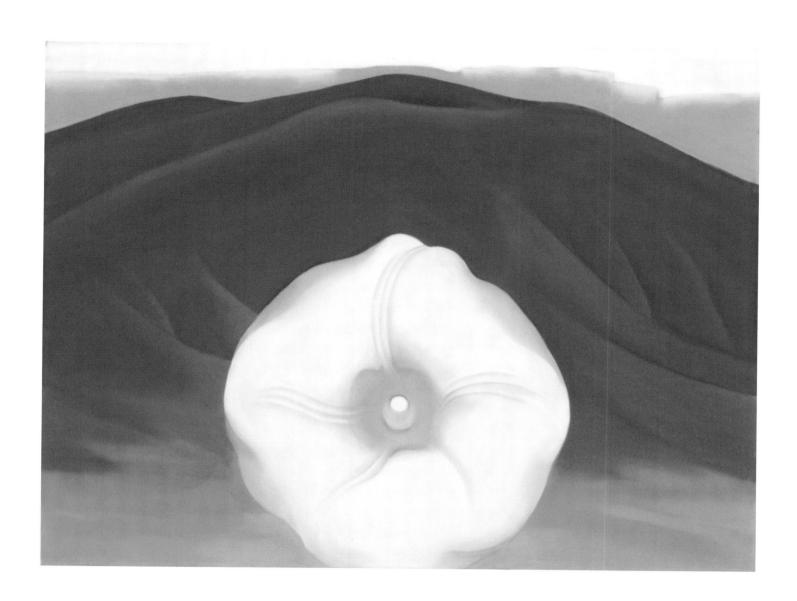

PLATES 206–10

These are drawings and paintings of two of the landscape configurations at Ghost Ranch in what O'Keeffe called her "backyard." The cliffs in *Untitled (Red and Yellow Cliffs)* dominate the composition, allowing almost no room for areas of sky. This implies that the viewer is very close to them, but in order to see the green trees near the lower edge of the painting in the scale and proportion in which they occur in the painting, the viewer must be very far away from the cliffs. Thus, O'Keeffe combined two very different points of view into a single painting whose spaces are both close and distant, or as she called it, the "faraway nearby." The result is a composition in which there is essentially no spatial depth—a phenomenon often seen in photography and that characterizes many of O'Keeffe's New Mexico landscapes.

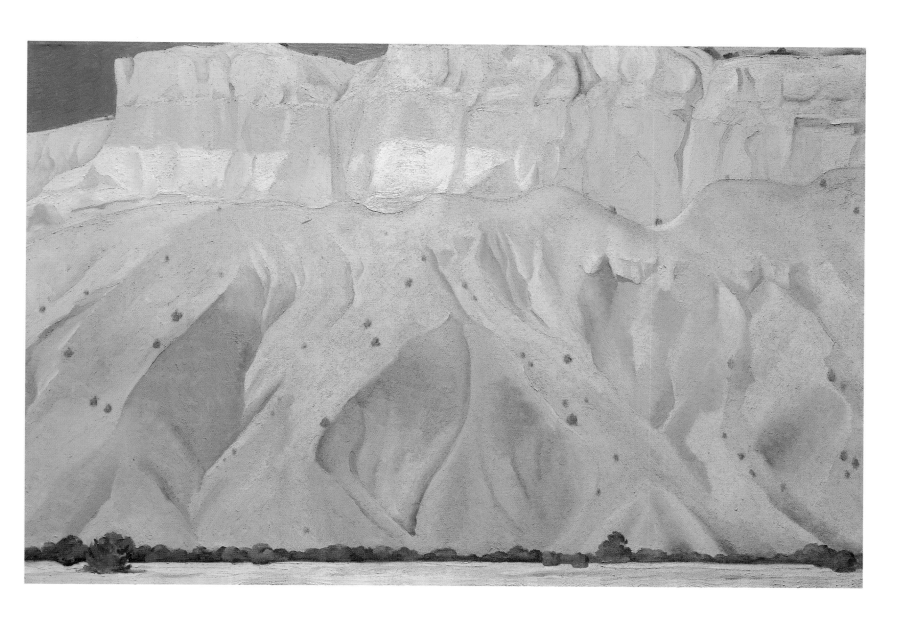

PLATE 206
Untitled (Red and Yellow Cliffs)
1940
Oil on canvas, 24 x 36 (61 x 91.4)
Gift, The Burnett Foundation

CR 998

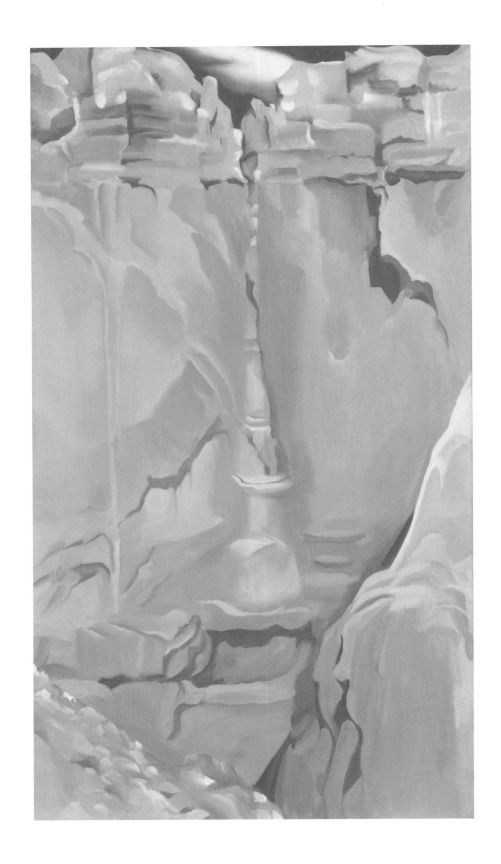

PLATE 208
Untitled (Dry Waterfall, Ghost Ranch)
c. 1943
Graphite and charcoal on paper, 23⅞ x 17⅞ (60.6 x 45.4)
Gift, The Burnett Foundation
© 1987 Private collection
CR 1071

PLATES 211—19

Pedernal, the flint-topped mountain that looms in the distance directly in front of the patio of O'Keeffe's Ghost Ranch house, became to O'Keeffe what Mont Sainte-Victoire was to Paul Cézanne. She made an extensive series of drawings and paintings of it. As she pointed out: "In front of my house there are low scrub brushes and cottonwood trees and, further out, a line of hills. And then I have this mountain. A flat-top mountain that slopes off on each side. A blue mountain. And to the left you can see snow covered mountains, far, far away." (In Carol Taylor, "Lady Dynamo—Miss O'Keeffe, Noted Artist, Is a Feminist," *New York World Telegram* [31 March 1945]: section 2, p. 9.) And later, she claimed: "It's my mountain." (In Ralph Looney, "Georgia O'Keeffe," *The Atlantic* 215, no. 4 [April 1965]: 110.)

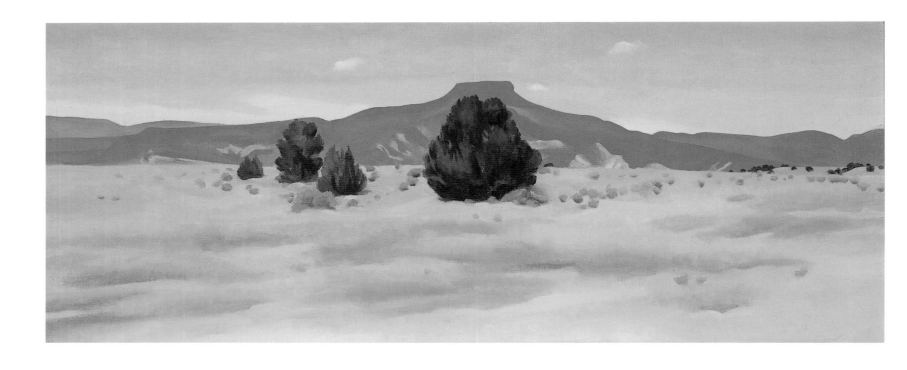

PLATE 211

Ghost Ranch Landscape

c. 1936

Oil on canvas, 12 x 30 (30.5 x 76.2)

Gift, Jerome M. Westheimer, Sr.

CR 912

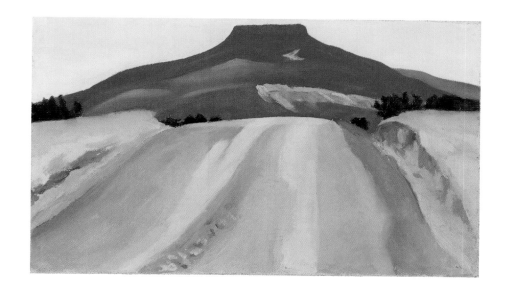

PLATE 212

Road to Pedernal

1941

Oil on canvas, 6⅛ x 10 (15.5 x 25.4)

Gift, The Georgia O'Keeffe Foundation

CR 1020

PLATE 213

Untitled (Road to Pedernal)

1941

Graphite on paper, 6 x 10 (15.2 x 25.4)

Gift, The Georgia O'Keeffe Foundation

CR 1019

239

PLATE 214

Untitled (Pedernal)

1941

Oil on board, 7 x 16 (17.8 x 40.6)

Gift, The Georgia O'Keeffe Foundation

CR 1021

240

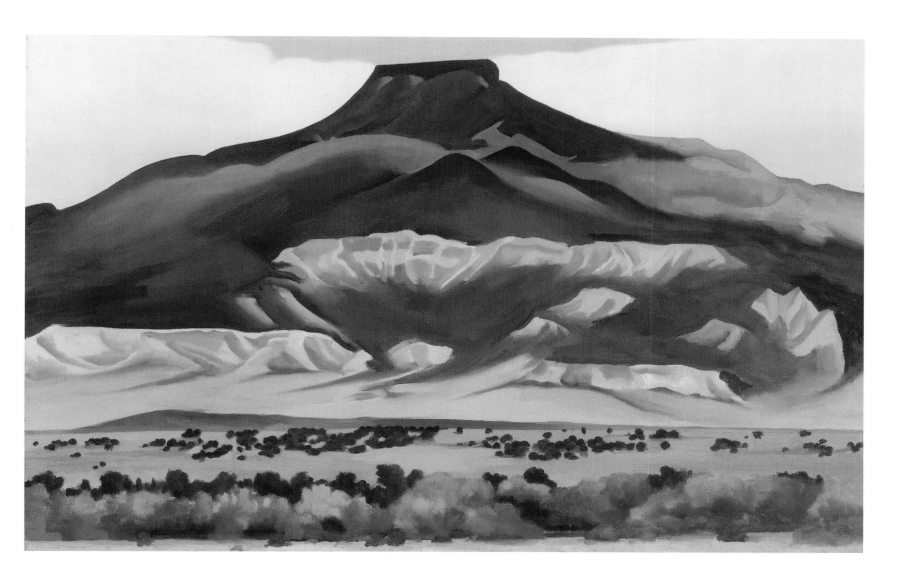

PLATE 215
Pedernal
1941
Oil on canvas, 19 x 30¼ (48.3 x 76.8)
Gift, The Georgia O'Keeffe Foundation

CR 1022

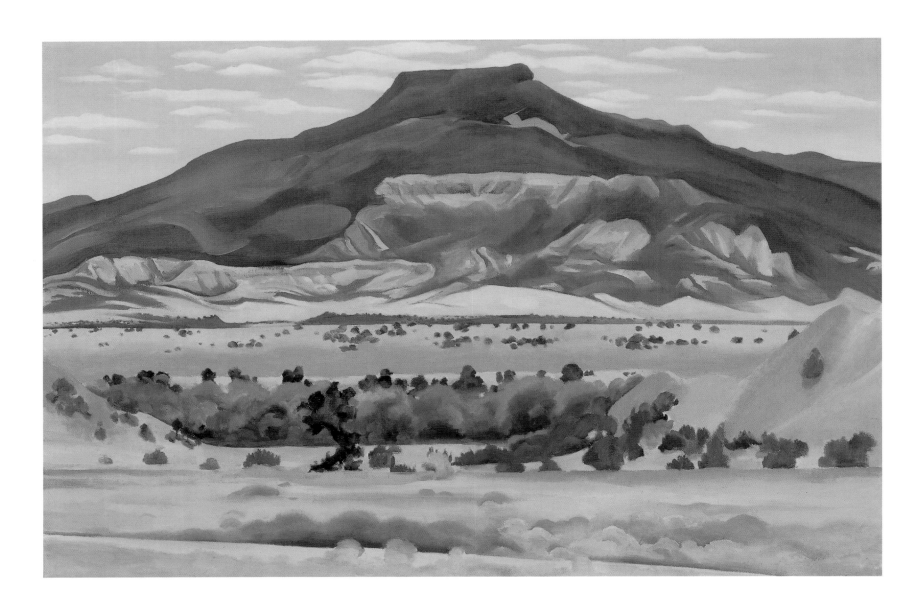

PLATE 216

My Front Yard, Summer

1941

Oil on canvas, 20 x 30 (50.8 x 76.2)

Gift, The Georgia O'Keeffe Foundation

CR 1023

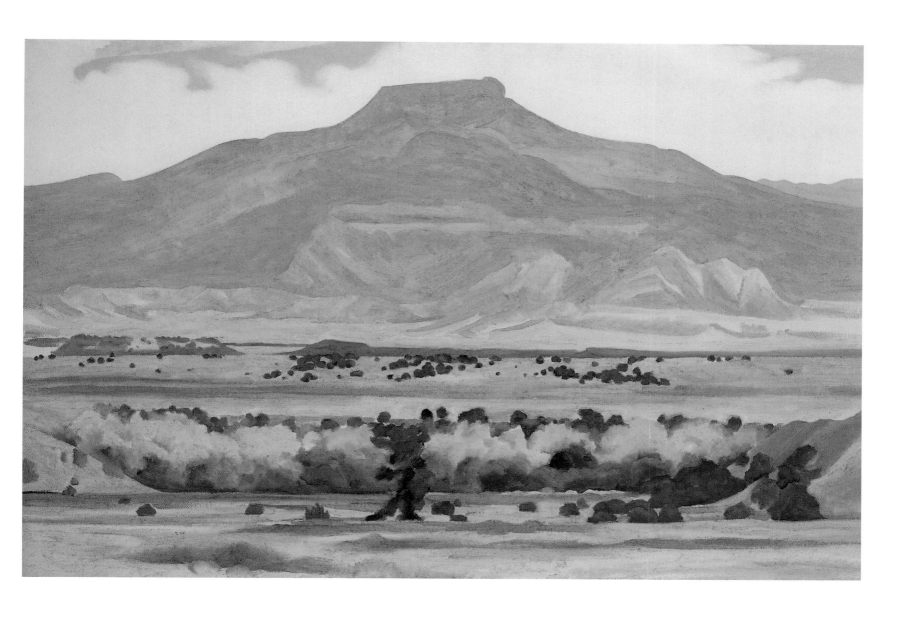

PLATE 217

Pedernal

1941/1942

Oil on canvas, 20⅛ x 30¼ (51.1 x 76.8)

Gift, The Burnett Foundation and The Georgia O'Keeffe Foundation

CR 1029

243

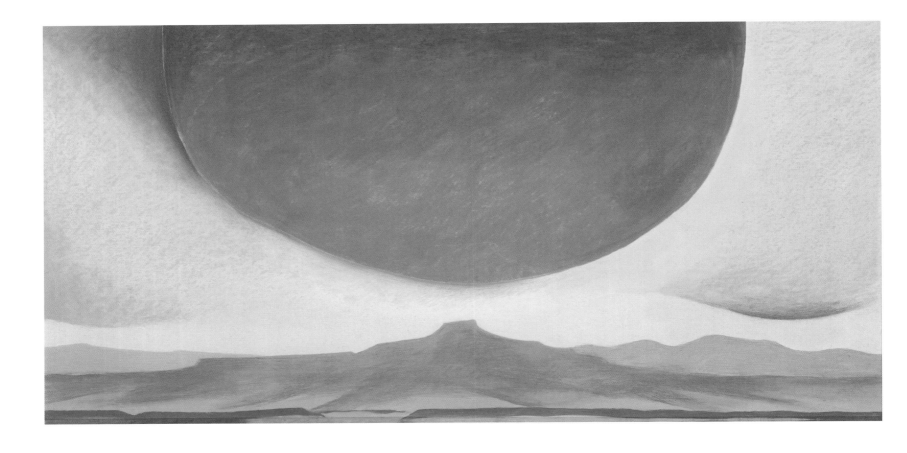

PLATE 218

Pedernal

1945
Pastel on paper, 21½ x 43¼ (54.6 x 109.9)
Gift, The Burnett Foundation
© 1987 Private collection

CR 1117

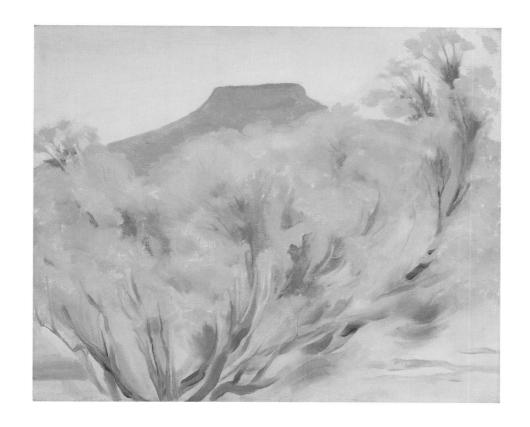

PLATE 219
Cottonwood and Pedernal
1948
Oil on canvas, 10 x 12 (25.4 x 30.5)
Gift, The Georgia O'Keeffe Foundation
CR 1165

245

O'Keeffe also commented on the source of a series of drawings and paintings of the land-scape configurations she later made in Abiquiu in the 1950s, a subject she had photographed in the 1950s (plate 299), and that she also addressed several decades later in both charcoal and watercolor drawings such as *Mesa with Branch Outline* and *Untitled (Landscape)*, 1978. She wrote: "Two walls of my room in the Abiquiu house are glass and from one window I see the road towards Española, Santa Fe and the world. The road fascinates me with its ups and downs and finally its wide sweep as it speeds toward the wall of my hilltop to go past me." (In *Georgia O'Keeffe*, 1976, unpaginated text accompanying entry 104.)

PLATE 220
Untitled (Mesa)
c. 1952
Graphite on paper, 5 x 8 (12.7 x 20.3)
Gift, The Georgia O'Keeffe Foundation
CR 1253

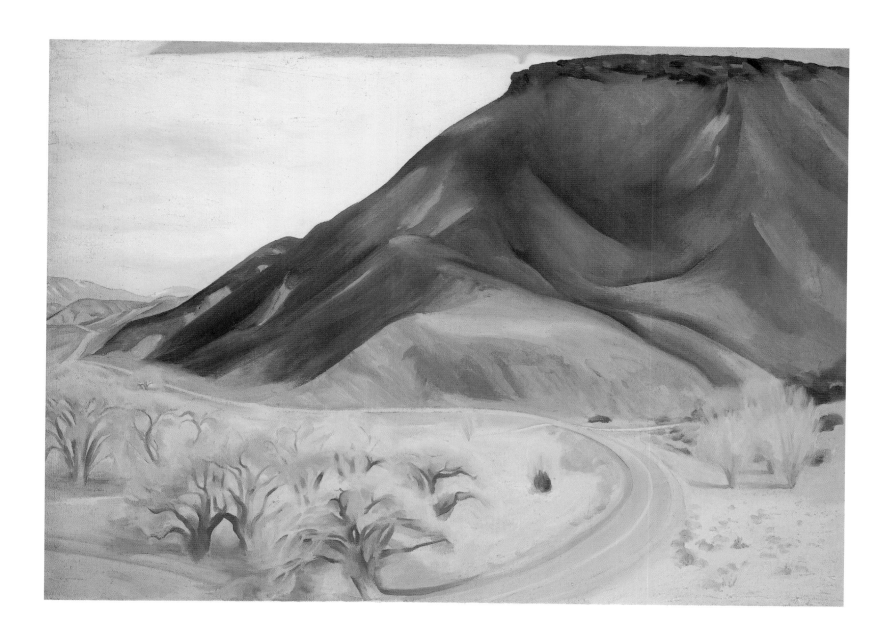

PLATE 221

Mesa and Road East

1952

Oil on canvas, 26 x 36 (66 x 91.4)

Gift, The Georgia O'Keeffe Foundation

CR 1234

247

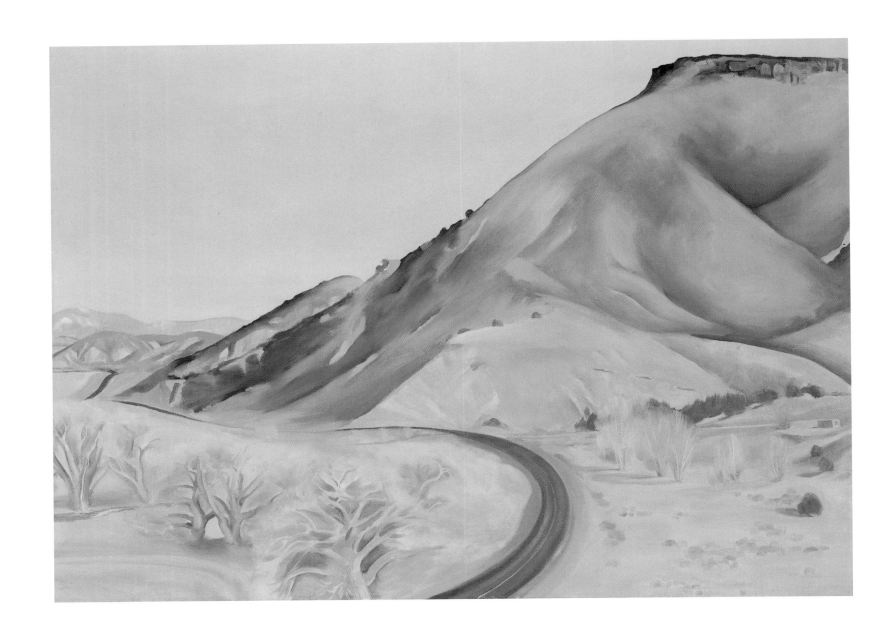

PLATE 222

Mesa and Road East II

1952

Oil on canvas, 26 x 36 (66 x 91.4)

Gift, The Georgia O'Keeffe Foundation

CR 1235

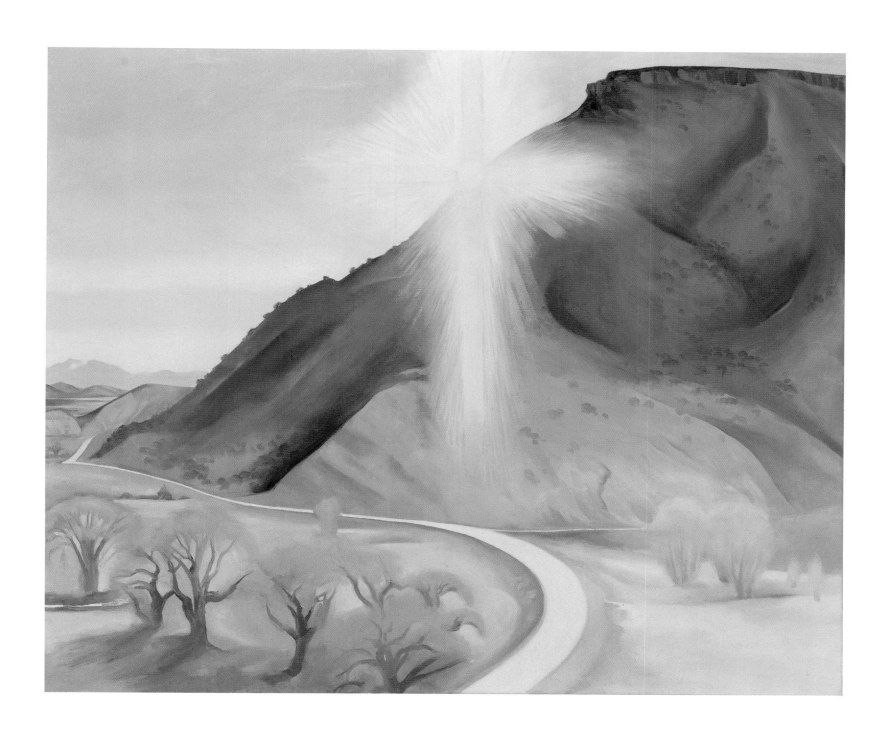

PLATE 223

Easter Sunrise

1953

Oil on canvas, 30 x 36 (76.2 x 91.4)

Gift, The Georgia O'Keeffe Foundation

CR 1266

PLATE 224

Mesa with Branch Outline

1978

Charcoal on paper, 24⅓ x 18¼ (62.2 x 46.4)

Gift, The Georgia O'Keeffe Foundation

CR 1633

250

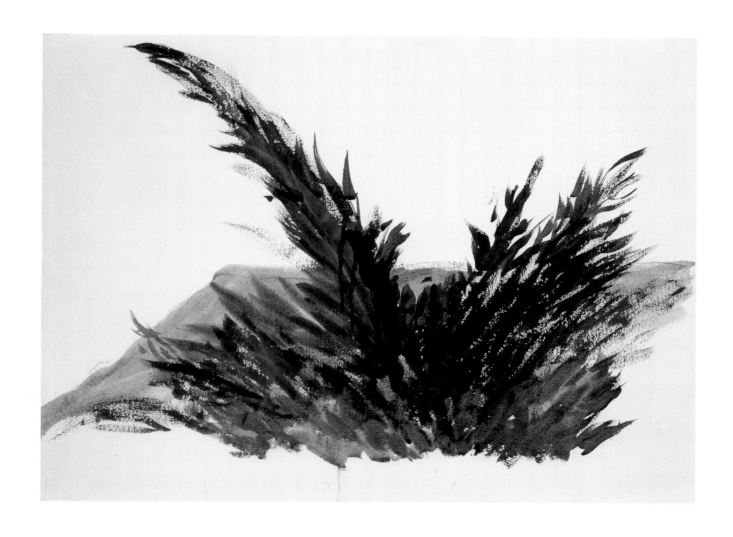

PLATE 225
Untitled (Landscape)
1978
Watercolor on paper, 22¼ x 30½ (56.5 x 77.5)
Gift, The Georgia O'Keeffe Foundation
CR 1637

251

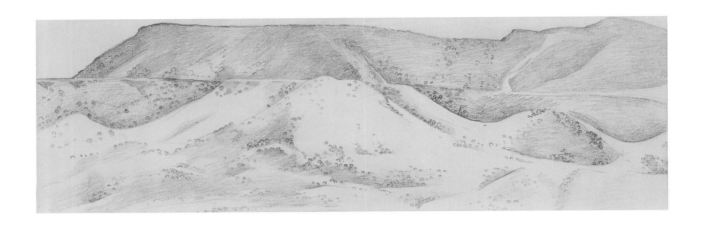

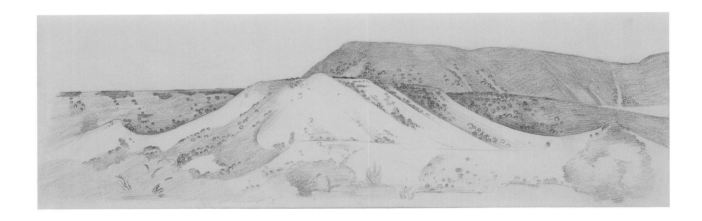

PLATE 226
Abiquiu Mesa I
c. 1944/1945
Graphite on paper, 5⅝ x 17½ (14.3 x 44.5)
Gift, The Burnett Foundation and The Georgia O'Keeffe Foundation
CR 1091

PLATE 227
Abiquiu Mesa II
c. 1944/1945
Graphite on paper, 5¼ x 17⅛ (14.6 x 44.1)
Gift, The Burnett Foundation and The Georgia O'Keeffe Foundation
CR 1092

Although paintings such as *Mesa and Road East* (plate 221) appear to be more or less faithful records of what O'Keeffe saw, some paintings in this and earlier periods are unapologetically abstract, as are *Black Place III* and *Black Place, Grey and Pink* (plates 231–32). This is also true of most of her landscape paintings dating from the late 1950s and 1960s, such as *Peruvian Landscape*, 1956/1957 and *Canyon Country, White and Brown Cliffs*, c. 1965 (plates 235, 246). In fact, O'Keeffe's late-career landscape paintings are far more abstract than they are representational, as can be seen if one compares photographs of the sites with the paintings that resulted. (See Barbara Buhler Lynes, "Georgia O'Keeffe and New Mexico: A Sense of Place," in *O'Keeffe and New Mexico: A Sense of Place* [Princeton: Princeton University Press, 2004], 11–58.)

Late in her career, she found that some of the abstract shapes that she had first explored in her abstractions of the 1910s occurred naturally in certain landscape configurations—particularly those she had discovered in New Mexico. For example, the central V-shape of *Black Place III* recalls that of *Blue and Green Music*, 1921 (fig. 3). As she said about New Mexico: "It was all so far away. . . . There was a quiet and an untouched feel to the country. . . . And I could work as I pleased!" (In "Wonderful Emptiness," *Time* 76, no. 17 [24 October 1960]: 77.)

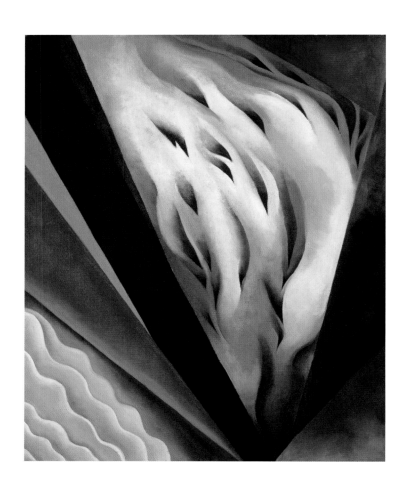

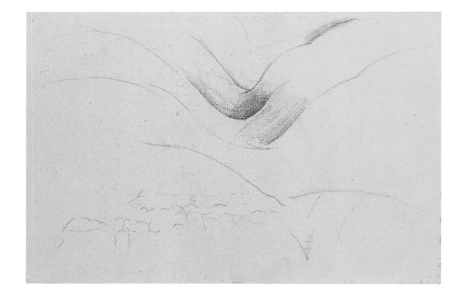

Figure 3
Blue and Green Music
1921
Oil on canvas, 23 x 19 (58.4 x 48.3)
The Art Institute of Chicago, Alfred Stieglitz Collection
Gift of Georgia O'Keeffe
CR 344

PLATE 228
Untitled (Black Place)
c. 1944/1945
Graphite on paper, 7⅝ x 11⅜ (19.4 x 28.9)
Gift, The Georgia O'Keeffe Foundation
CR 1098

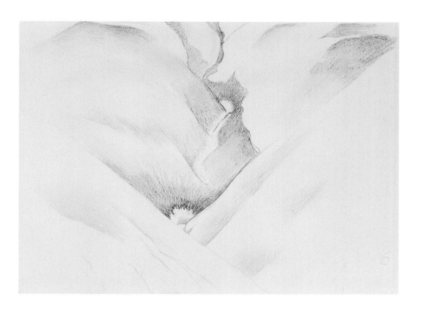

PLATE 229
Untitled (Black Place)
c. 1944/1945
Graphite on paper, 7¼ x 9¼ (18.4 x 23.5)
Gift, The Georgia O'Keeffe Foundation
CR 1101

PLATE 230
Untitled (Black Place)
c. 1944/1945
Graphite on paper, 7⅝ x 11⅜ (19.4 x 28.9)
Gift, The Georgia O'Keeffe Foundation
CR 1099

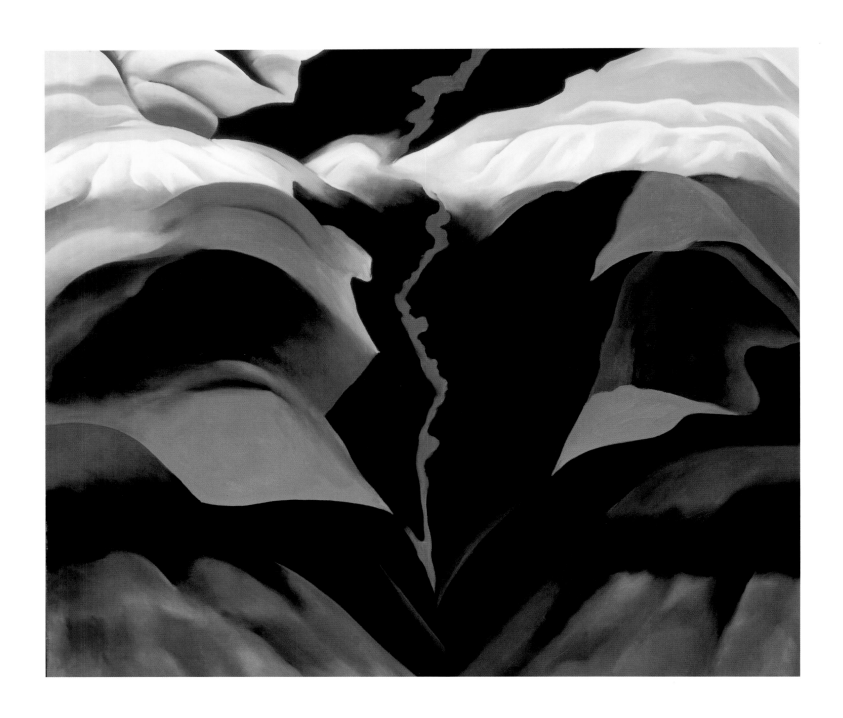

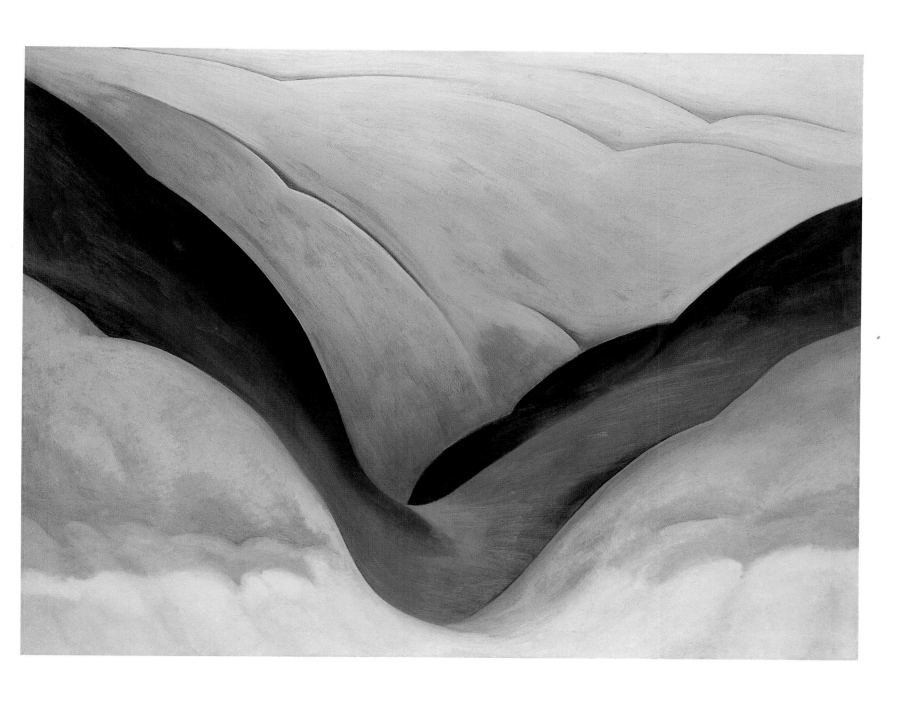

PLATE 232

Black Place, Grey and Pink
1949
Oil on canvas, 36 x 48 (91.4 x 121.9)
Gift, The Burnett Foundation

CR 1173

257

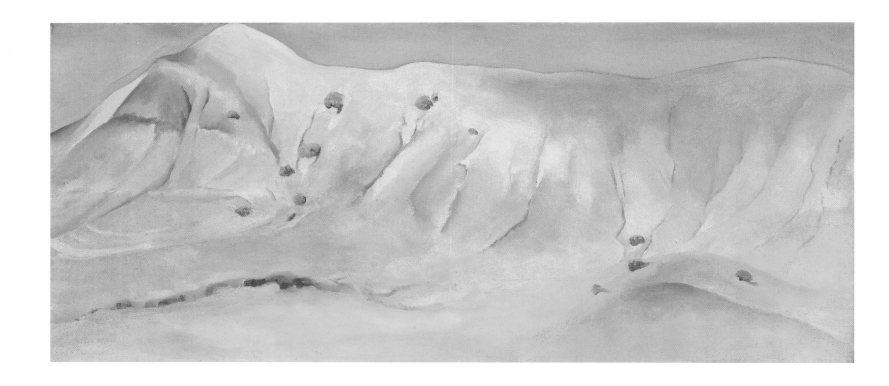

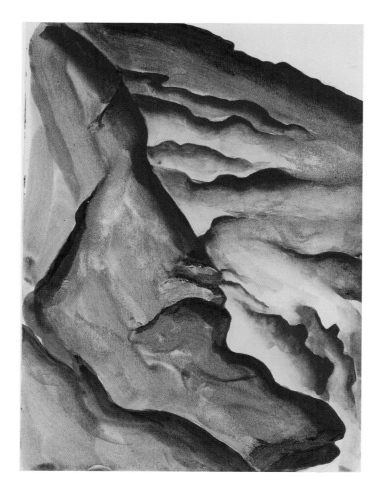

PLATE 234

Untitled (Peru)

1956

Graphite on paper, 9 x 11⅞ (22.9 x 30.2)

Gift, The Georgia O'Keeffe Foundation

CR 1303

PLATE 235

Peruvian Landscape

1956/1957

Watercolor on paper, 11¾ x 8¾ (29.8 x 22.2)

Gift, Mr. and Mrs. Eugene V. Thaw

CR 1309



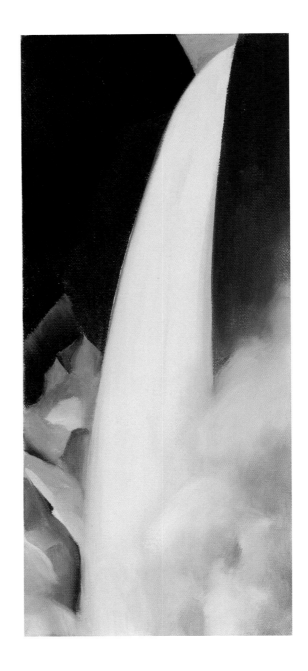

PLATE 236

Green and White

1957/1958

Oil on canvas, 17 x 7 (43.2 x 17.8)

Gift, The Burnett Foundation and The Georgia O'Keeffe Foundation

CR 1329

260

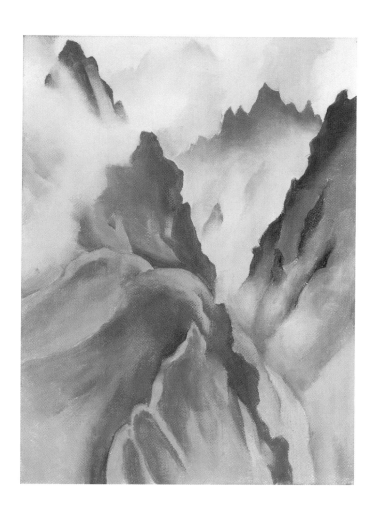

PLATE 237

Machu Pichu I

1957

Oil on canvas, 11⅛ x 8 (28.3 x 20.3)

Gift, The Georgia O'Keeffe Foundation

CR 1318

PLATE 238

Untitled (Peru)

1956

Graphite on paper, 9 x 7¾ (22.9 x 19.7)

Gift, The Georgia O'Keeffe Foundation

CR 1295

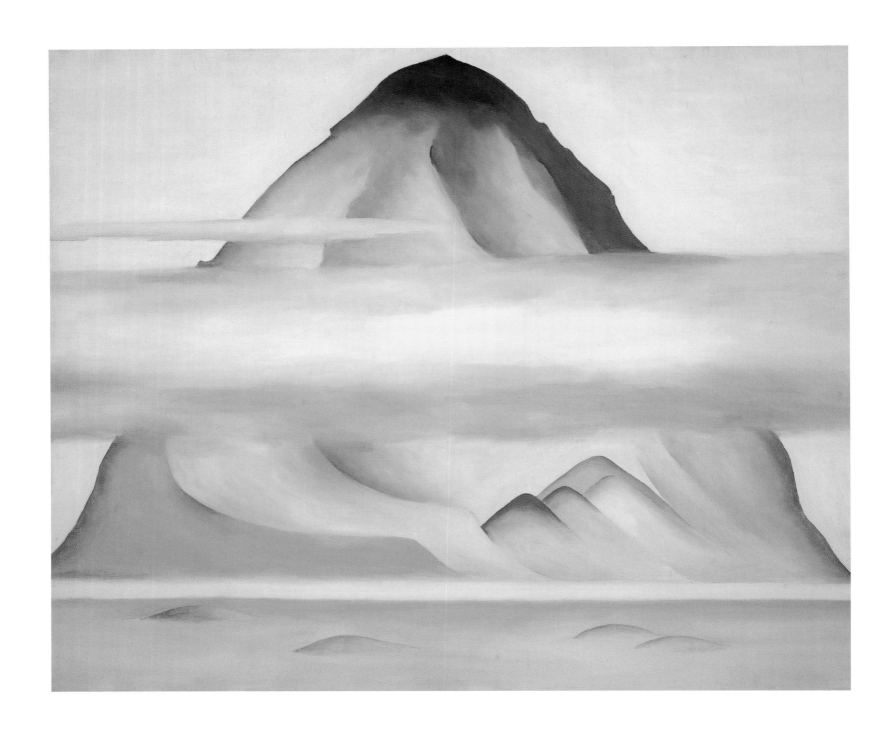

PLATE 239

Misti — A Memory

1957

Oil on canvas, 30 x 36 (76.2 x 91.4)

Gift, The Georgia O'Keeffe Foundation

CR 1319

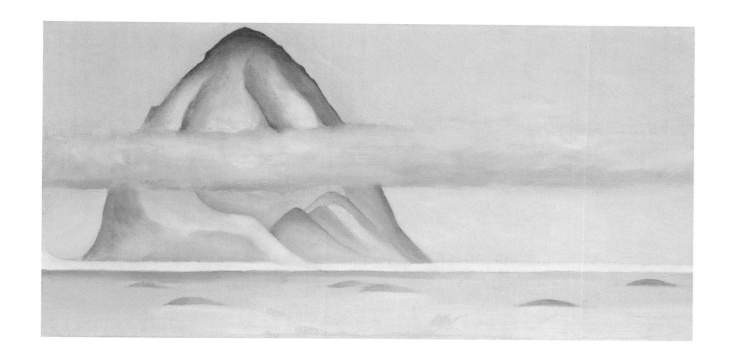

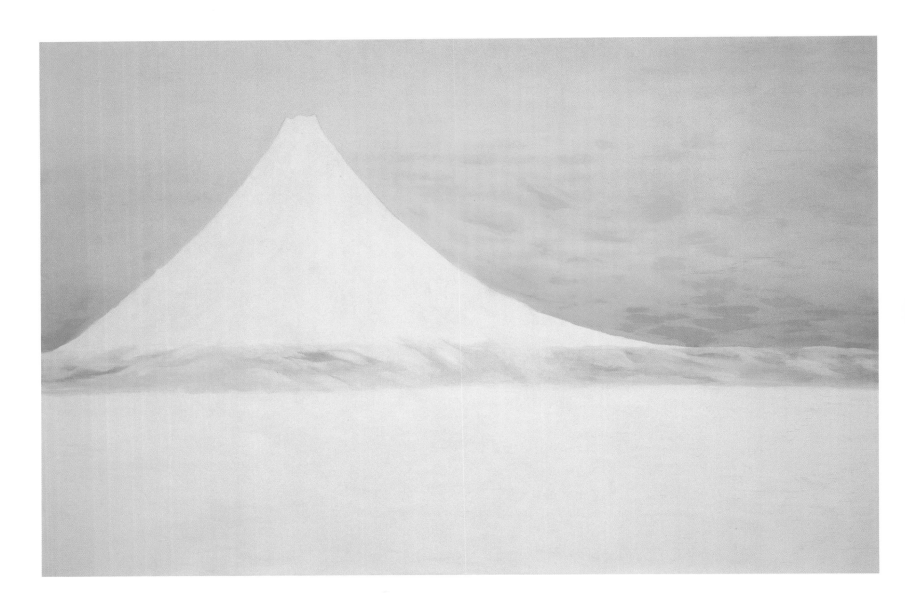

PLATE 241

Untitled (Mt. Fuji)

1960

Oil on canvas, 48 x 72½ (121.9 x 184.2)

Gift, The Georgia O'Keeffe Foundation

CR 1446

264

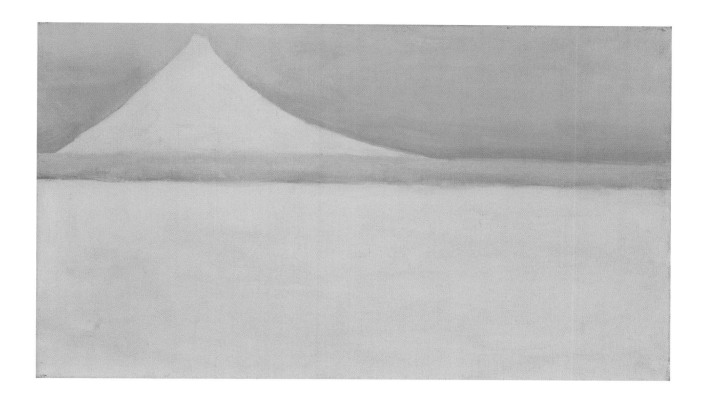

PLATE 242

Untitled (Mt. Fuji)
1960
Oil on canvas, 10 x 18 (25.4 x 45.7)
Gift, Gerald and Kathleen Peters

CR 1447

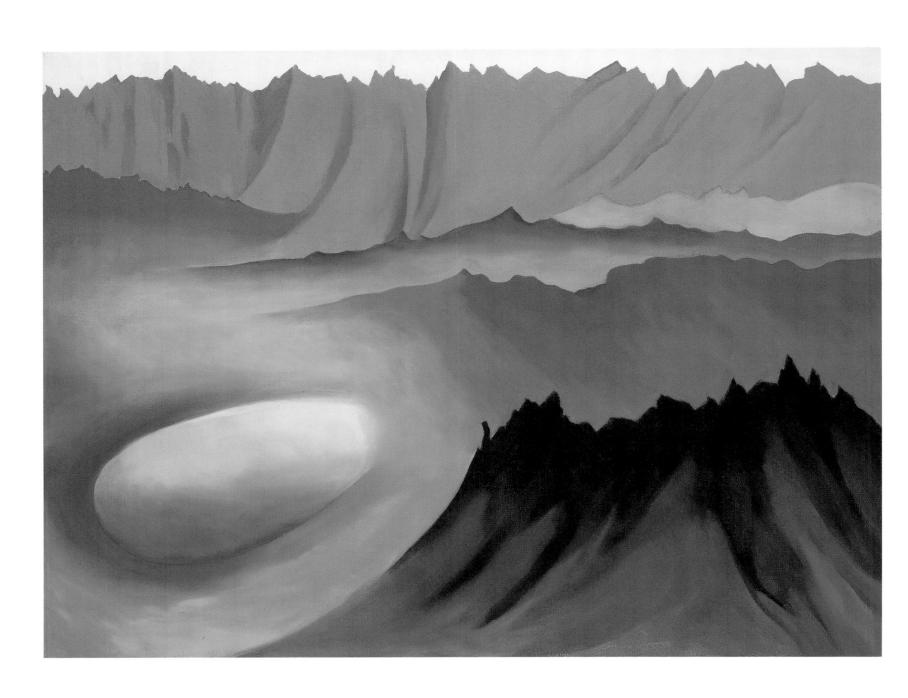

PLATE 243

Mountains and Lake

1961

Oil on canvas, 30 x 40 (76.2 x 101.6)

Gift, The Georgia O'Keeffe Foundation

CR 1462

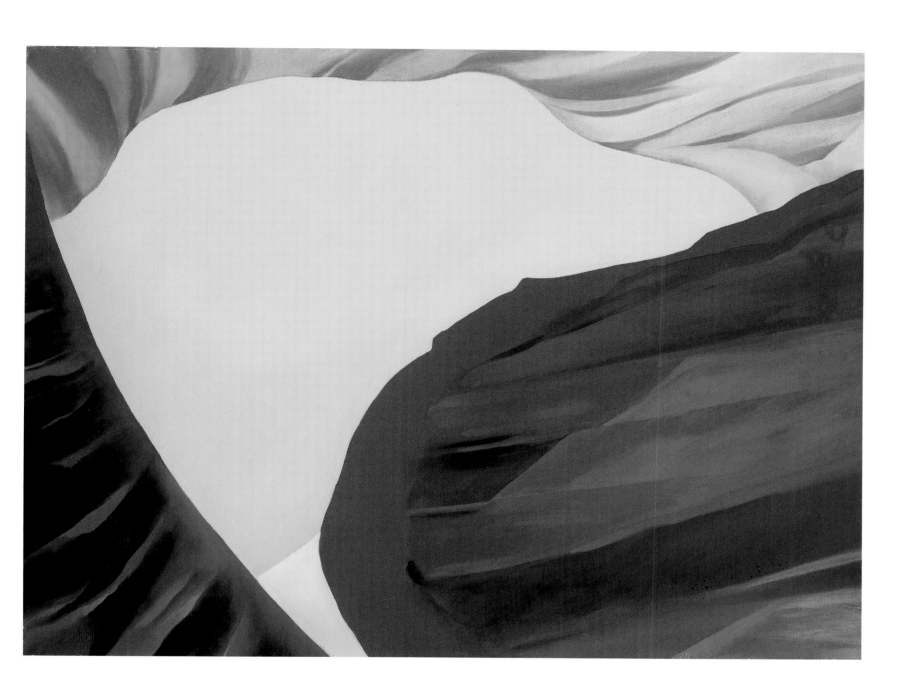

PLATE 244

On the River I

c. 1965

Oil on canvas, 30 x 40 (76.2 x 101.6)

Gift, The Georgia O'Keeffe Foundation

CR 1503

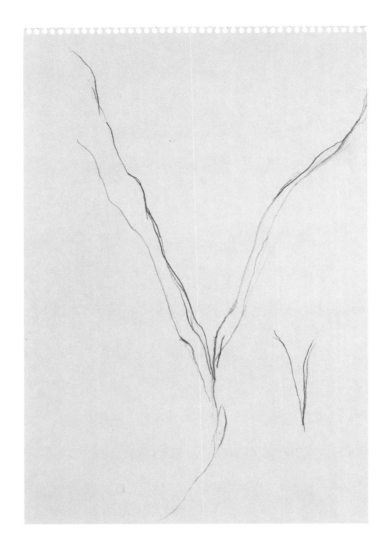

PLATE 245
Untitled (Landscape)
1960s
Graphite on paper, 13⅜ x 8⅞ (34 x 22.5)
Gift, The Georgia O'Keeffe Foundation

CR 1539

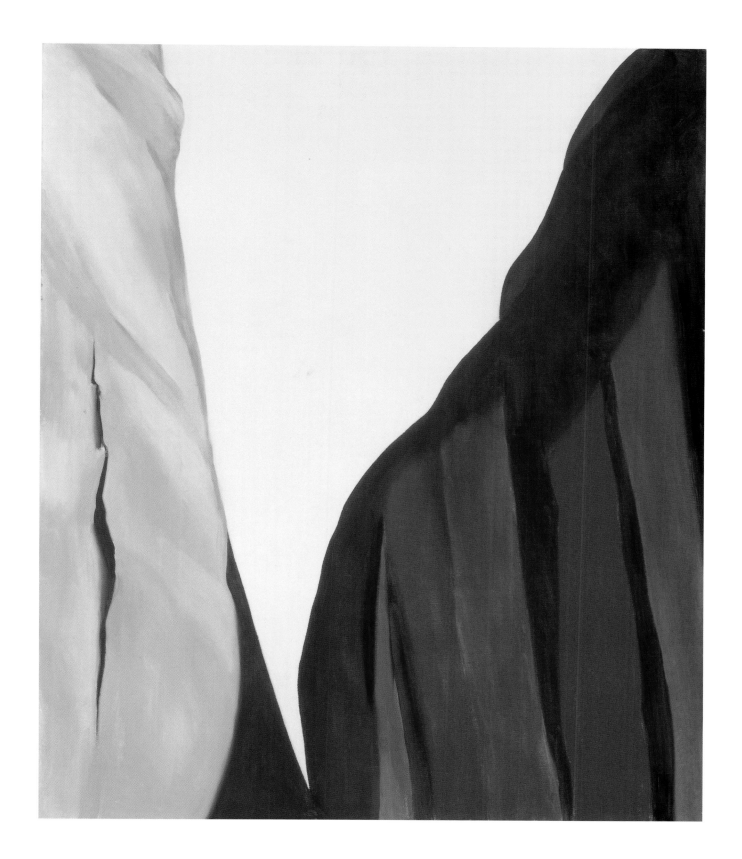

PLATE 246
Canyon Country, White and Brown Cliffs
c. 1965
Oil on canvas, 36 x 30 (91.4 x 76.2)
Gift, The Georgia O'Keeffe Foundation
CR 1501

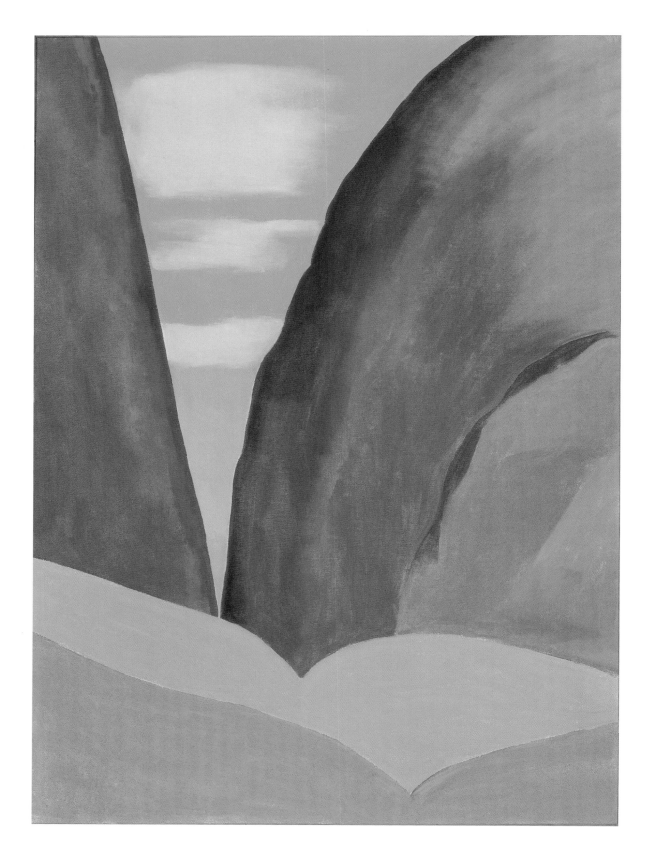

PLATE 247
Canyon No. II
c. 1965
Oil on canvas, 36 x 25 (91.4 x 63.5)
Gift, The Georgia O'Keeffe Foundation
CR 1502

PLATE 248
Untitled (Landscape)
1960s
Graphite on paper, 7 x 4¾ (17.8 x 12.1)
Gift, The Georgia O'Keeffe Foundation
CR 1560

271

Trees

I wish people were all trees and I think I could enjoy them then. (In Marsden Hartley, "Georgia O'Keeffe," from "Some Women Artists in Modern Painting," Chapter 13 in *Adventures in the Arts: Informal Chapters on Painters, Vaudeville, and Poets*, 116, Introduction by Waldo Frank [New York: Boni and Liveright, 1921, Reprint, New York: Hacker Art Books, 1972], 116.)

PLATES 249–50

Throughout her career, trees were an almost constant source of subject matter for O'Keeffe. This is especially true of the paintings she made at Lake George in the 1910s and 1920s, and the paintings she made after 1929 in New Mexico. Her trees often convey seasonal changes in nature, and, particularly in New Mexico, she chose to depict trees as both living and lifeless forms.

PLATE 249
Old Tree
1918
Watercolor on paper, 12 x 18 (30.5 x 45.7)
Gift, The Georgia O'Keeffe Foundation
CR 265

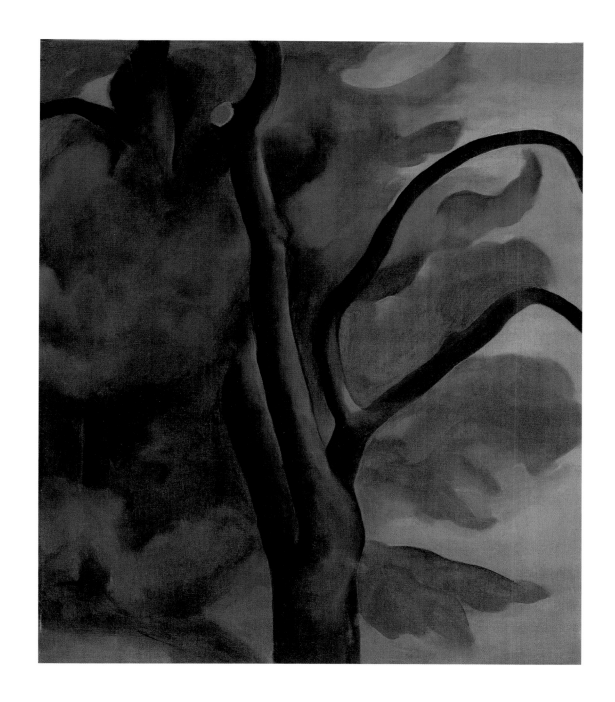

PLATE 250
Tree with Cut Limb
1920
Oil on canvas, 20 x 17 (50.8 x 43.1)
Gift, The Georgia O'Keeffe Foundation

CR 327

PLATES 251–53

O'Keeffe often painted trees at Lake George in the fall to capture the drama of their richly colored foliage. In some cases, she invoked the idea of fall by presenting the tree trunk and limbs devoid of foliage but surrounded by the reds and browns of their fallen leaves.

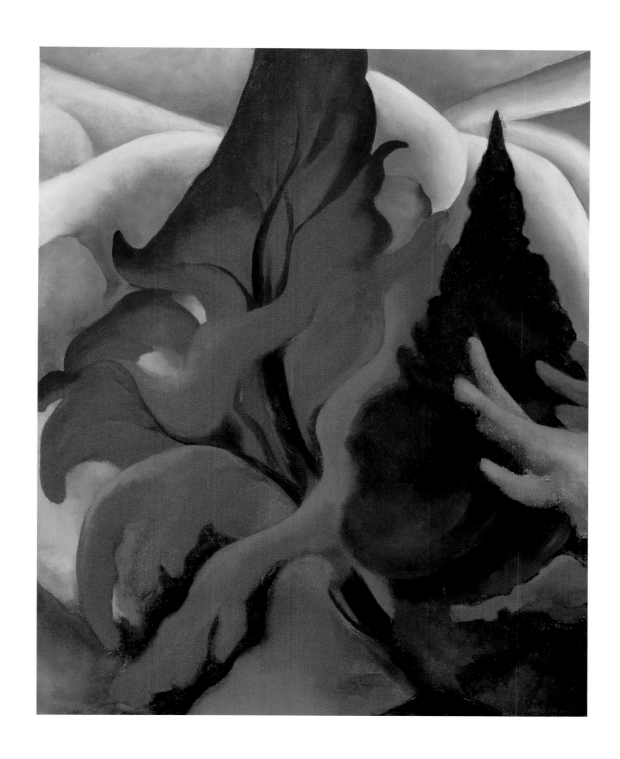

PLATE 251

Trees in Autumn

1920/1921

Oil on canvas, 25¼ x 20¼ (64.1 x 51.4)

Gift, The Burnett Foundation

CR 341

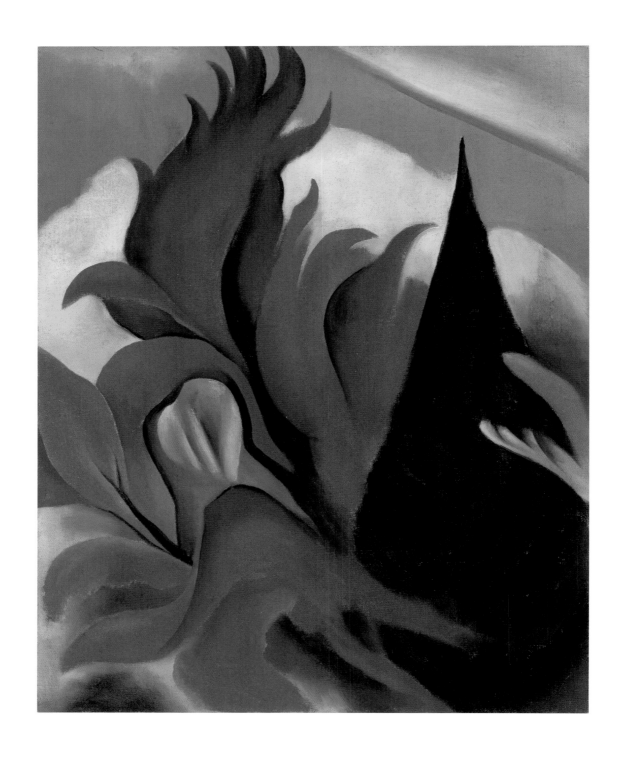

PLATE 252
Red Maple
1922
Oil on canvas, 25 x 20 (63.5 x 50.8)
Gift, The Georgia O'Keeffe Foundation
CR 399

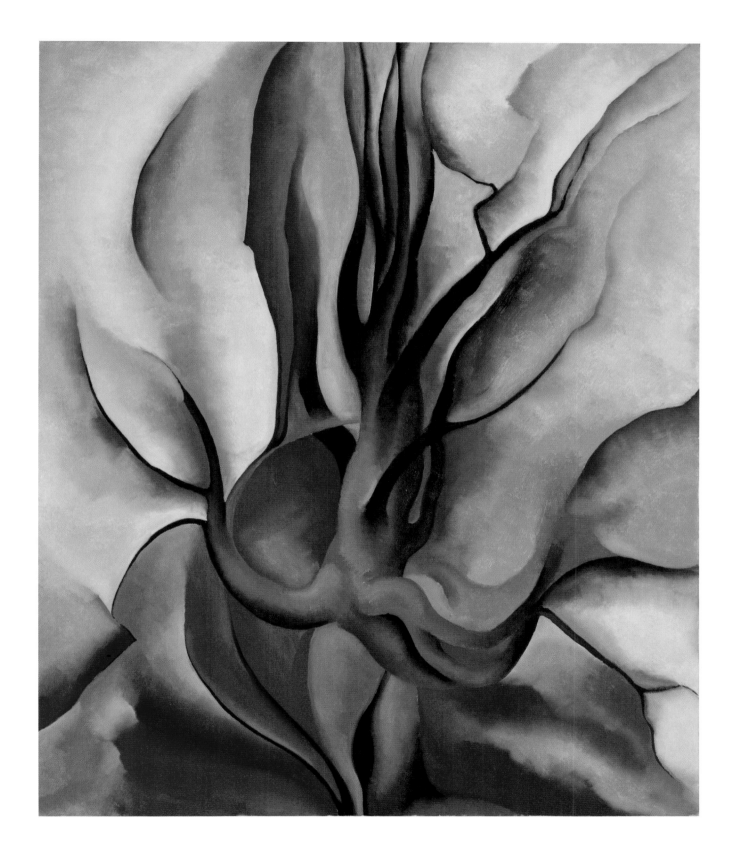

PLATE 253

Autumn Trees — The Maple

1924

Oil on canvas, 36 x 30 (91.4 x 76.2)

Gift, The Burnett Foundation and Gerald and Kathleen Peters

CR 474

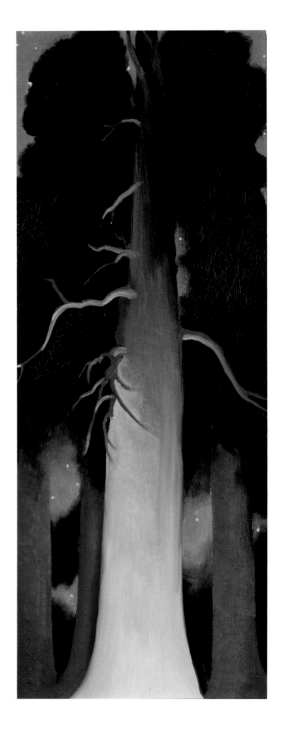

PLATE 254
Untitled (Dead Tree Bear Lake Taos)
1929
Graphite on paper, 7 x 4⅝ (17.8 x 11.7)
Gift, The Georgia O'Keeffe Foundation
CR 684

PLATE 255
Bear Lake, New Mexico
1930
Oil on canvas, 24 x 9 (61 x 22.9)
Promised gift, The Burnett Foundation
CR 745

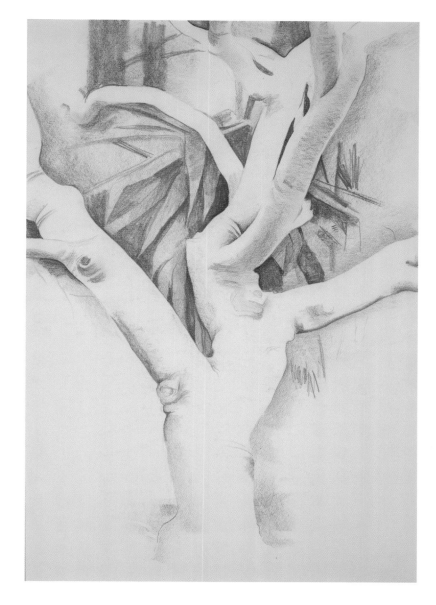

PLATE 256
Untitled (Banyan Tree)
1934
Graphite on paper, 21⅛ x 14¼ (55.2 x 37.5)
Gift, The Georgia O'Keeffe Foundation

CR 845

PLATE 257
Untitled (Banyan Tree)
1934
Graphite on paper, 21⅛ x 14¼ (55.2 x 37.5)
Gift, The Georgia O'Keeffe Foundation

CR 841

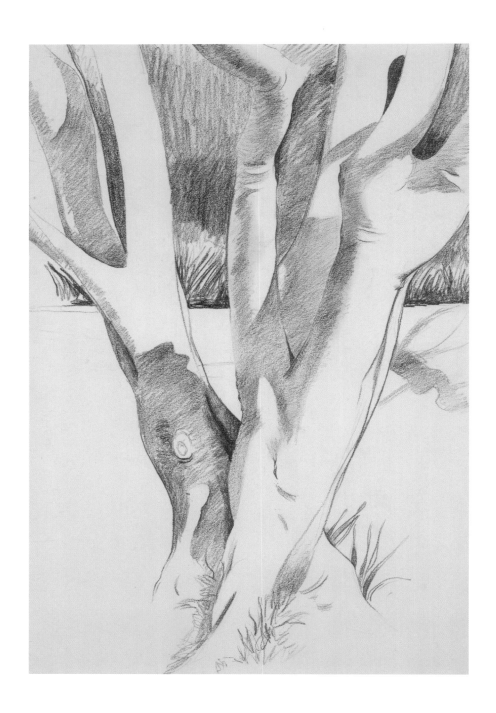

PLATE 258
Untitled (Banyan Tree)
1934
Graphite on paper, 21¼ x 14¼ (55.2 x 37.5)
Gift, The Georgia O'Keeffe Foundation
CR 840

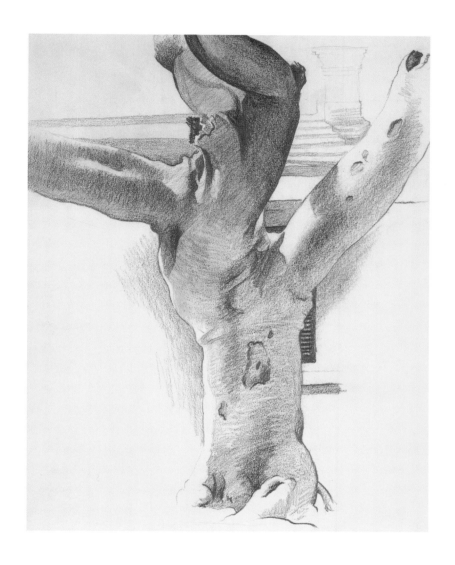

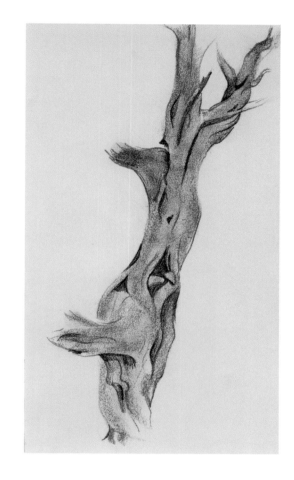

PLATE 259
Banyan Tree
1934
Graphite on paper, 14¾ x 11¼ (37.5 x 29.8)
Gift, The Georgia O'Keeffe Foundation
CR 839

PLATE 260
Dead Cedar Tree
1937
Graphite on paper, 10 x 5¾ (25.4 x 14.6)
Gift, The Georgia O'Keeffe Foundation
CR 934

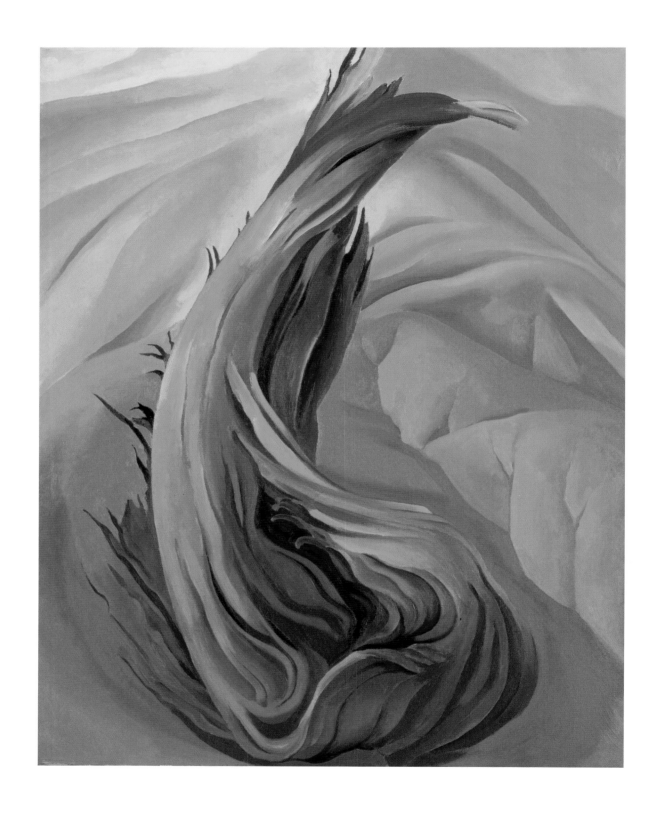

Sometimes O'Keeffe depicted the dead cedar and piñon trees that she saw in the landscape near her Ghost Ranch house in New Mexico. Of *Gerald's Tree*, she wrote: "[It] was one of many dead cedars out in the bare, red hills of Ghost Ranch. A friend [Irish poet Gerald Heard] visiting the Ranch that summer had evidently found it and from the footmarks I guessed he must have been dancing around the tree before I started to paint it. So I always thought of it as Gerald's tree." (In *Georgia O'Keeffe*, 1976, unpaginated text accompanying entry 90.)

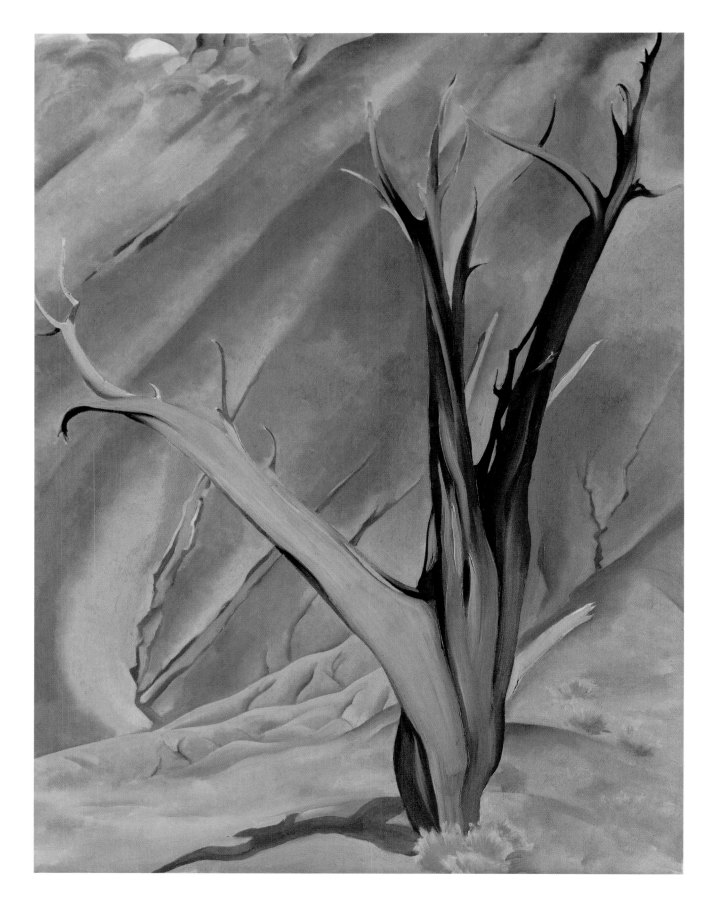

PLATE 262

Gerald's Tree I

1937

Oil on canvas, 40 x 30⅛ (101.6 x 76.5)

Gift, The Burnett Foundation

CR 936

286

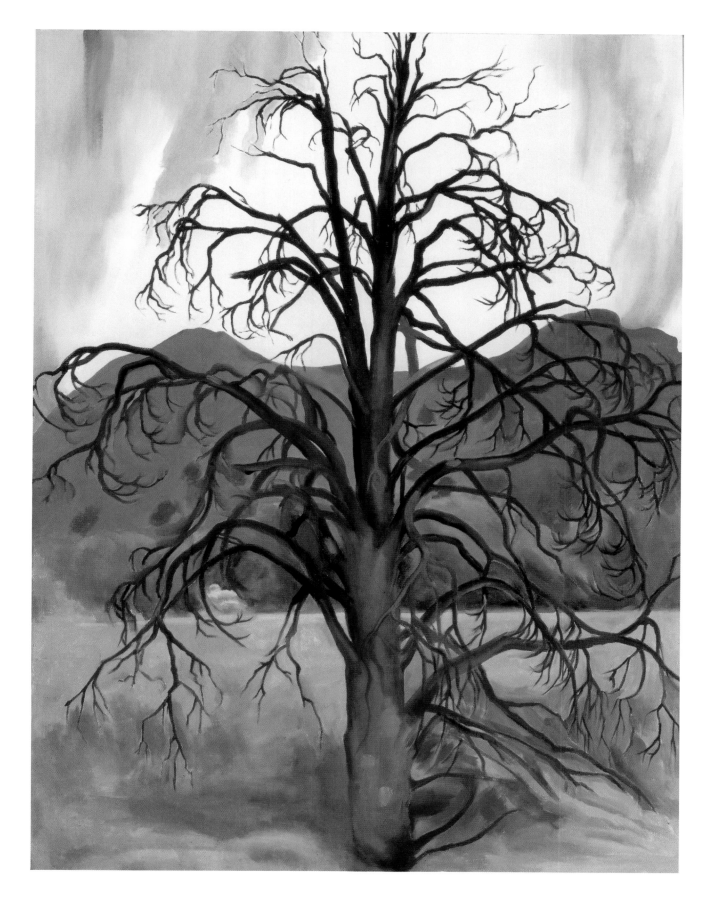

PLATES 264–79

Her most extensive series of paintings of trees is of the cottonwoods that filled the land of the river valley across from her Abiquiu house. She began these paintings in the 1940s and continued working with the subject through the 1950s. As she pointed out: "The Tree series I did from my window in Abiquiu—looking down into the valley. Some of these I also did in the car. I like to work out of doors." (In Katharine Kuh, *The Artist's Voice: Talks with Seventeen Artists* [New York: Harper & Row, 1960], 200.)

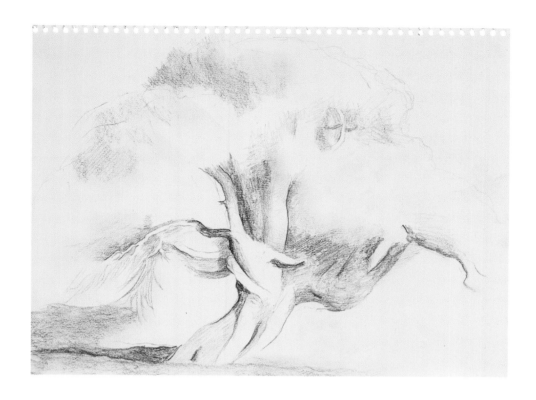

PLATE 264

Untitled (Tree)

1940s/1950s

Graphite on paper, 9 x 11⅞ (22.9 x 30.2)

Gift, The Georgia O'Keeffe Foundation

CR 1190

PLATE 265

Untitled (Tree)

c. 1946

Graphite on paper, 11¼ x 17⅞ (29.8 x 45.5)

Gift, The Georgia O'Keeffe Foundation

CR 1156

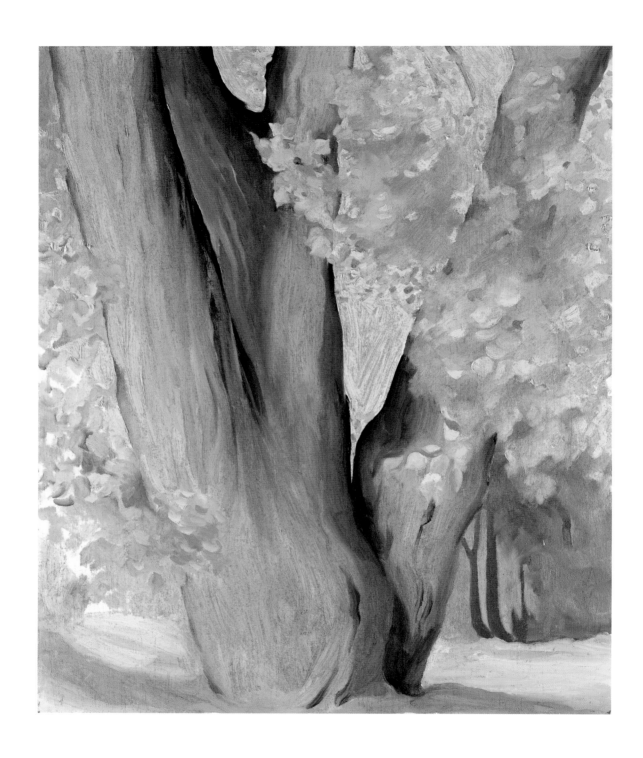

PLATE 266

Untitled (Cottonwood Tree)

1945

Oil on board, 24¼ x 20 (61.6 x 50.8)

Gift, The Georgia O'Keeffe Foundation

CR 1119

290

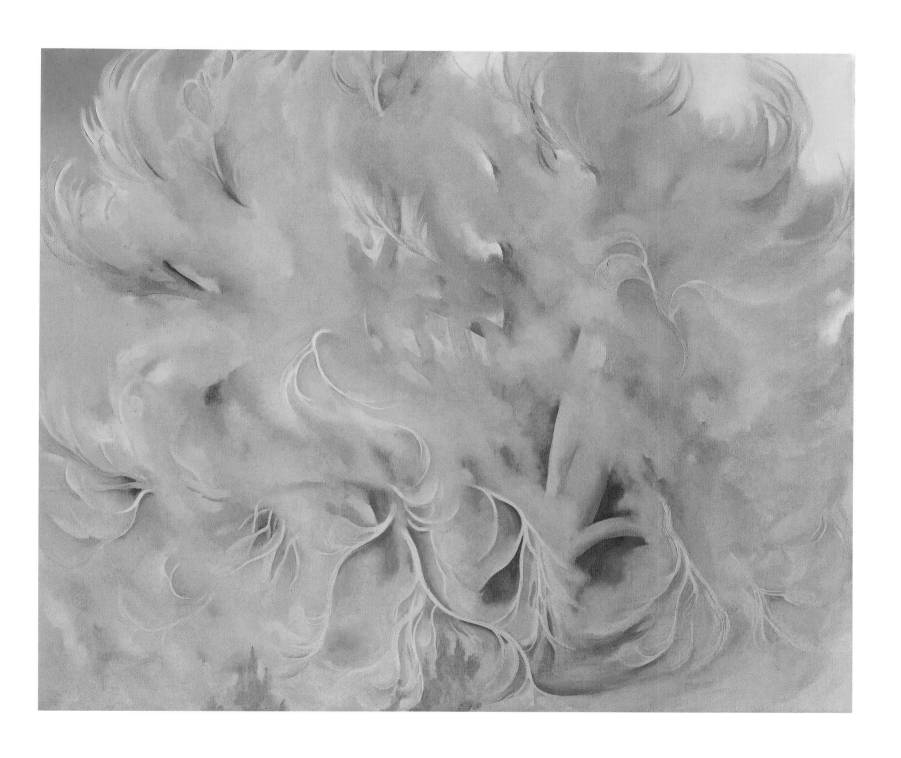

PLATE 267

Cottonwood Tree in Spring

1943

Oil on canvas, 30 x 36 (76.2 x 91.4)

Gift, The Burnett Foundation

CR 1067

291

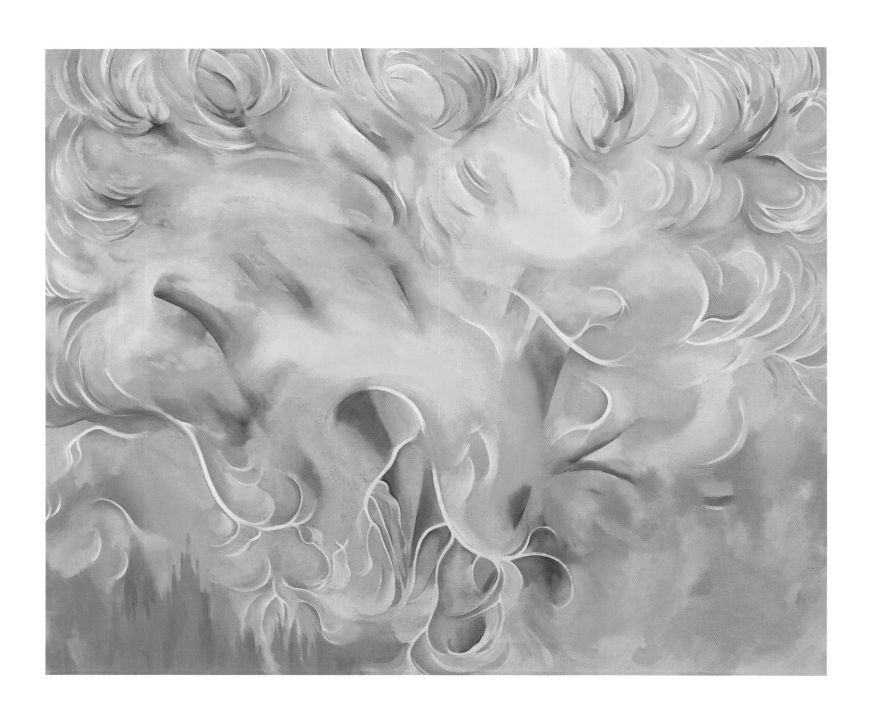

PLATE 268

Cottonwoods

c. 1952

Oil on canvas, 30 x 36 (76.2 x 91.4)

Gift, The Georgia O'Keeffe Foundation

CR 1261

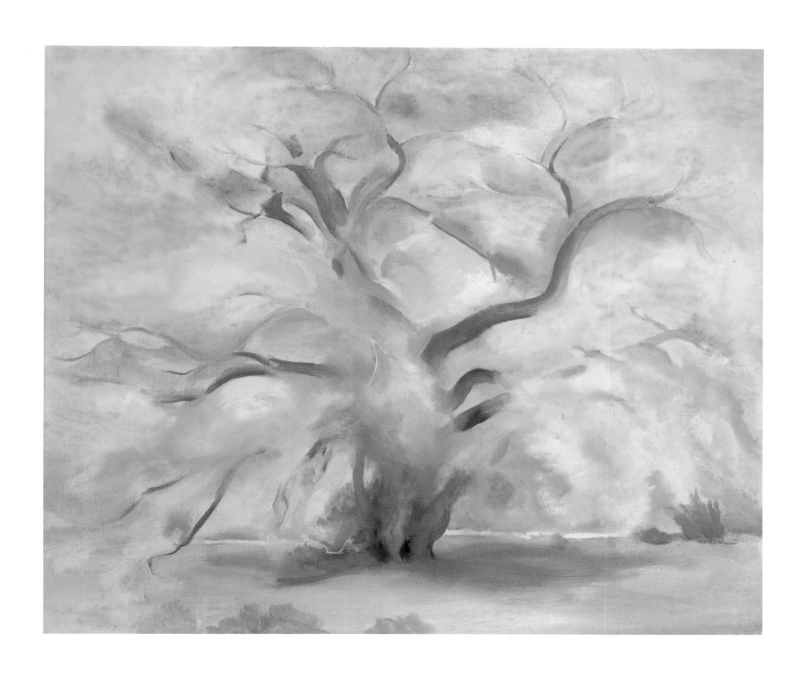

PLATE 269

Cottonwoods Near Abiquiu

1950

Oil on canvas, 22 x 26 (55.9 x 66)

Gift, The Georgia O'Keeffe Foundation

CR 1216

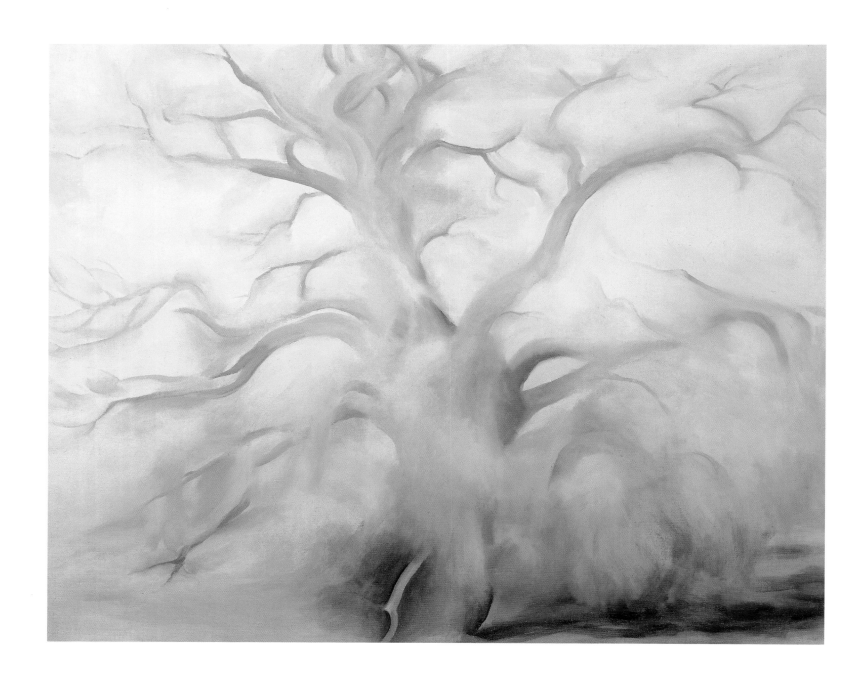

Winter Tree III

1953
Oil on canvas, 30 x 36 (76.2 x 91.4)
Promised gift, The Burnett Foundation

CR 1267

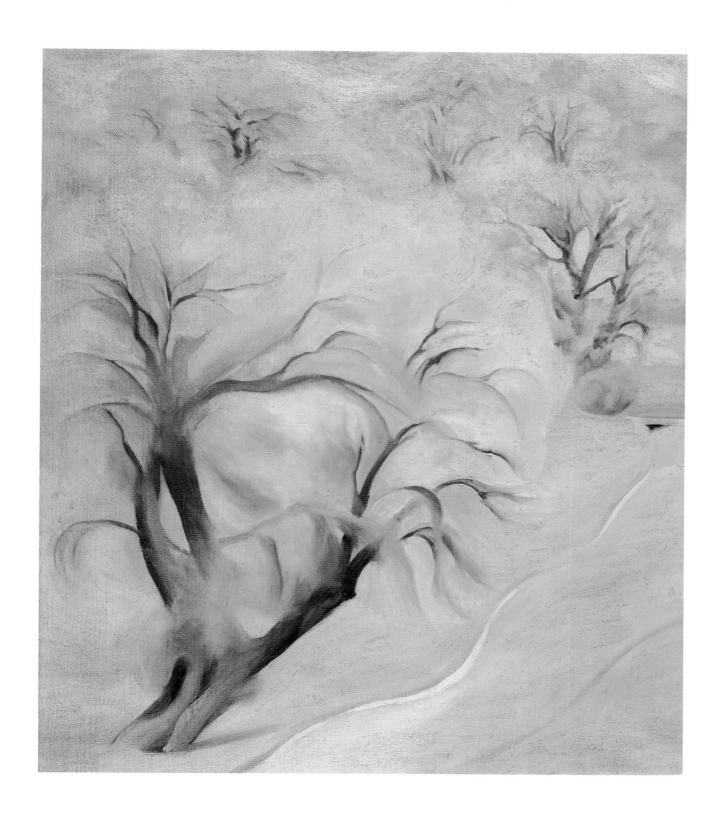

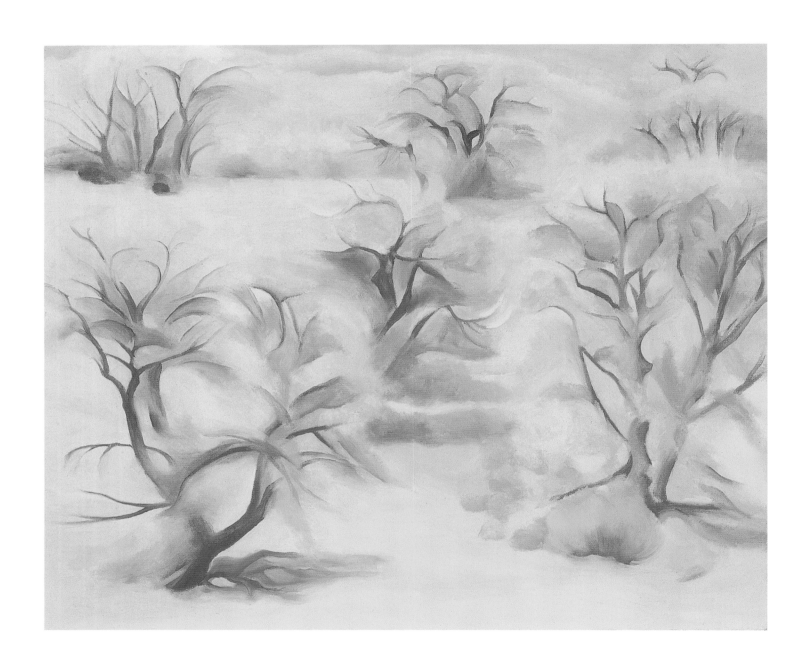

PLATE 272
Winter Trees, Abiquiu, III
1950
Oil on canvas, 25⅜ x 31 (64.5 x 78.8)
Gift, The Georgia O'Keeffe Foundation

CR 1220

296

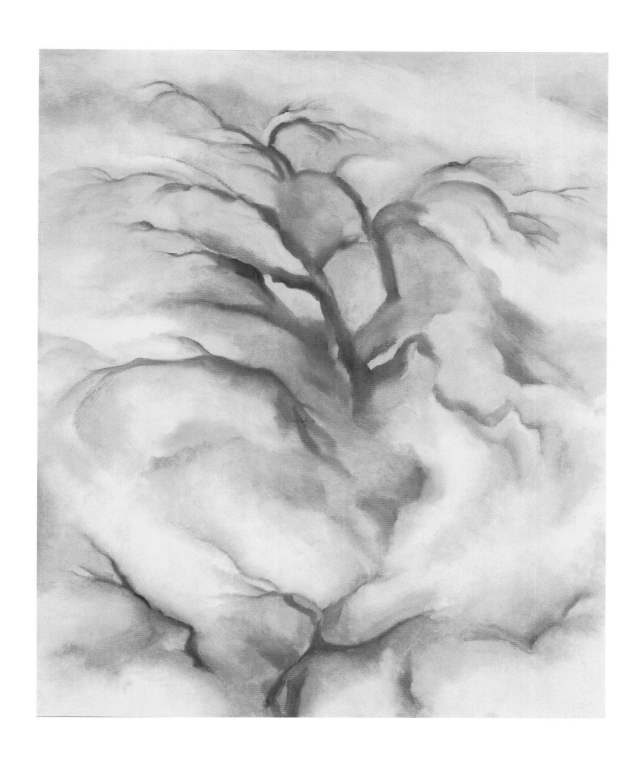

PLATE 273
Winter Trees, Abiquiu, I
1950
Oil on canvas, 24 x 20 (61 x 50.8)
Promised gift, The Burnett Foundation

CR 1218

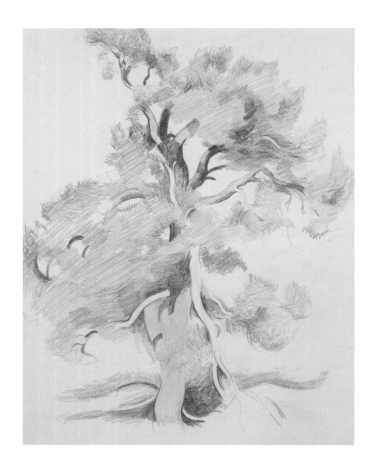

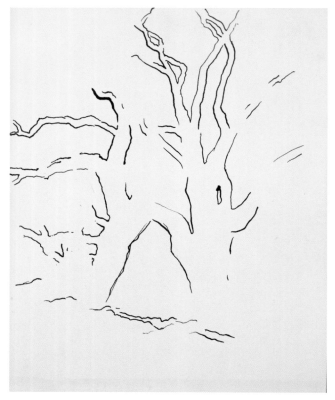

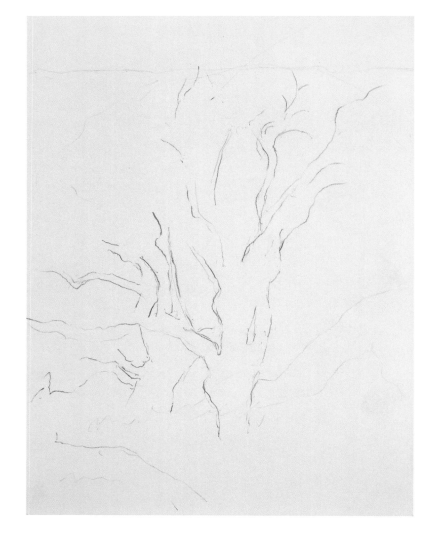

PLATE 274
Untitled (Tree)
1940s/1950s
Graphite on paper, 10¼ x 8 (26 x 20.3)
Gift, The Georgia O'Keeffe Foundation
CR 1186

PLATE 275
Untitled (Tree)
1952
Black ink on paper, 9¼ x 7½ (23.5 x 19.1)
Gift, The Georgia O'Keeffe Foundation
CR 1241

PLATE 276
Untitled (Tree)
1952
Graphite on paper, 15½ x 11½ (39.4 x 29.2)
Gift, The Georgia O'Keeffe Foundation
CR 1240

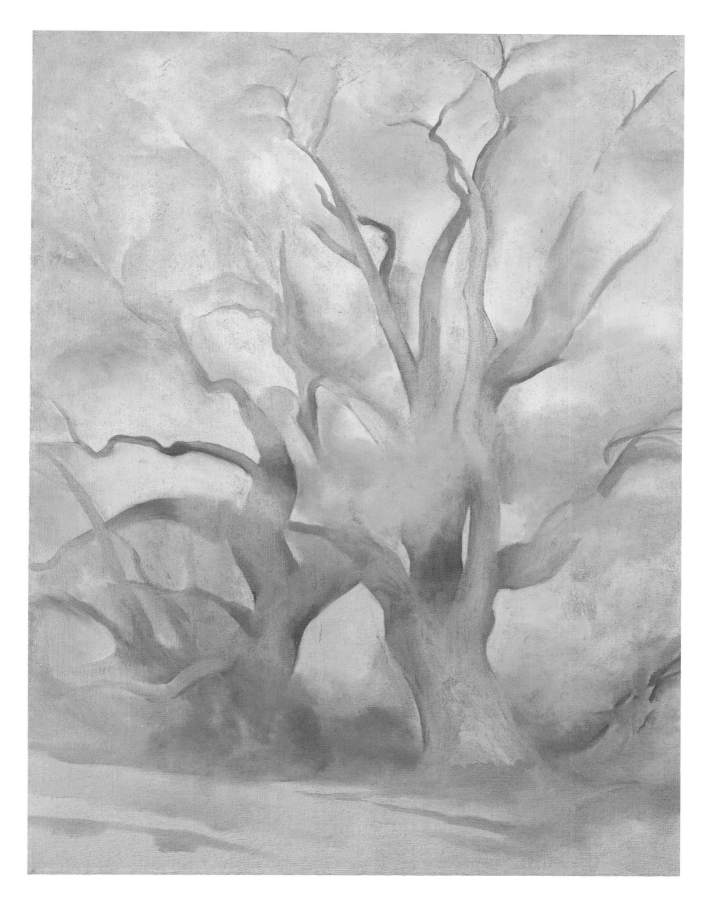

PLATE 277

Green Tree

1953

Oil on canvas, 41½ x 30⅜ (105.4 x 77.2)

Gift, The Georgia O'Keeffe Foundation

CR 1268

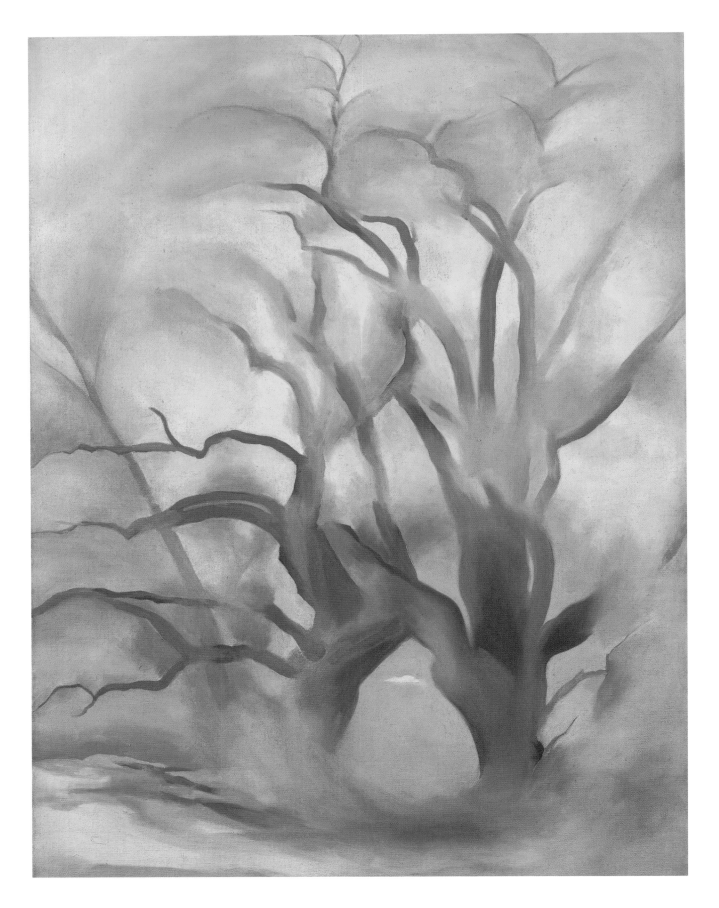

PLATE 278
Winter Cottonwoods East IV
1954
Oil on canvas, 40 x 30 (101.6 x 76.2)
Gift, The Georgia O'Keeffe Foundation

CR 1275

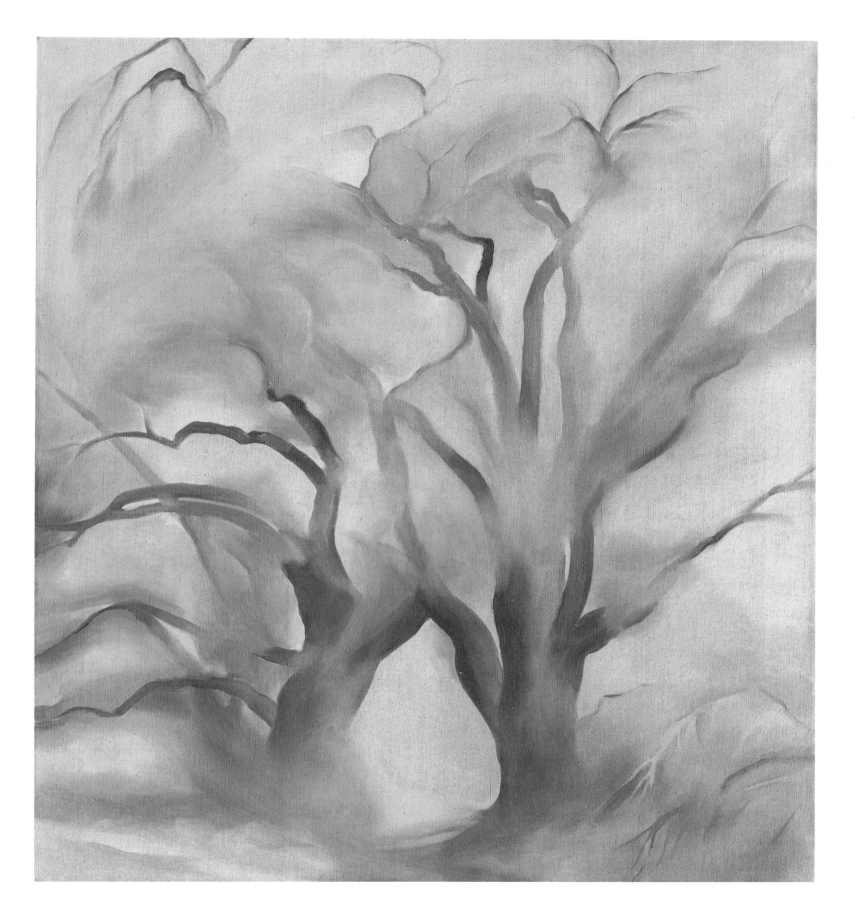

PLATE 279

Winter Cottonwoods East V

1954

Oil on canvas, 40 x 36 (101.6 x 91.4)

Gift, The Burnett Foundation

CR 1276

301

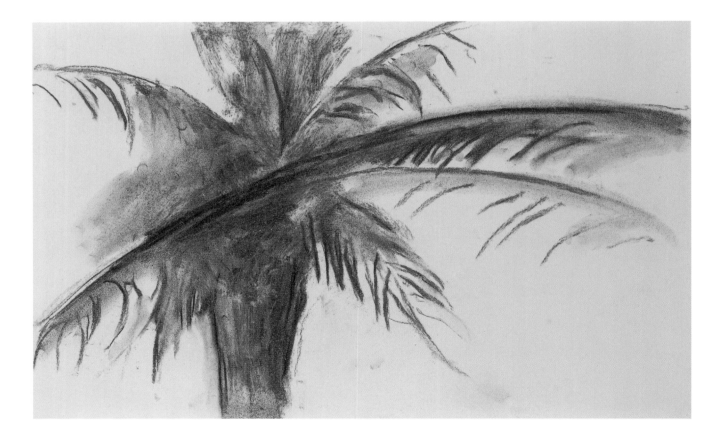

PLATE 280

Untitled (Tree)

1976

Black felt-tip pen on paper, 8½ x 13¼ (21.6 x 33.7)

Gift, The Georgia O'Keeffe Foundation

CR 1603

PLATE 281

Palm Tree at My Door — Antigua

1976

Charcoal on paper, 17⅞ x 27¼ (44.1 x 70.5)

Gift, The Georgia O'Keeffe Foundation

CR 1604

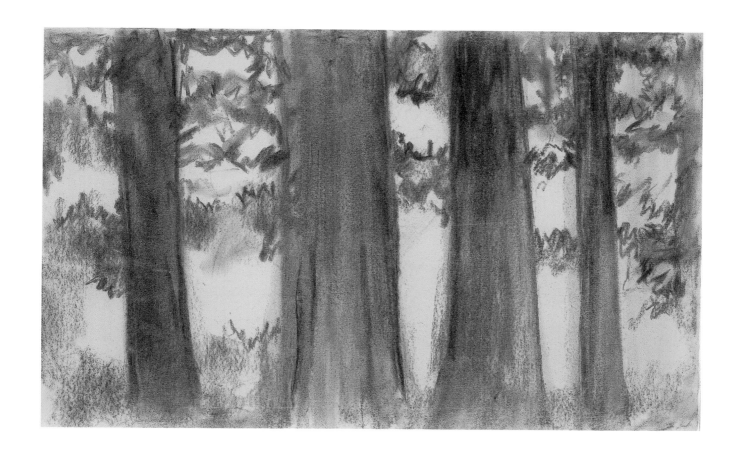

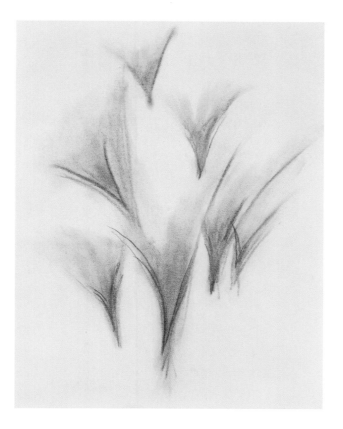

PLATE 282
Untitled (Redwoods Big Sur)
1976
Charcoal on paper, 17¼ x 27¼ (45 x 70.5)
Gift, The Georgia O'Keeffe Foundation
CR 1608

PLATE 283
Untitled (Abstraction Pine Tree)
1979
Charcoal on paper, 24 x 18⅜ (61 x 46.7)
Gift, The Georgia O'Keeffe Foundation
CR 1643

Other Works in
Georgia O'Keeffe Museum

Since its opening in 1997, Georgia O'Keeffe Museum has received a number of works by artists whose careers either paralleled hers or who worked during periods in which O'Keeffe was active. Early on, as gifts from private collectors, we first received paintings by Arthur Dove (plate 288) and Cady Wells (plate 285), and as a gift of the artist himself, a work by Kenneth Noland (plate 296). In addition, the Museum has been fortunate enough to receive as gifts works by many of the photographers who made portraits of O'Keeffe and her surroundings, such as Ansel Adams (plate 326), Philippe Halsman (plate 329), Yousuf Karsh (plate 330), and Eliot Porter (plate 328).

In 2000, the Museum received from Juan and Marie Hamilton a major gift of the personal, tangible property Georgia O'Keeffe owned, including art materials and many of the objects (bones, rocks, and shells) she made the subjects of her work. The next year, the Museum received a bequest from the Estate of Maria Chabot, O'Keeffe's friend and associate, that included the letters O'Keeffe had written Chabot beginning in 1940 and numerous photographs Chabot made of O'Keeffe, such as the well-known one of O'Keeffe on a motorcycle (plate 327). The Research Center published the letters O'Keeffe and Chabot exchanged in *Maria Chabot—Georgia O'Keeffe: Correspondence, 1941–1949*, eds. Barbara Buhler Lynes and Ann Paden (Albuquerque: University of New Mexico Press, 2002).

The Museum has also received major gifts from prominent art historians: the extensive library collection of Shirley Neilsen Blum and the archive of William Innes Homer.

In 2005, a private collector placed in the collection eight works by eight different modernist artists who worked in New Mexico between 1916 and the mid-1930s. These artists, who were O'Keeffe's contemporaries, are: George Bellows (plate 286), Thomas Hart Benton (plate 287), Stuart Davis (plate 294), Marsden Hartley (plate 289), Robert Henri (plate 290), Edward Hopper (plate 292), John Marin (plate 293), and John Sloan (plate 291). A year later, another private collector gave the Museum a painting by Oscar Bluemner (plate 295).

The Georgia O'Keeffe Foundation has been particularly generous. In honor of the Museum's fifth-year anniversary, the Foundation contributed 24 photographs by Alfred Stieglitz to the collection (plates 300–2; 304–7; and 309–25). And, as part of its contribution of assets to the Museum in early 2006, the Foundation increased the Museum's collection of photographs dramatically. Of the more than 1,700 photographs that came to the Museum from the Foundation at that time, about 150 are by O'Keeffe herself, while others are works by well-known professionals or are snapshots taken by friends and associates. A small selection of these images has been included here: three by O'Keeffe (plates 297–99), two by Stieglitz (plates 303 and 308), and three by Todd Webb (plates 331–33).

The Museum has been extremely fortunate to be the recipient of these works. Through the generosity of both private and institutional donors, our collections have expanded beyond the body of our rich holdings of works by Georgia O'Keeffe, helping to fulfill the Museum's objective of exhibiting works that place O'Keeffe's achievement within the historical context of her time.

PLATE 285
Cady Wells
Otowi Mountain
1936
Watercolor on paper, 13¼ x 21¼ (33.7 x 55.3)
Gift, Nathaniel O. and Page Allen Owings



PLATE 286
George Bellows
Santuario de Chimayo
1917
Oil on board, 19⅝ x 23⅝ (49.9 x 60)
Partial Gift, private collector

309

PLATE 287
Thomas Hart Benton
Train on the Desert
1926
Oil on canvas board, 13¼ x 19¼ (33.7 x 48.9)
Partial gift, private collector

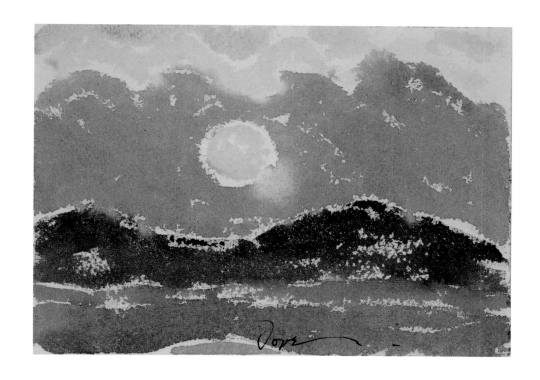

PLATE 288
Arthur Dove
Untitled (Mountain and Sun)
Undated
Watercolor on paper, 5 x 7 (12.7 x 17.8)
Gift, Mr. and Mrs. Eugene V. Thaw

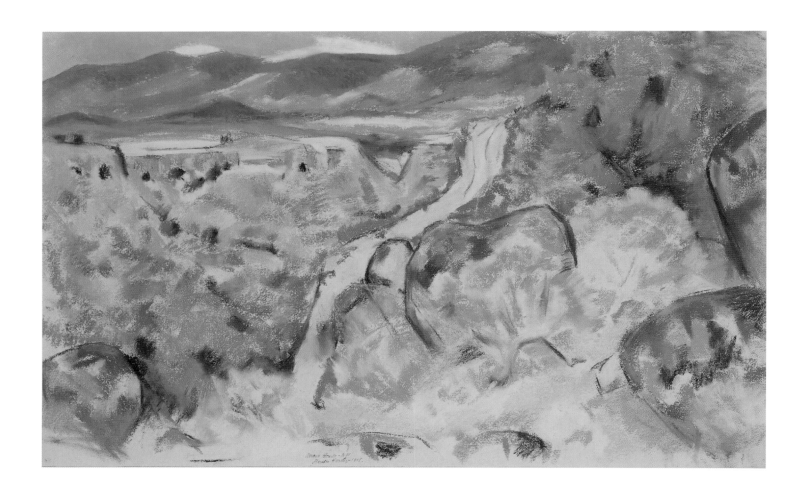

PLATE 289
Marsden Hartley
Arroyo Hondo—NM
1918
Pastel on paper, 17¼ x 27⅞ (43.8 x 70.2)
Partial gift, private collector

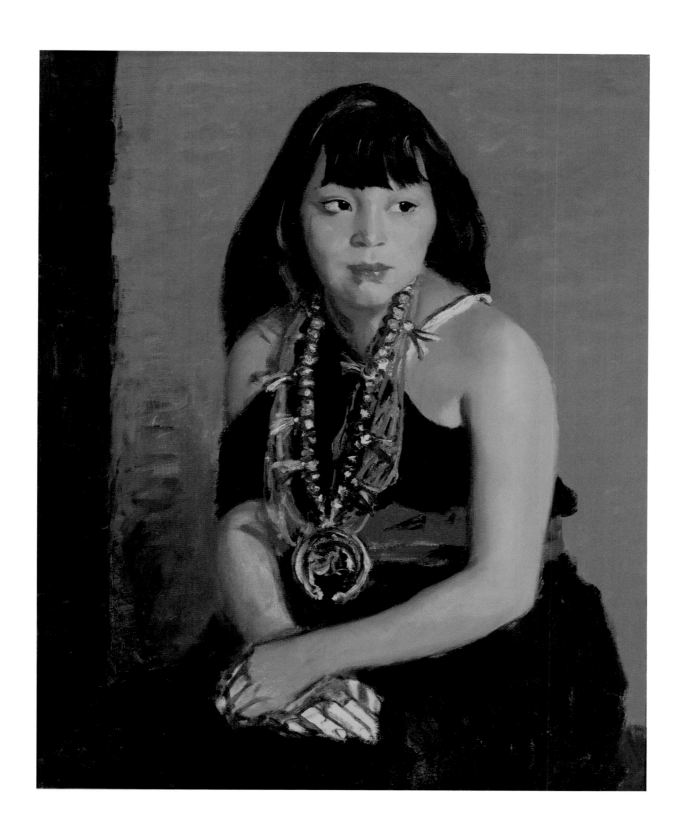

PLATE 290

Robert Henri
Julianita
1922
Oil on canvas, 32¼ x 26¼ (81.9 x 66.7)
Partial gift, private collector

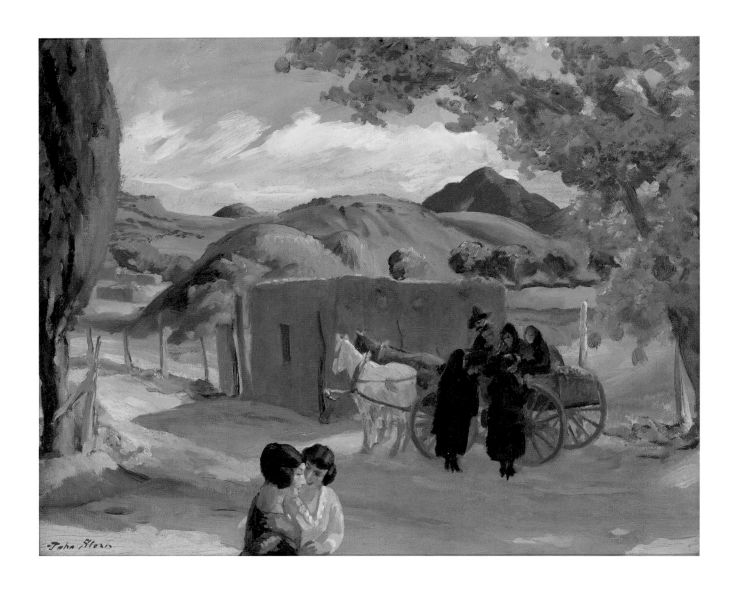

PLATE 291

John Sloan

La Cienega

1923

Oil on canvas, 18 x 22 (45.7 x 55.9)

Partial gift, private collector

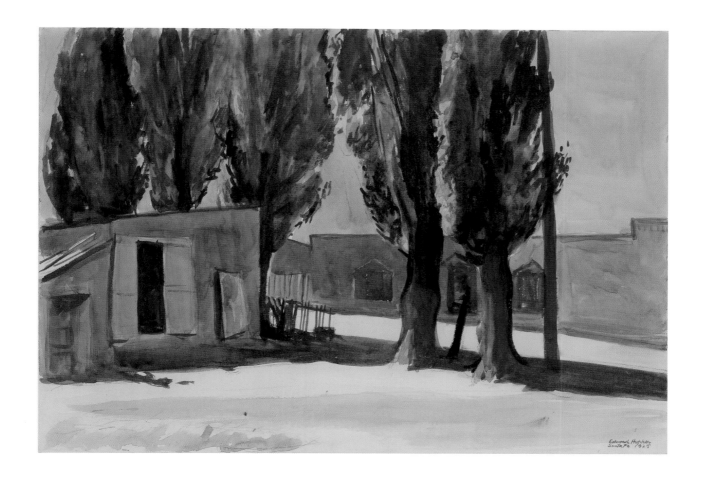

PLATE 292

Edward Hopper

Poplars

1925

Watercolor on paper, 14½ x 19½ (36.8 x 49.5)

Partial gift, private collector

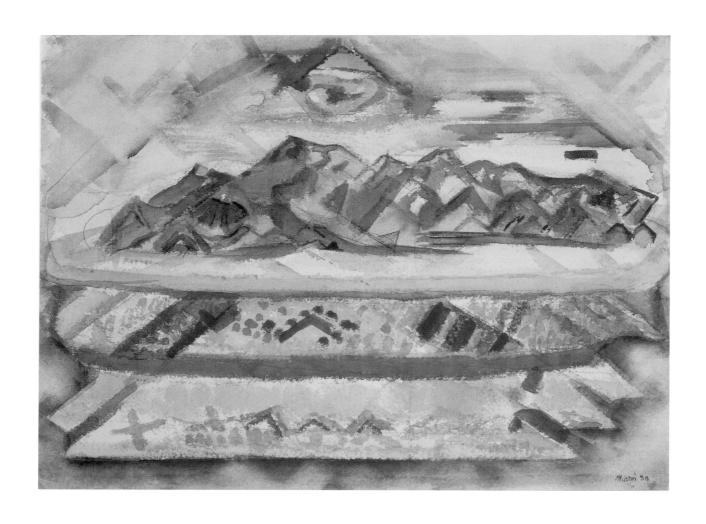

PLATE 293
John Marin
Mountains (Sangre de Cristo), New Mexico
1930
Watercolor on paper, 15¼ x 20¼ (38.7 x 51.4)
Partial gift, private collector
JM CR 30.24

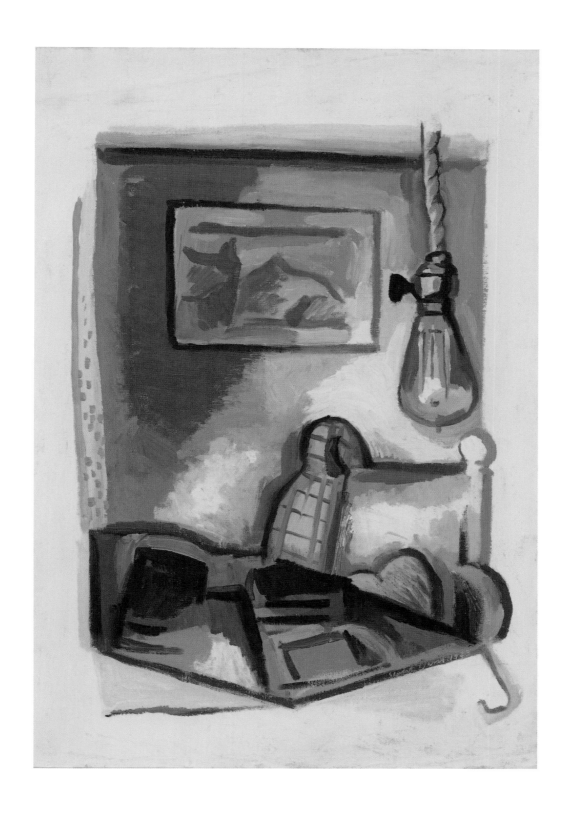

PLATE 294
Stuart Davis
Electric Bulb, New Mexico
1923
Oil on canvas, 32 x 22 (81.3 x 55.9)
Partial gift, private collector

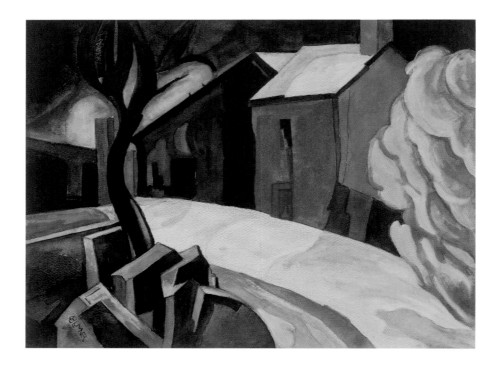

PLATE 295
Oscar Bluemner
Night and Snow (Winter Night)
c. 1929/1930
Watercolor, gouache, and graphite on paper, 7⅞ x 10¼ (20 x 26)
Gift, private collector

318

PLATE 296
Kenneth Noland
PK-0076
1979
Handmade paper, 24½ x 19½ (62.2 x 49.5)
Gift of the artist

319

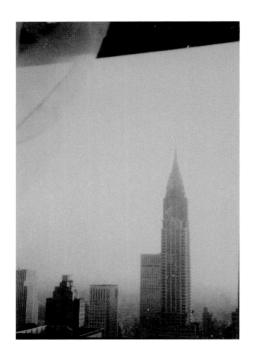

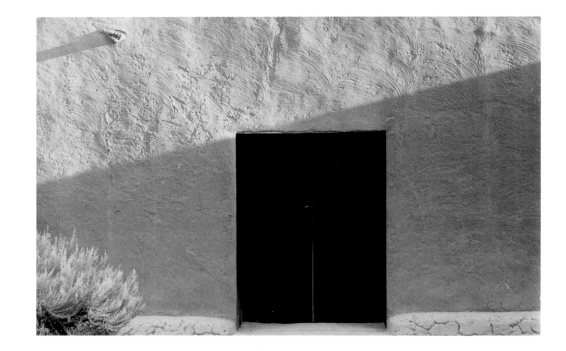

PLATE 297
The Chrysler Building Seen from the Shelton Hotel
Undated
Photograph, 4 x 2¼ (10.2 x 7)
Gift, The Georgia O'Keeffe Foundation

PLATE 298
Untitled (Patio Door, Abiquiu)
Undated
Photograph, 4 x 6 (10.2 x 15.2)
Gift, The Georgia O'Keeffe Foundation

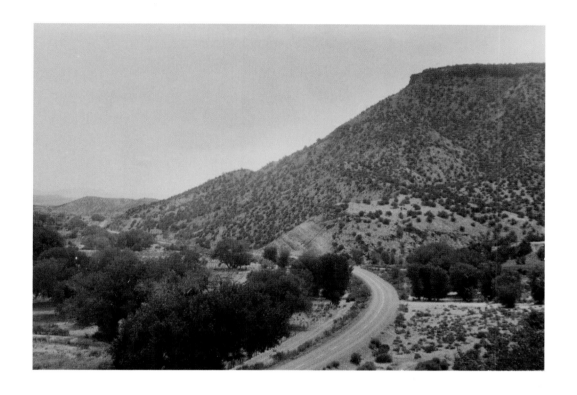

PLATE 299
Untitled (The Road from Abiquiu Toward Santa Fe)
Undated
Photograph, 4⅝ x 6⅜ (11.8 x 16.3)
Gift, The Georgia O'Keeffe Foundation

PLATE 301
Alfred Stieglitz
Georgia O'Keeffe at 291
1917
Platinum print, 9⁹⁄₁₆ x 7⅝ (24.3 x 19.4)
Gift, The Georgia O'Keeffe Foundation
AS CR 458

PLATE 302
Alfred Stieglitz
Georgia O'Keeffe
1918
Platinum print, 9⁵⁄₁₆ x 7¼ (23.7 x 17.4)
Gift, The Georgia O'Keeffe Foundation
AS CR 474

PLATE 303
Alfred Stieglitz
Georgia O'Keeffe
1918
Gelatin silver print, 10 x 8 (25.4 x 20.3)
Gift, The Georgia O'Keeffe Foundation

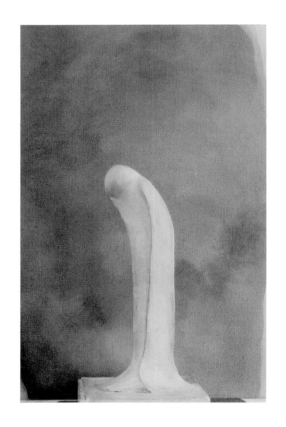

PLATE 304
Alfred Stieglitz
Interpretation
1919
Gelatin silver print, 5¼ x 3⅜ (13.3 x 8.6)
Gift, The Georgia O'Keeffe Foundation
AS CR 587

324

PLATE 305
Alfred Stieglitz
Georgia O'Keeffe—Hands
1919
Palladium print, 9⅜ x 7½ (23.8 x 19.1)
Gift, The Georgia O'Keeffe Foundation
AS CR 567

PLATE 306
Alfred Stieglitz
Georgia O'Keeffe—Hands
c. 1919
Gelatin silver print, 9½ x 7½ (22.9 x 19.1)
Gift, The Georgia O'Keeffe Foundation
AS CR 573

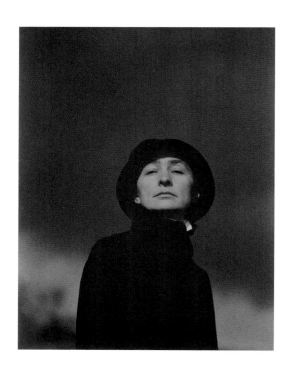

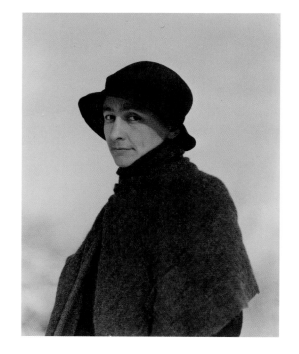



PLATE 307
Alfred Stieglitz
Portrait of Georgia, No. 1
1923
Gelatin silver print, 4½ x 3½ (11.4 x 8.9)
Gift, The Georgia O'Keeffe Foundation

AS CR 920





PLATE 308
Alfred Stieglitz
Georgia O'Keeffe
1924
Gelatin silver print, 4⁷⁄₁₆ x 3⁷⁄₁₆ (11.3 x 8.7)
Gift, The Georgia O'Keeffe Foundation

AS CR 1003



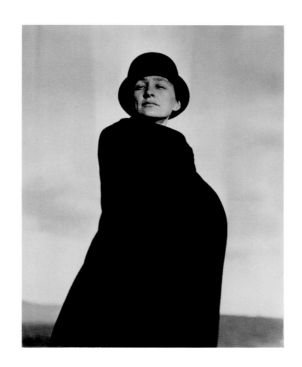

PLATE 309
Alfred Stieglitz
Georgia O'Keeffe
1920/1922
Palladium print, 4½ x 3⁹⁄₁₆ (11.4 x 9.1)
Gift, The Georgia O'Keeffe Foundation
AS CR 668

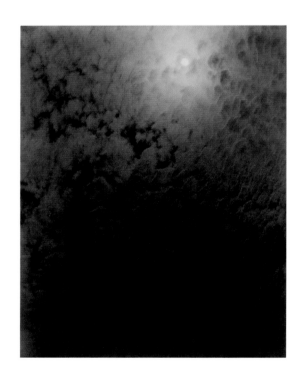

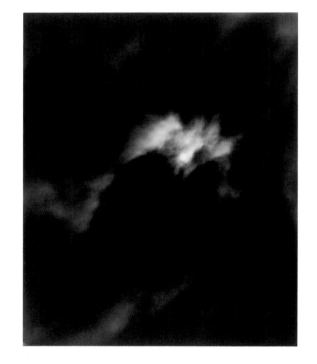

PLATE 310
Alfred Stieglitz
Equivalent
1926
Gelatin silver print, 4⅝ x 3⅝ (11.7 x 9.2)
Gift, The Georgia O'Keeffe Foundation
AS CR 1159

PLATE 311
Alfred Stieglitz
Equivalent
1926
Gelatin silver print, 4¹⁄₁₆ x 3⅝ (11.6 x 9.2)
Gift, The Georgia O'Keeffe Foundation
AS CR 1172

PLATE 313

Alfred Stieglitz

Equivalents

1927

Gelatin silver print, 3⅜ x 4⅝ (9.4 x 11.7)

Gift, The Georgia O'Keeffe Foundation

AS CR 1212

PLATE 314

Alfred Stieglitz

Equivalent

1927

Gelatin silver print, 3⅜ x 4⅝ (9.4 x 11.7)

Gift, The Georgia O'Keeffe Foundation

AS CR 1239

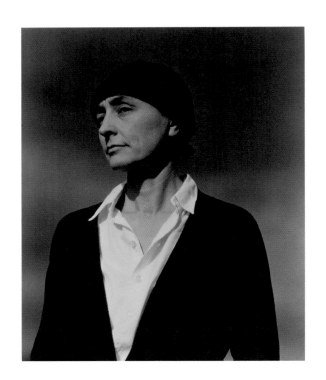

PLATE 315
Alfred Stieglitz
Georgia O'Keeffe
1928
Gelatin silver print, 4⅝ x 3⅜ (11.7 x 8.6)
Gift, The Georgia O'Keeffe Foundation
AS CR 1247

PLATE 316
Alfred Stieglitz
Equivalent HH₁
1929
Gelatin silver print, 4¾ x 3¾ (12 x 9.5)
Gift, The Georgia O'Keeffe Foundation
AS CR 1258

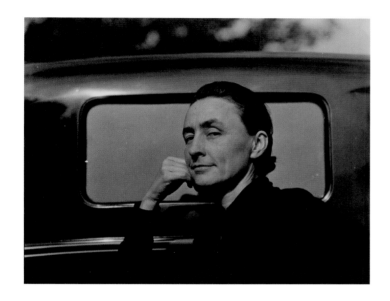

PLATE 317

Alfred Stieglitz

Georgia O'Keeffe — After Return from New Mexico, Equivalent O₁

1929

Gelatin silver print, 3⅛ x 4¾ (7.9 x 12)

Gift, The Georgia O'Keeffe Foundation

AS CR 1306

PLATE 318

Alfred Stieglitz

Equivalent

1930

Gelatin silver print, 3⅝ x 4⁹⁄₁₆ (9.2 x 11.6)

Gift, The Georgia O'Keeffe Foundation

AS CR 1340

PLATE 319
Alfred Stieglitz
The Dying Chestnut Tree
1927
Gelatin silver print, 9⅜ x 7⅜ (23.8 x 18.7)
Gift, The Georgia O'Keeffe Foundation
AS CR 1191

332

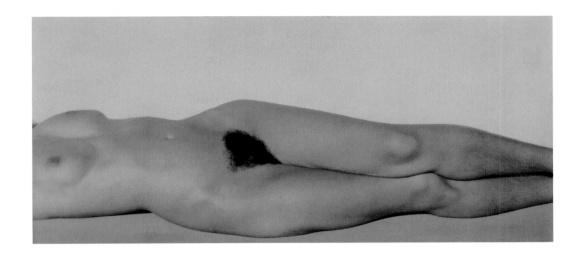

PLATE 320
Alfred Stieglitz
Georgia O'Keeffe — Torso
1931
Gelatin silver print, 4¼ x 9¼ (10.8 x 23.5)
Gift, The Georgia O'Keeffe Foundation
AS CR 1438

333

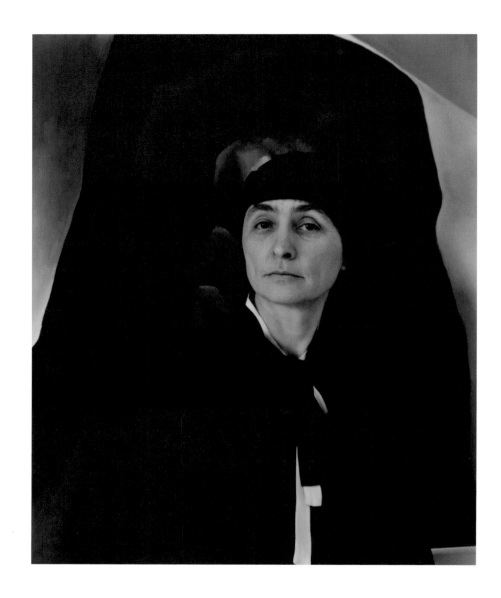

PLATE 321
Alfred Stieglitz
Georgia O'Keeffe
1930
Gelatin silver print, 8⅞ x 7¼ (22.5 x 18.4)
Gift, The Georgia O'Keeffe Foundation
AS CR 1319

334

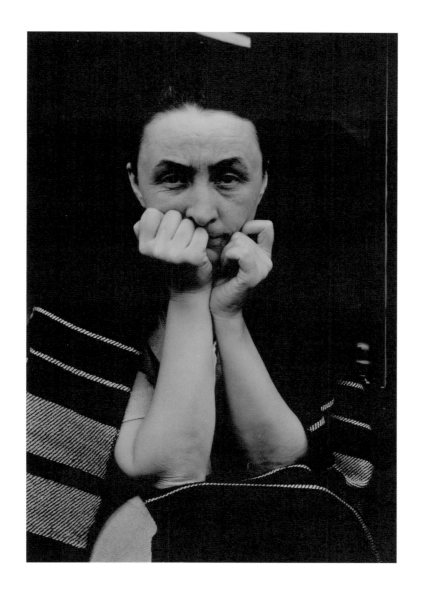

PLATE 322

Alfred Stieglitz

Georgia O'Keeffe

1935

Gelatin silver print, 8¾ x 6 (22.2 x 15.2)

Gift, The Georgia O'Keeffe Foundation

AS CR 1582

PLATE 323
Alfred Stieglitz
House and Trees, Lake George
1932
Gelatin silver print, 7¼ x 9¼ (18.4 x 23.5)
Gift, The Georgia O'Keeffe Foundation
AS CR 1466

336

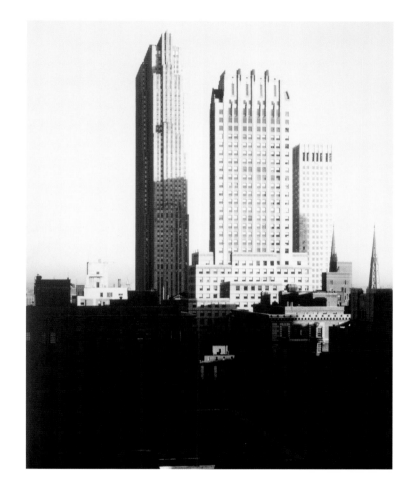

PLATE 324
Alfred Stieglitz
Poplars—Lake George
1932
Gelatin silver print, 9¼ x 7¼ (23.5 x 18.4)
Gift, The Georgia O'Keeffe Foundation
AS CR 1467

PLATE 325
Alfred Stieglitz
New York from the Shelton
1935
Gelatin silver print, 9⅜ x 7⅝ (23.8 x 19.4)
Gift, The Georgia O'Keeffe Foundation
AS CR 1571

PLATE 326
Ansel Adams
Georgia O'Keeffe and Orville Cox, Canyon de Chelly National Park
1937
Gelatin silver print, 7¾ x 11 (20 x 27.9)
Gift, The Georgia O'Keeffe Foundation

338

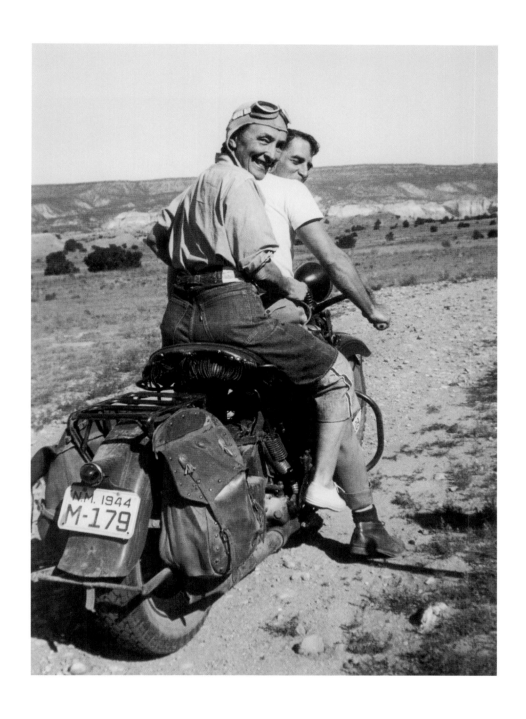

PLATE 327
Maria Chabot
O'Keeffe Hitching a Ride to Abiquiu, Ghost Ranch
1944
Photograph, 14 x 11 (35.6 x 27.9)

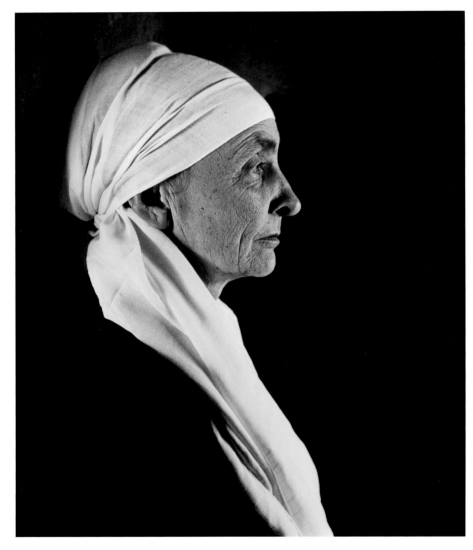

PLATE 328
Eliot Porter
Georgia O'Keeffe and Head of O'Keeffe by Mary Callery, Ghost Ranch,
New Mexico
1945
Photograph, 9¼ x 7⁷⁄₁₆ (24.1 x 18.9)
Gift of Gil Hitchcock

PLATE 329
Philippe Halsman
Georgia O'Keeffe
1948
Photograph, contemporary print, 20 x 24 (50.8 x 61)
© Halsman Estate

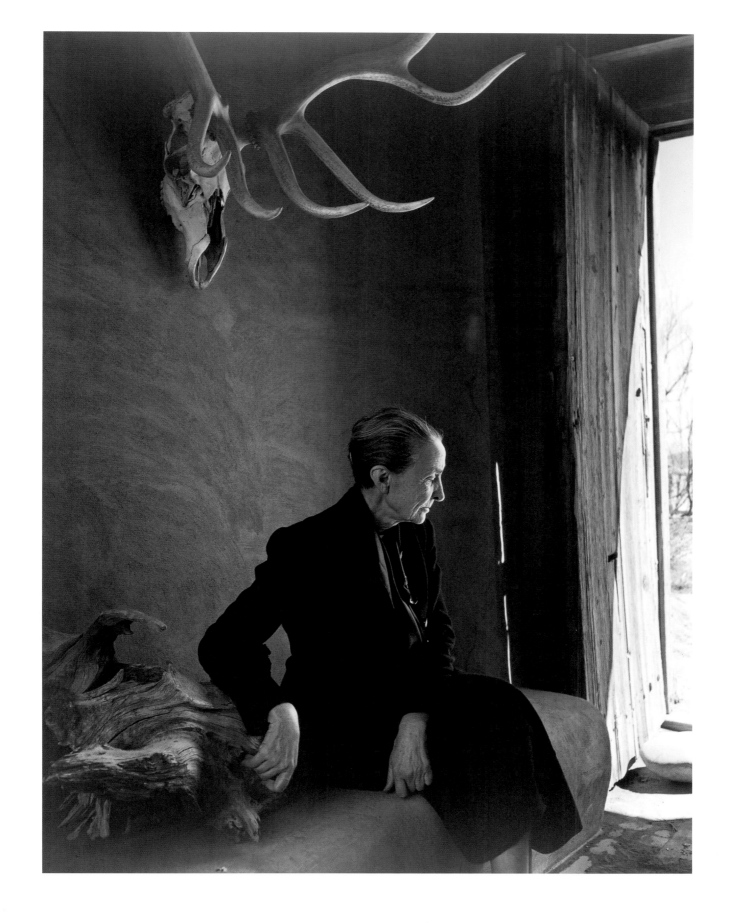

PLATE 330
Yousuf Karsh
Georgia O'Keeffe
1956
Gelatin silver print, 39 x 29½ (99.1 x 74.9)

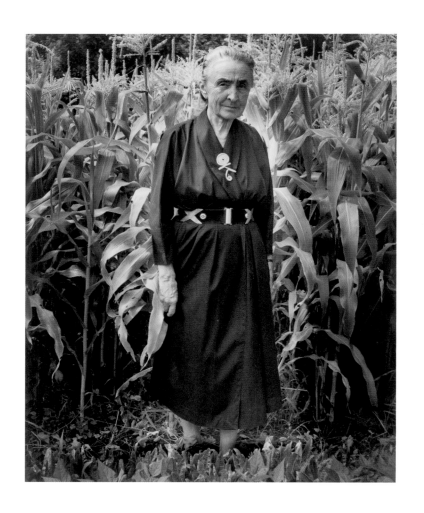

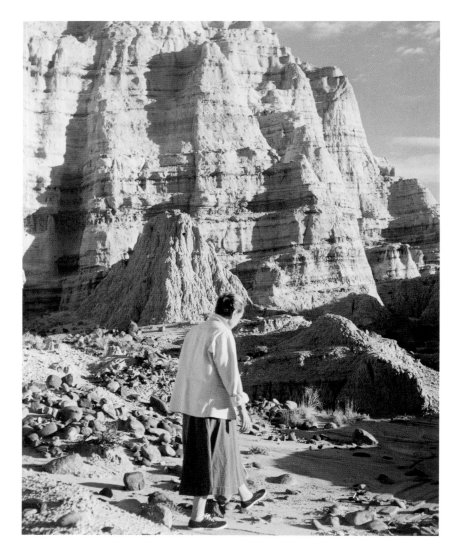

PLATE 331
Todd Webb
O'Keeffe in Abiquiu Garden in Front of Corn
Undated
Gelatin silver print, 9⅝ x 7⅝ (24.5 x 19.4)
Gift, The Georgia O'Keeffe Foundation

PLATE 332
Todd Webb
O'Keeffe Walking in The White Place, Abiquiu, NM
1955
Gelatin silver print, 14 x 11 (35.6 x 27.9)
Gift, The Georgia O'Keeffe Foundation

PLATE 333
Todd Webb
O'Keeffe with Footprints, Ghost Ranch
Undated
Gelatin silver print, 14 x 11 (35.6 x 27.9)
Gift, The Georgia O'Keeffe Foundation

343

PLATE 334
Ansel Adams
Georgia O'Keeffe
1981/1982
Photograph, 10⅛ x 13⅛ (25.7 x 33.3)
Gift of Juan and Anna Marie Hamilton

344

Chronology

1887

November 15: Georgia Totto O'Keeffe is born on a farm near Sun Prairie, Wisconsin.

1892–1900

Attends Town Hall School and, along with sisters Ida and Anita, receives art lessons at home; furthers art instruction with Sarah Mann, a local watercolorist.

1901–2

Attends Sacred Heart Academy, Madison, Wisconsin, for first year of high school, as boarder.

1902

Fall: O'Keeffe family moves to Williamsburg, Virginia.

1902–3

As sophomore, attends Madison High School; lives with her aunt, Leonore ("Lola") Totto.

1903–5

June 1903: Joins family in Williamsburg.

Fall 1903: Attends Chatham (Virginia) Episcopal Institute, as boarder.

June 1905: Graduates. In senior year, serves as art editor of the school yearbook, *Mortar Board*.

1905–6

Attends school at The Art Institute of Chicago.

1907–8

Attends the Art Students League, New York.

1908–11

Fall 1908: Moves to Chicago to work as free-lance commercial artist.

About 1910: Becomes ill and moves to Charlottesville, Virginia, to live with her mother, sisters, and brothers, who moved there from Williamsburg sometime in 1909.

May 1911: Applies for but does not receive teaching position in Williamsburg public schools.

Fall 1911: Temporarily teaches at Chatham Episcopal Institute.

1912

Attends summer school at the University of Virginia, Charlottesville and from 1913 to 1916, teaches summers there as assistant to Alon Bement, a professor of art from Teachers College, Columbia University, New York.

1914–15

Attends Teachers College.

Summer: Teaches as Bement's assistant, University of Virginia.

Fall 1915: Moves to Columbia, South Carolina, to teach at Columbia College.

1916

January: Alfred Stieglitz first sees O'Keeffe's work and begins corresponding with her.

February: Returns to Teachers College for additional course work.

May: Stieglitz opens a group show at his gallery, known as 291, that includes O'Keeffe's recent charcoal drawings.

Summer: Teaches as Bement's assistant, University of Virginia.

Fall: Moves to Texas to head the art department at West Texas State Normal College, Canyon, Texas.

1917

April: Stieglitz opens *Georgia O'Keeffe*, the first one-person show of her work, at 291.

June: Travels to New York to see her exhibit and spends several days with Stieglitz.

August: Vacations in and around Ward, Colorado, and on return to Texas, spends several days in Santa Fe, New Mexico.

1918

June: Moves to New York at Stieglitz's invitation, where for the next eleven years she lives either in the city (winter and spring) or at Lake George, New York (summer and fall), with occasional excursions to, among other places, Maine; Washington, D.C.; and Wisconsin.

1923

January: Stieglitz opens *Alfred Stieglitz Presents One Hundred Pictures: Oils, Water-colors, Pastels, Drawings, by Georgia O'Keeffe, American* at The Anderson Galleries. He subsequently organizes exhibitions of her work annually until his death in 1946.

1924

December 11: Marries Stieglitz.

1925

November: O'Keeffe and Stieglitz take up residence at the Shelton Hotel in New York City.

1929

April–August: Travels to Santa Fe; after arrival, moves to Taos as guest of Mabel Dodge Luhan, who provides O'Keeffe with a studio.

1930

Late April–August: Is in New Mexico.

1931

Late April–July: Is in New Mexico.

1932

May–October: Is at Lake George.

1933

January: O'Keeffe becomes ill and moves to New York apartment of sister Anita Young.

February: Admitted to Doctor's Hospital suffering from psychoneurosis, but, in March, is able to see her exhibition at An American Place.

March–April: Recuperates in Bermuda.

May–December: At Lake George with occasional trips to New York.

October: At Lake George, is recovered enough to begin drawing.

1934

January: Begins painting after a thirteen-month hiatus.

March–April: Is in Bermuda.

Late April–early May: Spends a week in New York and at Lake George.

June–October: Is in New Mexico.

August: Makes first visit to Ghost Ranch, a dude ranch north of Abiquiu owned by Arthur Pack.

1935

July–November: Is in New Mexico at Ghost Ranch.

1936

April: O'Keeffe and Stieglitz move from the Shelton Hotel to a penthouse apartment at 405 East 54th Street.

June–September: Is in New Mexico; spends first summer living at the house at Ghost Ranch that she buys in 1940—Rancho de los Burros—where she subsequently lives almost every summer until 1949, when she moves to New Mexico permanently.

1937

July–October: Is in New Mexico.

1938

Spring: Receives a commission from Steuben to make a design for a glass plate (six were made; five were sold and one was kept by Steuben).

August–November: Is in New Mexico.

1939

Late January–April: Travels to Hawaii to paint as a guest of the Dole Pineapple Company.

1940

June–November: Is in New Mexico; buys Rancho de los Burros. Meets Maria Chabot, an aspiring writer, who lives with her summers at Ghost Ranch until 1945, managing the house and facilitating camping/painting trips.

1941

May–November: Is in New Mexico.

1942

June–November: Is in New Mexico.

1943

April–October: Is in New Mexico.

1944

April–October: Is in New Mexico.

1945

May–November: Is in New Mexico.

December: After her return to New York, O'Keeffe purchases a ruined hacienda in the village of Abiquiu.

1946

June: Is in New Mexico; Chabot begins renovating the Abiquiu hacienda, which she completes in 1949.

July 10: O'Keeffe goes to New York.

July 13: Stieglitz dies.

Late September–November: O'Keeffe in New Mexico.

1947

January–early summer: Is in New York (where she primarily lives until 1949), working to settle the Stieglitz estate along with Doris Bry, who becomes a friend, and from the 1960s to the 1970s, O'Keeffe's agent.

August–December: Is in New Mexico.

1948

April–October: Is in New Mexico.

1949

June: Moves permanently to New Mexico, spending part of each year at her Ghost Ranch and Abiquiu properties.

1956

Mid-March to mid-June: Travels to Peru.

1959

January–April: Travels to Southeast Asia, the Far East, India, the Middle East, and Italy.

1960

Late October–November: Makes second trip to Asia.

1961

Late July–early August: Makes rafting trip on Colorado River.

1965

May: Makes trip to Lake Powell and Colorado River.

1969

September–October: Makes trip to Lake Powell, Glen Canyon, and Colorado River.

1971

Early in year: Loses central vision; retains only peripheral sight.

1972

Completes last unassisted oil painting (*The Beyond*, plate 39).

1973

Meets artist Juan Hamilton, who teaches her to work with clay, becomes her assistant, close friend, and later, her representative.

1984

Discontinues making art and moves to Santa Fe.

1986

March 6: Dies at St. Vincent's Hospital, Santa Fe.

Selected Bibliography

Adato, Perry Miller (producer and director). *Georgia O'Keeffe*. Videotape, 59 min., produced by WNET/ THIRTEEN for Women In Art, 1977. Portrait of an Artist, no. 1. Series distributed by Films, Inc./Home Vision, New York.

Berman, B. Vladimir. "She Painted the Lily and Got $25,000 and Fame for Doing It! Not in a Rickety Atelier but in a Hotel Suite on the 30th Floor, Georgia O'Keefe [sic], New Find of Art World, Sets Her Easel." *New York Evening Graphic* (12 May 1928), 3M.

Brennan, Marcia. *Painting Gender, Constructing Theory: The Alfred Stieglitz Circle and American Formalist Aesthetics.* Cambridge, MA: MIT Press, 2001.

Cowart, Jack, Juan Hamilton, and Sarah Greenough. *Georgia O'Keeffe: Art and Letters* [exh. cat., Washington, D.C.: National Gallery of Art, Washington]. Boston: New York Graphic Society Books, 1987.

Curiger, Bice, Carter Ratcliff, and Peter J. Schneemann. *Georgia O'Keeffe* [exh. cat., Zurich, Switzerland: Kunsthaus Zurich]. Ostfildern-Ruit: Hatje Cantz, 2003.

Dijkstra, Bram. *Georgia O'Keeffe and the Eros of Place.* Princeton: Princeton University Press, 1998.

Drohojowska-Philp, Hunter. *Full Bloom: The Art and Life of Georgia O'Keeffe.* New York: W.W. Norton, 2004.

Eldredge, Charles C. *Georgia O'Keeffe.* Library of American Art Series. The National Museum of American Art, Smithsonian Institution. New York: Harry N. Abrams, Inc., 1991.

——. *Georgia O'Keeffe: American and Modern* [exh. cat., Hayward Gallery, London]. New Haven: Yale University Press, 1993.

Fine, Ruth E., Barbara Buhler Lynes, with Elizabeth Glassman and Judith Walsh. *O'Keeffe on Paper* [exh. cat., Washington, D.C.: National Gallery of Art, Washington, D.C. in association with the Georgia O'Keeffe Museum, Santa Fe]. New York: Harry N. Abrams, 2000.

Giboire, Clive, ed. *Lovingly, Georgia: The Complete Correspondence of Georgia O'Keeffe and Anita Pollitzer.* New York: Simon & Schuster, 1990.

Glueck, Grace. "It's Just What's In My Head. . . ." *New York Times* (18 October 1970), section 2, p. 24.

Hartley, Marsden. "Georgia O'Keeffe" from "Some Women Artists in Modern Painting." Chapter 13 in *Adventures in the Arts: Informal Chapters on Painters, Vaudeville, and Poets,* 116–19. Introduction by Waldo Frank. New York: Boni and Liveright, 1921. Reprint. New York: Hacker Art Books, 1972.

Hassrick, Peter H., ed. *The Georgia O'Keeffe Museum.* New York: Harry N. Abrams, Inc., 1997.

"Horizons of a Pioneer: Georgia O'Keeffe in New Mexico." *Life* 64 (1 March 1968): 40–49.

"I Can't Sing, So I Paint! Says Ultra Realistic Artist; Art Is Not Photography—It Is Expression of Inner Life!: Miss Georgia O'Keeffe Explains Subjective Aspect of Her Work." *New York Sun* (5 December 1922), 22.

Keller, Allan. "Animal Skulls Fascinate Georgia O'Keefe [sic] but She Can't Explain It—Not in Words: If She Could She'd Have to Do It by Painting Another Animal Skull—New York Artist Paints Because She Has To, but Must Be Alone." *New York World-Telegram* (13 February 1937), A2.

Kuh, Katharine. *The Artist's Voice: Talks with Seventeen Artists.* New York: Harper & Row, 1960.

——. "Georgia O'Keeffe by Georgia O'Keeffe," *Saturday Review* (22 January 1977), 44–46.

Lisle, Laurie. *Portrait of an Artist: A Biography of Georgia O'Keeffe.* New York: Seaview Books, 1980. Rev. ed., New York: Washington Square Press, 1987.

Looney, Ralph. "Georgia O'Keeffe." *The Atlantic* 215, no. 4 (April 1965), 106–13.

Lynes, Barbara Buhler. *Georgia O'Keeffe.* New York: Rizzoli International Publications, Inc., 1993.

——, Neil Printz, Heather Hole, and John W. Smith. *Georgia O'Keeffe and Andy Warhol: Flowers of Distinction* [exh. cat., Georgia O'Keeffe Museum, Santa Fe]. Santa Fe: Georgia O'Keeffe Museum, 2005.

——. *Georgia O'Keeffe and the Calla Lily in American Art, 1860–1940* [exh. cat., Georgia O'Keeffe Museum, Santa Fe]. New Haven: Yale University Press, 2002.

——. *Georgia O'Keeffe: Catalogue Raisonné.* 2 vols. New Haven: Yale University Press; National Gallery of Art, Washington, D.C.; Georgia O'Keeffe Foundation, Abiquiu, 1999.

———. *Georgia O'Keeffe Museum: Highlights from the Collection*. New York: Harry N. Abrams, 2003.

———. "Georgia O'Keeffe, "My Own Tune." In *Modern Art in America: Alfred Stieglitz and His New York Galleries*, edited by Sarah Greenough, 261–69 [exh. cat., National Gallery of Art, Washington, D.C.].

———, Lesley Poling-Kempes, and Frederick W. Turner. *Georgia O'Keeffe and New Mexico: A Sense of Place* [exh. cat., Georgia O'Keeffe Museum, Santa Fe]. Princeton: Princeton University Press, 2004.

———. "Reconstructing the Exhibition." In *Georgia O'Keeffe in Williamsburg: A Re-creation of the Artist's First Public Exhibition in the South*, January 27–May 27, 2001 [exh. cat.], the Muscarelle Museum of Art, Williamsburg, VA: 41–46.

———. "The Language of Criticism: Its Effect on the Art of Georgia O'Keeffe in the 1920s." In *From the Faraway, Nearby: Georgia O'Keeffe as Icon*, edited by Christopher Merrill and Ellen Bradbury, 43–54. Reading, MA: Addison-Wesley Publishing Company, 1992. Reprint, *Woman's Art Magazine* 51 (March/April 1993): 4–9.

——— and Ann Paden, eds. *Maria Chabot/ Georgia O'Keeffe: Correspondence, 1941–1949*. Albuquerque: University of New Mexico Press, 2003.

———. "O'Keeffe and Feminism: A Problem of Position." In *The Expanding Discourse: Feminism and Art History*, edited by Norma Broude and Mary D. Garrard, 436–49. New York: HarperCollins, 1992.

———. *O'Keeffe, Stieglitz and the Critics: 1916–1929*. Ann Arbor: UMI Research Press, 1989. Reprint, Chicago: University of Chicago Press, 1991.

———, Russell Bowman. *O'Keeffe's O'Keeffes: The Artist's Collection* [exh. cat., Milwaukee Art Museum, Milwaukee, in association with the Georgia O'Keeffe Museum, Santa Fe]. London: Thames and Hudson, 2001.

McBride, Henry. "The Palette Knife." *Creative Art* 8, no. 2 (February 1931): supp. 45.

Messinger, Lisa Mintz. *Georgia O'Keeffe*. New York: Thames and Hudson, 2001.

O'Keeffe, Georgia. "Desert Bones." *Georgia O'Keeffe: Paintings 1944* [exh. checklist, An American Place, New York]. New York, 1945.

———. *Georgia O'Keeffe*. New York: Viking Press, 1976. Reprint, New York: Penguin Books, 1985.

———. "To MSS. and its 33 subscribers and others who read and don't subscribe!" Letter to the editor. *MSS.*, no. 4 (December 1922): 17–18.

Peters, Sarah Whitaker. *Becoming O'Keeffe: The Early Years*. New York: Abbeville Press, 1991. Rev. ed. New York: Abbeville Press, 2001.

Pollitzer, Anita. *A Woman on Paper: Georgia O'Keeffe*. New York: Simon & Schuster, 1988.

Rich, Daniel Catton. "The New O'Keeffes." *Magazine of Art* 37, no. 3 (March 1944): 110–11.

Robinson, Roxana. *Georgia O'Keeffe: A Life*. New York: Harper & Row Publishers, 1989. Reprinted, Hanover, NH: University Press of New England, 1999.

Ross, Isabel. "Bones of Desert Blaze Art Trail of Miss O'Keeffe: Transition from Calla Lilies to Bleached Skulls Seems Natural Step to Painter—Blends Them with Lilies—Together, They Express Her Feelings, She Explains." *New York Herald Tribune* (29 December 1931): 3.

Seiberling, Dorothy. "The Female View of Emotion." *New York Magazine* 7, no. 6 (11 February 1974): 54.

Taylor, Carol. "Lady Dynamo—Miss O'Keeffe, Noted Artist, Is a Feminist." *New York World Telegram* (31 March 1945), section 2, p. 9.

Turner, Elizabeth Hutton. *Georgia O'Keeffe: The Poetry of Things* [exh. cat., The Phillips Collection, Washington, D.C.]. New Haven: Yale University Press, 1999.

Udall, Sharyn R. *Carr, O'Keeffe, Kahlo: Places of Their Own*. New Haven: Yale University Press, 2001.

Watson, Ernest W. "Georgia O'Keeffe." *American Artist* (June 1943): 10.

Weisman, Celia. "O'Keeffe's Art: Sacred Symbols and Spiritual Quest." *Woman's Art Journal* 3, no. 2 (Fall 1982/Winter 1983), 10–14.

"Wonderful Emptiness." *Time* 76, no. 17 (24 October 1960): 74–75, 77.

Zito, Tom. "Georgia O'Keeffe: At Home on Ghost Ranch, the Iconoclastic Artist at 90." *Washington Post* (9 November 1977): C1.

Index